Rediscovering Traces of Memory: The Jewish Heritage of Polish Galicia

Patrick,

It was a pleasure to have you here in Kraków 2015

Enjoy this stimulating book of the world that was

best wishes Kono!

GALICIA JEWISH MUSEUM

PUBLISHED ON BEHALF OF THE GALICIA JEWISH MUSEUM, KRAKÓW

THE GALICIA JEWISH MUSEUM EXISTS TO COMMEMORATE THE VICTIMS OF THE
HOLOCAUST AND TO CELEBRATE THE JEWISH CULTURE OF POLISH GALICIA

THE LITTMAN LIBRARY OF JEWISH CIVILIZATION

Dedicated to the memory of

LOUIS THOMAS SIDNEY LITTMAN

who founded the Littman Library for the love of God
and as an act of charity in memory of his father

JOSEPH AARON LITTMAN

יהא זכרם ברוך

'Get wisdom, get understanding:
Forsake her not and she shall preserve thee'

PROV. 4: 5

The Littman Library of Jewish Civilization is a registered UK charity
Registered charity no. 1000784

Rediscovering Traces of Memory
The Jewish Heritage of Polish Galicia

JONATHAN WEBBER

PHOTOGRAPHS BY

CHRIS SCHWARZ

THE LITTMAN LIBRARY OF JEWISH CIVILIZATION · OXFORD

INDIANA UNIVERSITY PRESS · BLOOMINGTON & INDIANAPOLIS

2009

The Littman Library of Jewish Civilization

PO Box 645
Oxford OX2 0UJ, UK
www.littman.co.uk

Published in the United States and Canada by

Indiana University Press
601 North Morton Street
Bloomington, Indiana 47404
www.iupress.indiana.edu

The Galicia Jewish Museum

ul. Dajwór 18
31-052 Kraków, Poland
www.galiciajewishmuseum.org

A catalogue record for this book is available from the British Library

Library of Congress Cataloging-in-Publication Data
Webber, Jonathan.
Rediscovering traces of memory : the Jewish heritage of Polish Galicia /
Jonathan Webber; with photographs by Chris Schwarz.
p. cm. — (The Littman library of Jewish civilization)
Includes bibliographical references and index.
ISBN 978–1–906764–03–6 – ISBN 978–0–253–22185–8
1. Jews—Galicia (Poland and Ukraine)—History. 2. Poland—Ethnic relations.
I. Schwarz, Chris, 1948–2007. II. Title.
DS134.55.W43 2009 943.8'6004924–dc22 2009019303

Designed and typeset by Pete Russell, Faringdon, Oxon

Printed in China on acid-free paper by Asia Pacific Offset

This book is dedicated to the memory of

C H R I S S C H W A R Z

12 JANUARY 1948 – 29 JULY 2007

Photographer

*Founder and Director of the
Galicia Jewish Museum, Kraków*

Chris devoted the last years of his life to photographing the traces of
Jewish life still to be seen in Polish Galicia and then creating a museum
where they could be on permanent display in an exhibition entitled
Traces of Memory. In this way he made many thousands of people aware
not only of the Jewish world that was destroyed by the Holocaust
but of the efforts being made to preserve the memory of it in present-day
Poland. Through his creativity and openness to the world he brought
people together and gave them a new understanding of history and of
moral responsibility

The research and photographic project from which
this book derives was principally supported by the

HAROLD HYAM WINGATE FOUNDATION (London)

and the

LUCIUS N. LITTAUER FOUNDATION (New York)

Publication was facilitated by the

ADAM MICKIEWICZ INSTITUTE (Warsaw)

as part of **POLSKA! YEAR** in the UK

Contents

Prologue

The purpose of this book is to present and interpret a selection of photographs from the collection of the Galicia Jewish Museum in Kraków that document the traces of the Jewish heritage that are still to be found in Poland, more than sixty years after the Holocaust — and to consider what they mean, what they represent, and how they can refine our understanding of the Polish Jewish past.

Let me begin by acknowledging the photographer, Chris Schwarz. All the photographs in this book are his. It was an enormous privilege to work with such a talented professional photographer, a man of great emotional depth. He knew how to open people's eyes to new vistas, new ways of seeing, new interpretations of what there is to be seen. When I started researching the subject, I had not realized just how powerful visual images could be — but during the years that I worked with Chris Schwarz, seeing the world through his lens in more ways than one, I benefited greatly from his insights.

Aware of how much his photographs have to say and how important it is to let them speak for themselves, I have kept my captions short. More detailed historical, cultural, and scholarly information, including references to the relevant literature, has been provided in a set of notes at the back, arranged in order of the photographs.

The research and photography on which this book is based took many years. I had come to Poland at the end of the 1980s as a guest of the Institute of Sociology of the Jagiellonian University in Kraków, to work with them in the general field of Jewish studies, which after many years of neglect in Poland was only then beginning to be accepted as a legitimate area of research. I was scholar-in-residence for several years at the

All that is left of the Jewish Poland of old are fragments — fragments of a shattered world; and as fragments they cannot tell the whole story

Institute's summer schools, which were held in a variety of small towns out in the countryside — and there it was that the idea was born to search out the traces of the Jewish past that could still be found dotted about, randomly and unpredictably, whether in physical form (such as surviving synagogue buildings) or more intangibly, in the memories of local people. With the help of the Institute's staff and students I collected a substantial amount of material about both, but to keep the project manageable I restricted myself just to southern Poland, to the territory that was within the former nineteenth-century province of Austro-Hungarian Galicia.

Then came my encounter with Chris: he and I were both from England, but a mutual interest in the Jewish heritage of Galicia led us to a collaboration which began in 1993 and continued into the early years of the present century. I shared with him all I knew, and I gave him a list of places I had found that in my opinion were worth photographing for the documentary record. When he came back and showed me his first photographs I was astonished not only at the quality of his work but at his new vistas and interpretations. The 'Galicia project', as we called it, gathered momentum: Chris searched for funding, I continued to look for fresh places for him to photograph, and by about 2002 Chris had accumulated an archive of about one thousand images. It was a close partnership, and certainly Chris was the closest colleague I have ever had. Of course there were differences of opinion, but instead of 'I think' it slowly became 'we think'.

The Jewish realities of present-day Poland were a considerable challenge to document because of their inherent complexity. To do so effectively one needs not only to grasp the enormity of the destruction that took place during the Holocaust at the local level but also to appreciate the richness and variety of the world that has largely vanished. Chris and I must have travelled thousands of miles criss-crossing southern Poland, each of us working village by village and town by town in order to assemble the material to document this. We spoke endlessly about specific photos, whether they captured the essential spirit of the place. It was not the case that Chris went out and took photographs, leaving me to wonder at a later

To understand the past, images of the Holocaust need to be seen alongside images of how Jewish life once flourished

*One needs to grasp the
enormity of the destruction
but also the richness and
variety of the world that
has vanished*

stage what was worth saying about each of them. On the contrary, and certainly in the later stages of the project, it was a creative collaboration. Sometimes he would have to return in order to retake a particular shot; sometimes I would have to return in order to check whether (for example) there was a more important tombstone in some other cemetery. We discussed the scope for a scholarly book and how it would be arranged. It was agreed we would not attempt a comprehensive, fully inclusive survey of Polish Galicia, but instead I came up with a five-part thematic approach that we called 'Traces of Memory'.

Tragically, in the meantime, Chris was diagnosed with a cancer that he knew was terminal. He made the decision to spend the last years of his life in Kraków and to open a museum there, both in order to show the world a representative sample of his work and to further the educational mission in which he believed. And thus, in 2004, the Galicia Jewish Museum was opened, with Traces of Memory as its permanent exhibition. Chris died in 2007, at the age of 59, having seen his museum come into existence and become widely appreciated. He was full of imaginative and creative ideas for its future. It continues now, after his death, to reach out to large numbers of visitors, and constitutes an important fixture both in the local Polish cultural scene in Kraków and also to the Jewish world at large, anxious to commemorate the victims of the Holocaust as well as to celebrate the Jewish civilization which was destroyed. He left behind an important legacy—to educate both Poles and Jews, to challenge their prejudices and misconceptions over what is still, for many, a contested past, and through his photographs to expose them to each other's histories as well as their own. Chris's artistic insight, and his commitment, charisma, energy, and moral involvement with the subject, made a profound impression on all who were privileged to know him.

This book of Chris Schwarz's photographs is thus written and published posthumously. I hope he would have been satisfied with the way I have presented them. Conceptually it reflects the five-part structure that I

envisaged for the larger, more detailed book we were working towards, *Traces of Memory: The Ruins of Jewish Civilization in Polish Galicia*, a structure that I further elaborated together with Chris as we selected the pictures for the exhibition at the Galicia Jewish Museum, and indeed an earlier version of this catalogue was published by the museum in 2005. It had a similar title: *Photographing Traces of Memory*. Its intention, as the title implied, was to give Chris the opportunity to present his own photographs, and he wrote the captions from the perspective of the photographer. My contribution there was to provide some brief introductory notes to each of the five sections, reflecting the structure we had agreed on for the exhibition. This book is rather different. With a view to enriching the content I have chosen a somewhat different sample of Chris's photographs (hence *Rediscovering Traces of Memory*), provided all the captions, completely rewritten the section introductions, and added the background notes and bibliography. In describing and interpreting the traces of Jewish life and culture for the general reader, my intention has been to put the photographs into context, clarify their meaning, and explain the ideas that they express in a manner that is informative, accessible, and thought-provoking.

Chris's brilliance and devotion as a photographer came through to me repeatedly. In order to get the best possible shots he was willing to carry his heavy equipment and trudge through deep snow, search out vantage points from which to take photos that would reflect the range of attitudes and emotions we wanted to document, wait patiently for the right weather, negotiate with troublesome onlookers, and insinuate himself with charm into private apartments with windows overlooking the places he needed to photograph. Sometimes he would send me a field-note telling me about his frustrations in thinking how to photograph a particular place, for example 'Went twice to visit it and did not even get the camera out of the car . . . Then went back in rather poor light . . . nothing there . . . got into the car, depressed, thinking I would have to leave it—when the sun came out, and though the building was in

Chris Schwarz's photographs open people's eyes to new vistas, new ways of seeing, new interpretations of what there is to be seen

shadow there was this beautiful light on the tree. Once the picture was developed I realized I had something for me rather special—with this very tall sunlit tree reaching upwards . . . a positive uplifting image . . .'.

In short, Chris understood that his photography could influence the way people perceive things. His photographs are stunning, in both senses of the word. Taken at all seasons of the year, they help us become acquainted with the landscape in which Jews lived, in all its variety, and specifically in its Polish setting. He has provided us with a vitally important benchmark, defining the situation of the Jewish heritage in Poland two generations after the Holocaust. In many ways he was a latter-day Roman Vishniac, but a photographer who, unlike Vishniac, had to content himself with the last traces of memory rather than the documentation of a living Jewish world. The condition of those traces will continue to evolve in the future, for better or for worse; but at least here we have a statement of how these things looked in our own day.

Our work together lasted more than fifteen years—twelve years on the photography and then three years at the Galicia Jewish Museum. Each of us benefited from the help and advice of a substantial number of people, from the inception of the project through to its completion. The list of names that follows is just the tip of the iceberg: all of these people, in their own way, have left their invisible mark on this publication.

Let me begin at the end and thank Jenny Harris, Ian Montrose, and David Tilles, selected by Chris in his lifetime to be trustees of the Galicia Jewish Museum under my chairmanship. They all admired Chris's photographic work in Poland and helped him create an appropriate institution where it could be seen by the public and where as founding director of the museum he could implement his educational vision. This mission is now very ably and energetically continued by Kate Craddy, Chris's successor as museum director, supported by Edyta Gawron and Maciej Skocz as members of the board of directors in Kraków, and by a committed group of museum staff.

The photographs provide a vitally important benchmark, defining the situation of the Jewish heritage in Poland two generations after the Holocaust

In reviewing the long years of research and photography which gave rise to the Traces of Memory project, let me first thank the trustees of the Harold Hyam Wingate Foundation and of the Lucius N. Littauer Foundation whose financial support covered a very large part of the expenses before the idea arose of creating a museum. Other institutional sponsors have included the Institute for Polish–Jewish Studies, the Oxford Centre for Hebrew and Jewish Studies, the Institute for Social and Cultural Anthropology of the University of Oxford, the University of Birmingham, and the Congregation Sof Ma'arav of Honolulu, Hawaii. There were personal donations from Derek Gold and David Lewis, and private family foundations in memory of Lili Tapper and George and Carmel Webber. Also among our facilitators from those early days were Alan Crown and Ian Montrose, without whose encouragement none of this work would have happened.

But in a very important sense the project is also to be understood as the result of the extraordinary friendliness and openness of local people in Poland over a number of years. Officials in local municipal offices, local history enthusiasts, caretakers of local Jewish cemeteries—all such people, and many more besides, gave me a lot of their time and willingly pointed out to me the remains of the local synagogue, or the empty piece of land where it used to be, and shared their memories of pre-war times. There were almost no guidebooks in those days as there are today. But Jews were a definite part of their world, and they remembered a great deal—even the names of Jews who once lived on their town's main square. All these people contributed meaningfully to this book. I can here single out only a few names: sociologists and anthropologists at the Jagiellonian University, Kraków, beginning with Zdzisław Mach and the late Andrzej Paluch, who introduced me to a number of very helpful colleagues, including Łucja Kapralska and Annamaria Orla-Bukowska; staff at the Auschwitz Museum, including Krystyna Oleksy, Piotr Setkiewicz, Teresa Świebocka, and Jerzy Wróblewski; specialists at the Jagiellonian University in Jewish studies, including Michał Galas and Leszek Hońdo; Eleonora Bergman and Jan Jagielski of the Jewish Historical Institute, Warsaw; and

Wherever I went local Poles were ready to share their memories of the Jewish past, pulling from their wallets faded pre-war photos of their Jewish friends and neighbours

innumerable people out in the smaller towns, including Maria Nitkiewicz (Łańcut), Mirosław Ganobis (Oświęcim), Adam Bartosz (Tarnów), and Paulina Podkanowicz (Zakopane). The project benefited from the friendship of many people in Kraków who took a close personal interest, among them Tadeusz Jakubowicz, Marek and Katarzyna Kucia, Andrzej Maksymowicz, Bernard Offen, Małgosia and Wojtek Ornat, and Halina and Marian Pawelski; and from the very beginning of the research it benefited enormously from the personal involvement of Annette Winkelmann (Berlin). A variety of British students and colleagues accompanied me on my fieldwork, always offering help and support, among them Bob Parkin, Stephen Smith, and Sonia Misak (née Lucas); it was in fact through Sonia that I first met Chris. For research assistance I am especially indebted to Lindsey Taylor-Guthartz, and for encouragement with the project I remember with gratitude the late Gillian Rose and the late Rafael (Felek) Scharf, as well as Mary Aldworth (for typing my field-notes), Denis Lawlor (for computer assistance), Steven Maier (for legal assistance), and—last but not least—Duvid and Naomi Singer of the Bobov hasidic community of Borough Park, New York (for their infectious enthusiasm for Jewish Galicia). The above list is very far indeed from being exhaustive. In particular, in compiling these names I am conscious of being unable to consult Chris about those he would have wished to thank, but I am sure that he would have wanted me to mention Bogdan and Alina Frymorgen, Sophie Read, and Victor Seedman, as well as a variety of local Polish students whose names I unfortunately do not know—except that they travelled with him, helped him carry his equipment, and acted as his assistants and interpreters. Unfortunately Chris left behind no list giving such information, nor do I have any details about the equipment or methods he used—his cameras, film, the length of exposure, or other technical data.

I owe a special debt of gratitude to my long-suffering publishers, who have waited very patiently for a much longer, more detailed book on the subject. That book is still in preparation; it will have five hundred photographs, seven times the number here, and very much more text. However, after Chris's death they kindly agreed to publish this book too, on behalf of the Galicia Jewish

We were encouraged by the infectious enthusiasm for Jewish Galicia that we constantly encountered

Museum, to accompany the exhibition in the meantime. The outstanding design input by Pete Russell, who from the start showed great interest in the whole project and wanted to develop a visual and typographic concept that would do justice both to Chris's photographs and to the subject, has been invaluable; the artistry of this book is entirely his creation. My thanks are due also to Colette Littman and Roby Littman, the directors of the Littman Library, who warmly encouraged this publishing project from the start, to Ludo Craddock, the Littman Library's good-humoured and supportive CEO, and to Janet Moth, for her clear-headed and insightful copy-editing. My wife Connie, managing editor of the Library, has lived with *Traces of Memory* for many long years — she accompanied me to every single place recorded in this book, mulled over my thoughts and helped me elaborate them, and in ways too numerous to record here has been nothing less than my invisible co-author.

To the readers of this book, and especially the kind people I have mentioned above, I must apologize for any errors which have crept into the text. If there is one person in particular whom I could single out who would have ensured this book had no important errors, it is Henryk Hałkowski. Born in 1951, Henryk was one of the most remarkable Jews of the post-war generation in Kraków: his knowledge and love of the history, traditions, and legends of the city were beyond compare, and he willingly shared his knowledge with his many friends locally and internationally. The text of this book benefited immeasurably from his many pertinent observations over the twenty years I knew him. Unfortunately he died suddenly in January 2009, as this book was being completed, and so he never had a chance to see the final manuscript. To Henryk, to Chris, and to all those who continue to devote themselves to preserving the memory and the traces of the Jewish past in Polish Galicia, this book is humbly dedicated.

University of Birmingham
February 2009

Jonathan Webber

It is the duty of our generation to preserve the memory and the traces of the Jewish past in Polish Galicia, where so many elements of the Jewish world as we know it had their origins

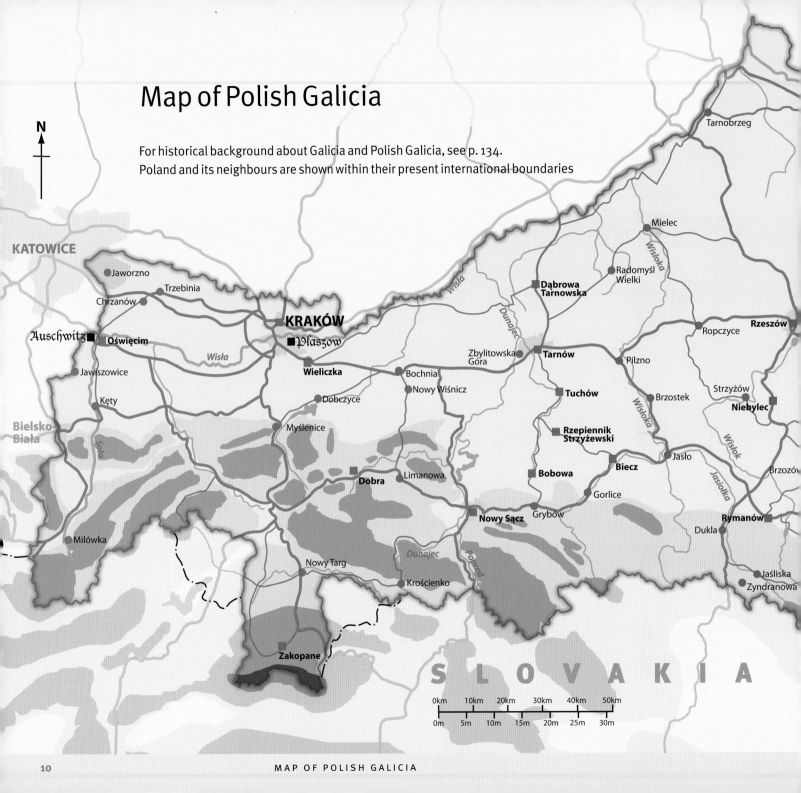

Map of Polish Galicia

For historical background about Galicia and Polish Galicia, see p. 134.
Poland and its neighbours are shown within their present international boundaries

N

KATOWICE

Jaworzno
Trzebinia
Chrzanów
Auschwitz
Oświęcim
Jawiszowice
Kęty
Bielsko-Biała
Milówka

KRAKÓW
Płaszow
Wieliczka
Bochnia
Nowy Wiśnicz
Dobczyce
Myślenice
Dobra
Limanowa
Nowy Sącz
Grybów
Nowy Targ
Krościenko
Zakopane

Wisła
Wisła
Soła
Dunajec
Poprad

Mielec
Dąbrowa Tarnowska
Radomyśl Wielki
Zbylitowska Góra
Tarnów
Tuchów
Rzepiennik Strzyżewski
Bobowa
Biecz
Gorlice

Ropczyce
Rzeszów
Pilzno
Brzostek
Strzyżów
Niebylec
Jasło
Brzozóv
Rymanów
Dukla
Jaśliska
Zyndranowa

Wisłoka
Wisłoka
Wisłok
Jasiołka

Tarnobrzeg

Dunajec

S L O V A K I A

0km 10km 20km 30km 40km 50km

0m 5m 10m 15m 20m 25m 30m

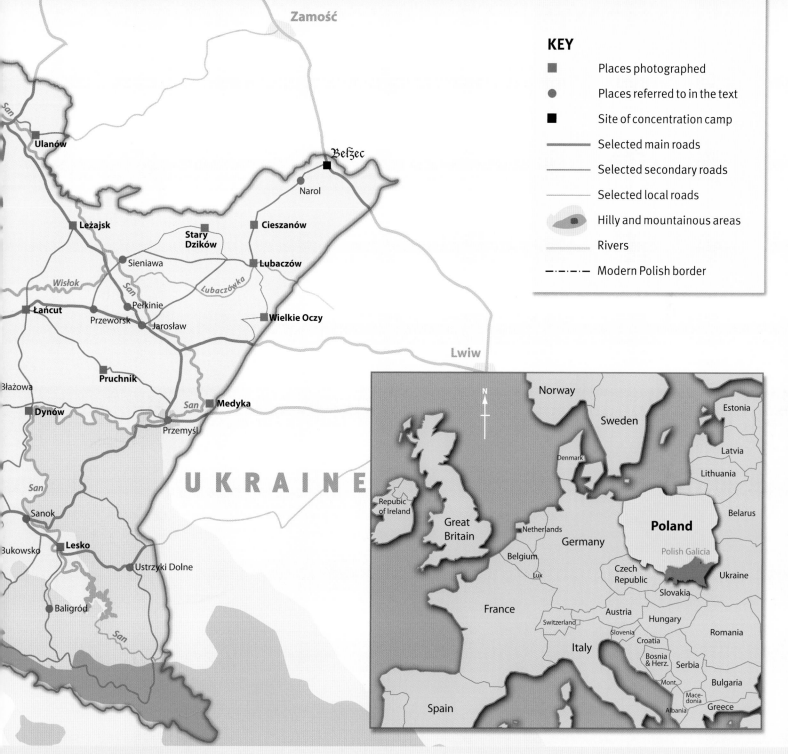

KEY

- Places photographed
- Places referred to in the text
- Site of concentration camp
- Selected main roads
- Selected secondary roads
- Selected local roads
- Hilly and mountainous areas
- Rivers
- Modern Polish border

Zamość

San

Ulanów

Bełżec

Narol

Leżajsk

Stary
Dzików

Cieszanów

Sieniawa

Wisłok

San

Łubaczówka

Lubaczów

Łańcut

Pełkinie

Przeworsk

Jarosław

Wielkie Oczy

Pruchnik

Błażowa

San

Medyka

Dynów

Przemyśl

Lwiw

UKRAINE

San

Sanok

Lesko

Bukowsko

Ustrzyki Dolne

Baligród

San

MAP OF POLISH GALICIA

Introduction

Jewish civilization developed in Poland over a period of more than eight hundred years until it was brutally destroyed during the Holocaust. It was a civilization of enormous creativity and vitality.

For about three hundred years, down to the beginning of the twentieth century, Poland was regarded by Jews as the principal centre of the Jewish diaspora and indeed was home to the largest Jewish community in the world. In the middle of the nineteenth century, before the start of the mass Jewish migrations to the USA, close to 90 per cent of the world's Jews lived in Europe, of whom the majority lived in the Polish lands. To this day the contributions of the great rabbis of Poland to both Jewish law and Jewish spirituality remain deeply respected, and most of the main political, artistic, literary, and intellectual movements that have characterized the Jewish world in the modern period were developed or had their origins in these lands. For several centuries, Jewish cultural self-awareness has thus pivoted around the Polish experience.

Virtually the whole of the Polish Jewish world was physically destroyed during the Holocaust. Close to 90 per cent of Poland's Jews were forced out of their homes and murdered. Of those who survived, relatively few attempted to rebuild their lives as Jews in Poland; a large percentage of those who did so subsequently left the country. Today the Jewish population of Poland is less than half of 1 per cent of what it was before the Second World War. With the Jews gone, synagogues have been converted to other uses, or simply left to decay; Jewish cemeteries lie abandoned; former Jewish community buildings have been turned into blocks of flats or student dormitories. The whole environment of Jewish Poland gives out an overwhelming sense of tragic absence.

The Jewish civilization in Poland was one of enormous creativity and vitality—but since the Holocaust the sense of tragic absence is what dominates

The memory of the long Jewish past in Poland has become almost completely overshadowed by our knowledge of the end of the story — images of the Holocaust, of Auschwitz and the atrocities committed there. But if we are fully to understand and make sense of the Jewish past in Poland we need to place another set of images alongside these: images of those traces of the Jewish presence in Poland that are still to be found in the towns and villages where Jewish life once flourished. It is these two sets of images together, in the context of an appreciation also of the work that is being done today in Poland consciously to memorialize the Jewish past, that are being treated in this book as 'traces of memory'.

What this book sets out to do is precisely to offer an inclusive view of these traces of memory. It is not a historical survey in the conventional sense, nor are there any pre-war photographs here. On the contrary, what this book presents are contemporary photographs, to show what can be seen today about the past. In so doing, it offers a completely new way of looking at the Jewish past in Poland that was left in ruins. We offer it in tribute to the rich Jewish heritage of the country; in memory of the violence with which it was destroyed by the Germans; and in appreciation of the manifold ways in which the totality of this past is being remembered and represented in Poland today. The idea has been to try to piece together a composite image of the traces of Jewish life and culture in Galicia that still exist and to suggest how a present-day visitor or reader can try to make sense of this past. Hence the use of colour — a conscious decision by the photographer to emphasize that the images are of present-day realities, not at all remote representations of a faded history.

It is a complex subject, and this book is intended to offer only a very short introduction. There is no attempt to be fully comprehensive, for example by covering all towns and villages one by one. To do that would have required a very much larger number of photographs than it has been appropriate to include here. The aim of this book, like the exhibition of photographs on display at the Galicia Jewish Museum from which it

Our knowledge of the end of the story has overshadowed the memory of the long Jewish past in Poland

derives, has been quite different: to hint at the complexity of the subject by showing its different dimensions and the different moods in which it can be approached.

As I hope this book shows, there is in any case more than one reality to be found in Poland today regarding its Jewish past, and more than one emotion with which to approach it. Even if some of the old synagogue buildings that have survived are still in ruins, some of them have been partly or fully restored, albeit often used for other purposes. There are not only the remains of the former concentration camps such as at Auschwitz, but also remote Holocaust monuments deep in the countryside. Efforts are certainly being made to restore the public memory of the Jews in Poland, by both local people and foreign Jews; but such 'memory work' is largely uncoordinated, and it is hard to generalize. What is true of one village can give no indication of what there is in the next village a short distance away. There are places which were famous among Jews before the war but which lack appropriate memorials today, and there are also other, less well known, places which have important monuments that preserve the local memory of their Jewish past. With the exception of the city of Kraków, where a number of synagogues and other Jewish community buildings in the former Jewish quarter happened to survive, it is not possible to visit any single town or village and obtain a full, global sense of how things used to be before the Holocaust, nor of what happened there during the Holocaust. So the task of piecing together into some coherent shape the random surviving relics, traces, and memories of this destroyed culture is a difficult one.

What is presented in this book is therefore not a geographical nor a chronological survey, but something else entirely. The starting point is the acknowledgement that making sense of the relics, traces, and memories depends on one's approach. There are those for whom Poland after the Holocaust is one vast graveyard, where everything Jewish is in

The present-day realities are multi-dimensional: things look different when seen close up

ruins; there are others who want to search out the beautifully restored synagogues, or whatever else is left that shows the creativity and greatness of Jewish spiritual and cultural achievements in Poland over many centuries. There are those who are interested more specifically in the local events of the Holocaust, and there are others who have devoted themselves energetically to activities that memorialize the past and would like to know more about the people who are involved in such work.

It is differences in approach such as these which have inspired the five-part structure of this book and on which the Traces of Memory concept has been based. The five sections that follow form a series of perspectives which, taken together, can help us make sense of what is in fact a multi-layered set of realities that all simultaneously exist today. What this structure sets out to convey is precisely that there is no single, stereotyped way of interpreting present realities in Poland as far as the Jewish past is concerned, but rather that our understanding must incorporate a number of diverse and contrasting elements. Hence the organization of the photographs into five sections is intended to suggest five different ways of thinking about the traces of the Jewish past still to be seen in Poland today, more than sixty years after the Holocaust. These five sections reflect the idea that present-day Poland can inspire not just one set of feelings but a much wider range of emotions — a profound sense of sadness in the encounter with the ruins; the opportunity to reconnect with an exceptionally vigorous and vibrant Jewish civilization, including its sense of sanctity and spirituality; a sense of horror at the process of destruction during the Holocaust and the need to mourn the vast loss of life that took place; an awareness of the very varied ways of coping with the past, including the desire to forget about it altogether; and, finally, the inspiration that can be found in the work of those individuals and institutions, both Jewish and non-Jewish, that have committed themselves to preserving memory and contributing to the revival of a wider interest in Polish Jewish culture. It is a complex emotional journey.

To encounter the traces of memory in Polish Galicia is to go on a complex emotional journey

Different perspectives and emotions overlap and interlock continuously

These diverse aspects and emotions are not watertight categories. On the contrary, they overlap and interlock with each other at many points. For example, a restored synagogue that has been turned into a Jewish museum lacks the patina of informality that would normally characterize a synagogue in everyday use, and in that sense such a former synagogue, intended for tourists and other visitors rather than for local worshippers, can also be taken as a symbol of the destruction, odd though that may sound. Some readers may therefore disagree with the way specific photographs have been 'classified' into this or that section; however, the intention has been to propose meanings—or at least to draw attention to potential meanings, not necessarily to the exclusion of others. In my experience of present-day Jewish Poland I have encountered many emotions, ranging from anger to optimism, and my objective, in arranging the photographs as I have, is to communicate something of that range through the mechanism of dividing up the subject into different sections. The five sections, in other words, are simply an organizational device to express the idea that there are multiple ways of seeing the subject. In practice, two or more of the five perspectives and their corresponding emotions may thus coexist simultaneously—to a greater or lesser degree, depending on the individual and the context—and moreover they are subject to change, sometimes as a result of personal experience or new knowledge. The photographs show things as if they were fixed, stable realities; they do not show the uncertainties, the inconsistencies, or the changes in people's memories of the past, and they certainly cannot show what isn't there—for example, the gaping holes, the silences, and the absences that are so obvious to survivors. This is something I have tried to mention in the captions and background notes.

The handful of photographs accompanying this introduction is intended to highlight this multidimensionality, and in that sense to set the stage for what is to follow. On the one hand they refer to the long and distinguished history of the Jews of Poland; on the other, they refer to their absence today and the inhuman tragedy surrounding their disappearance.

One of the photographs draws attention to an important Jewish preoccupation—the existence of antisemitism in Poland. This has been such a recurrent phenomenon over the centuries that for many Jews it is still one of the dominant motifs of their memory of the country, and the subject is returned to at different points in this book. But obviously it was hard to make a photograph of something which would characterize the memory of pre-war alienation and antisemitism, let alone the counter-memory which also needs to be included—that Jews could feel at home in the Polish environment and indeed, like anyone else, have a certain love of their local, familiar landscape. Elements of memory such as these can only be hinted at, not adequately explored, and in that sense what has here been pieced together is far from a perfect picture. All that we have, in any case, are fragments—fragments of a shattered world. The lone surviving tombstone of the former Jewish cemetery in Płaszów is a symbol both of the catastrophe and of the challenge to us today in trying to make sense of what has been left behind and to integrate it into the heritage that is to be bequeathed to the future.

All that we have are just the traces of memory. How can we piece them together into a heritage to be bequeathed to the future?

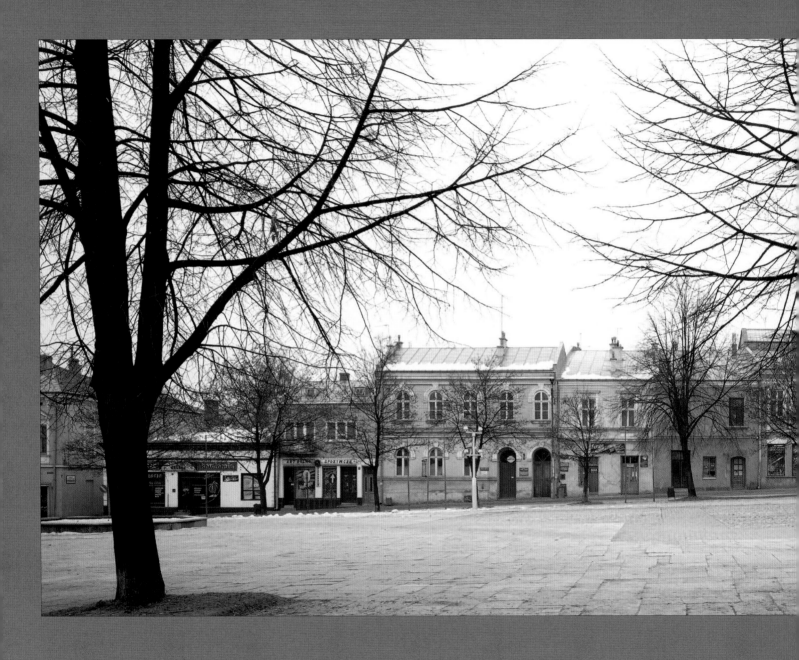

INTRODUCTION

1 Present-day realities of Polish Galicia: the town square empty of Jews

The main square of the small town of Biecz.
The building with the arched doors and
windows was once the synagogue;
now it is the public library.

This deserted scene well symbolizes the
Jewish realities of post-Holocaust Poland.
The Jewish community that lived here
before the war comprised only about five
hundred people—making up 15 per cent or
so of the total population—but it had
Jewish schools, Jewish youth movements,
distinguished rabbis, and an important
Jewish library. The main square would have
been full of Yiddish-speaking Jewish traders.
Today the sound of Yiddish has gone:
there are few traces that Jews lived here at
all, other than the Jewish cemetery.
For former Jewish residents, returning here
brings to mind the idea expressed in the
opening line of the book of Lamentations:
a forlorn city, once so full of people but now
lonely as a widow.

SEE NOTE ON P. 136

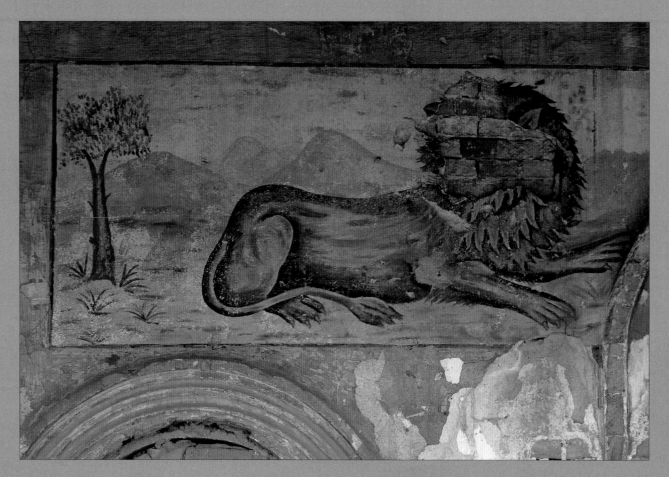

2 The lion of Judah, derelict and headless

Present-day Poland is not only largely empty of Jews as a result of the Holocaust; the Jewish society and civilization which had flourished for centuries there is essentially in ruins. All that is left today is but a tiny remnant.

At the entrance to the abandoned, ruined synagogue in the small town of Dąbrowa Tarnowska is this painting of a lion. Many Galician synagogues had a picture of a lion, representing a passage in the Talmud exhorting Jews to be as strong as a lion in devoting themselves to the service of God. Here, in an extraordinarily expressive way, the head of the lion has gone, and the brickwork is showing through. The lion is dead. This derelict, crumbling painting can be taken as a symbol of the Holocaust, a silent testimony to the world that was destroyed.

SEE NOTE ON P. 136

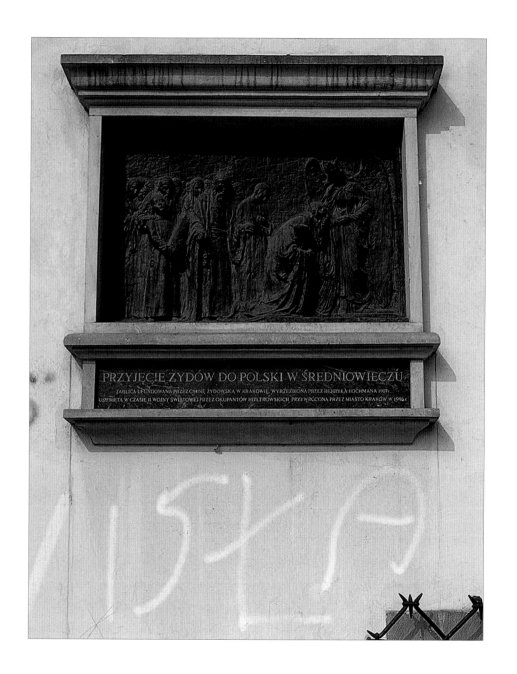

3 The Jews being formally welcomed to Poland in medieval times

A bas-relief plaque on the old town hall of Kazimierz, the main Jewish district of pre-war Kraków, records the fact that Jews were formally welcomed to Poland in the Middle Ages. It was made by the Jewish sculptor Henryk Hochman in 1907.

Jews are known to have been in Poland at least from the end of the eleventh century. They were given protection under the law as well as the right to self-government and freedom of religion under the Kalisz Statute of 1264. In the fourteenth century there was an influx of Jewish refugees, fleeing from persecution in Germany and Bohemia-Moravia. This was during the reign of King Kazimierz the Great; he formally reconfirmed the Jewish privileges and encouraged Jews to settle. They prospered, and by the sixteenth century Poland had become a major centre of Jewish life. It was also a centre of rabbinic scholarship; Kraków in particular became famous as the seat of eminent rabbis whose works are held in the highest esteem to this day.

SEE NOTE ON P. 136

4 A history of antisemitic violence

Jewish prosperity in Poland eventually brought prejudice and jealousy from the Catholic clergy and the trade guilds. Even in the sixteenth century, when Jews could travel and trade freely in Poland, twenty cities obtained the special privilege of barring Jews altogether (known as *de non tolerandis Judaeis*). Everyday social relations between Poles and the Jewish minority over the centuries were regularly punctuated by periods of tension and mob violence.

This ongoing hostility and violence that Jews suffered from their Catholic neighbours distort other recollections of Poland, overshadowing the fact that the conditions of life in Poland allowed them to develop an extraordinarily rich religious and cultural life there over many centuries. With the hindsight afforded by the Holocaust, the combination of the anti-Judaism of the Polish Catholic Church and modern forms of political and economic antisemitism has come to be seen by many Jews as the key characteristic feature of the Jewish experience in Poland and is certainly one of the dominant motifs of the present-day Jewish memory of the country.

This tombstone, in the old Jewish cemetery of Kraków, is a grim reminder of this history. In May 1637, during one of a number of anti-Jewish street riots in Kraków in the seventeenth century, Poles seized forty Jews and threatened to throw them all into the river. Some of the Jews saved themselves by promising to convert to Christianity, but seven were drowned. This event caused such disquiet that the Kraków rabbinate fixed the anniversary in perpetuity as a day of mourning when special commemorative prayers were to be recited. This plain slab marks the place where these Jews lie buried.

SEE NOTE ON P. 137

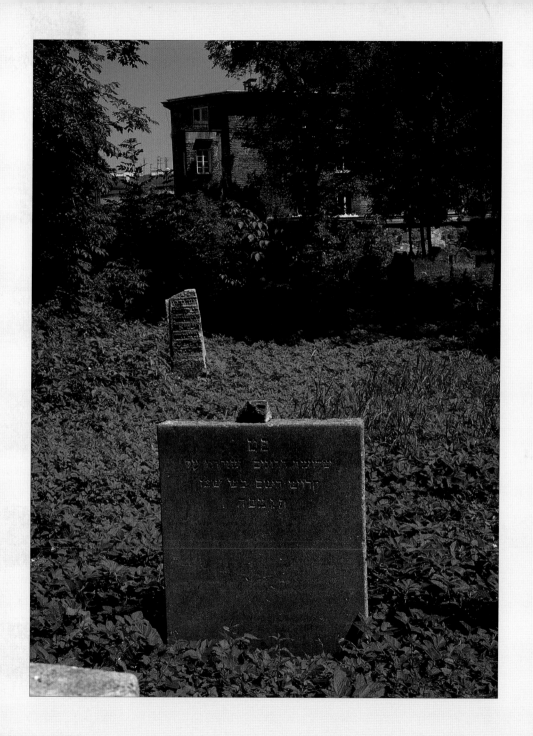

5 A lone Jewish tombstone highlights the randomness of the surviving traces of memory

For many Jews, this photo of the one solitary legible tombstone of the former Jewish cemetery of Wola Duchacka in Kraków, an area now part of Płaszów, is perhaps as close as one can get to a visual representation of Jewish Poland today—a featureless graveyard, empty except for the occasional chance relic. The Jewish memory of Poland for the most part encompasses merely the poverty, the antisemitism, and the death and destruction of the Holocaust.

In essence, the purpose of this book is to explore this image, through a journey across the territory of southern Poland in the former province of Galicia. It is a difficult and sometimes disorienting journey: things are not always what they seem to be at first glance. For example, this cemetery later became the site of a concentration camp. So does this one tombstone that survived represent the last trace of a normal, pre-Holocaust Jewish world, or is it to be taken as a symbol of the tragic events that engulfed it? There is no simple answer: it seems to mean both things at once.

SEE NOTE ON P. 137

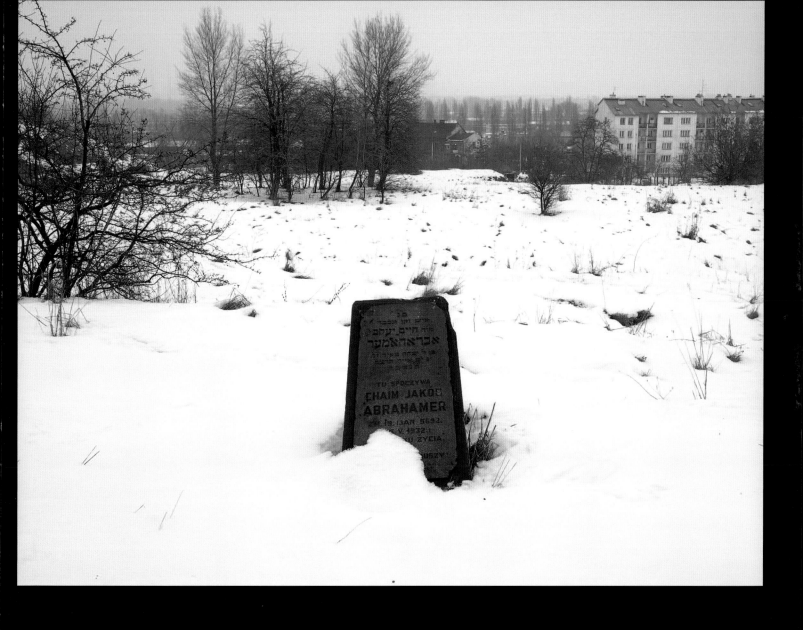

6 Hebrew inscription proclaiming faith in God that survived in the shadow of Auschwitz

This stone tablet, dating from 1907, carries the inscription in Hebrew, 'Know before whom you are standing—before the supreme king of kings, the Holy One, blessed be he. I have set God before me, always.' This text was commonly used in Polish synagogues to encourage proper devotion among those coming to pray, and it is the only such pre-war stone tablet to have survived intact in Polish Galicia.

What is astonishing about this tablet is its location—it is in the last remaining synagogue building in the town of Oświęcim, just over one mile from the death camp of Auschwitz.

The survival of Hebrew inscriptions, Jewish tombstones, synagogue buildings, and indeed any traces or fragments of the remarkable Jewish civilization that flourished in Poland over many centuries has been unpredictable, random, and uncoordinated. Is there, perhaps, something symbolic in the fact that an inscription of this nature somehow survived within walking distance of Auschwitz?

SEE NOTE ON P. 138

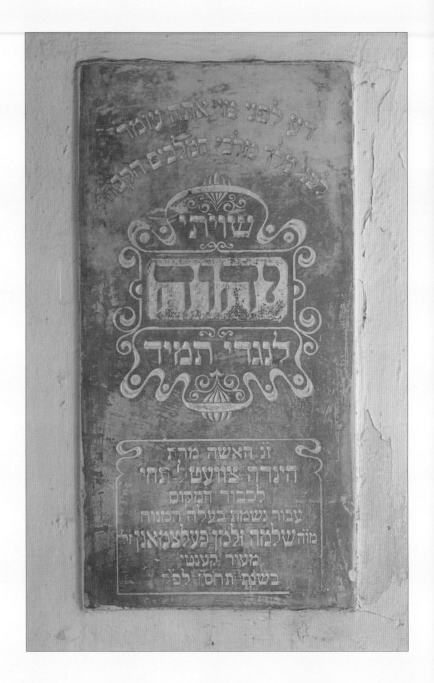

1 Jewish Life in Ruins

This first section focuses on ruins: it is, after all, the key present-day reality of the Jewish past in Poland. When the Germans occupied the country in the Second World War, they systematically rounded the Jews up in the towns and villages where they lived, and then deported them to places where they would, sooner or later, be murdered.

What the Jews left behind — their homes, their possessions, their synagogues, their community institutions, their cemeteries — testifies both to the richness and diversity of the culture they had built up in Poland over many centuries and to the immensity of its destruction. In most cases, their homes and possessions were looted, the synagogues were ransacked and then set on fire, and the cemeteries were pillaged for their stones, which were reused as building materials in road construction, street paving, and the like. The physical traces of Jewish life were left in total ruin after the Holocaust. Poland, as seen through the eyes of Jews living in other countries, especially Holocaust survivors, is a graveyard, a landscape of ruins.

Many of these ruins have continued physically to survive, as ruins, into the present day. There are roofless synagogues open to the sky, their interiors totally overgrown, with bushes growing out from their walls, synagogues propped up by rough-and-ready scaffolding or with only the central pillars still standing. In such devastated synagogues the empty, desecrated *aron hakodesh* — the focal point of a synagogue where the sacred scrolls of the Torah are stored — symbolizes the horror of the brutal persecution. Countless eyewitness reports from every country in German-occupied Europe describe how the scrolls would be deliberately ripped out, torn to pieces, set on fire, danced upon.

For many Jews, Poland is a vast Jewish graveyard, a landscape of ruins

These had been flourishing communities, in many localities with a history going back for centuries. These synagogues witnessed weddings and joyful processions; the cemeteries contained carefully carved tombstones. But now there is hardly anyone even to look after these places, which are left to rot. The Hebrew inscriptions have decayed, and today are barely legible. The worshippers are long since gone, and the physical remains of their culture linger on, damaged beyond repair. There was no preparation for leaving all this to posterity. On the contrary, the clock simply stopped. Jewish history was interrupted in mid-flow. These centres of Jewish life are enveloped in a sense of desolation. There is nothing but silence, the painful ruins that are the evidence of the tragedy. In village after village, town after town, there are no Jewish communities any more. The banality of the ruins they left behind is painful to look at.

The ruins of cemeteries and tombstones present a similarly eloquent, poignant testimony. There are cemeteries with tombstones scattered on the ground as if on a dustheap or piled up as if by a hurricane, cemeteries where a few scattered tombstones fallen to the ground is all that is left, cemeteries treated by the locals as parkland and used for cycling or as pedestrian thoroughfares, cemeteries where all the tombstones have vanished and nothing remains but the brambles and dense thickets of shrubs that have grown up where tombstones were before, cemeteries where even the trees themselves have fallen down over the tombstones. There are cemeteries where the gravestones that are left behind are like amputated stumps; they have been smashed to pieces and abandoned.

These ruins are profoundly expressive testimony to the society that was uprooted and destroyed. They are fragments marking the presence of a world that is no longer present. But they are not always easy to find: even Jewish cemeteries quite near to a main road may be in ruins and totally overgrown with vegetation, and it is possible to travel through the region without becoming aware of their existence. Sometimes abandoned Jewish cemeteries have been built over or merged with adjacent land used for agricultural purposes. Ruins of buildings, or at least all traces of former

Jewish ownership, may also have disappeared completely: for example, Hebrew and Yiddish inscriptions may have decayed to the point that new owners of the buildings have plastered them over. A small plot of wasteland or parkland in a city centre may represent the spot where a synagogue that lay in ruins for years was then finally demolished.

In many places a cemetery in ruins is the only trace remaining to show that there was once a Jewish community there. Such relics are thus the last glimpse of the past before these physical traces are gone for ever, before the reduction to nothingness, when the very existence of a local Jewish community will survive only in the memory. But the shame and sense of abandonment and desecration that such ruins project have occasionally had the opposite effect — to encourage local authorities, or the families of Jews whose ancestors are buried in the local cemetery, to set about restoring them to something of their former glory.

The photographs in this section not only reinforce the Jewish image of Poland as a landscape of death and destruction; they also reflect present-day reality. These ruins are authentic objects in real places. Many continue to deteriorate year by year; a few attract restoration projects. But there are far too many, far too badly decayed, for restoration to be a viable option. The destruction affected every town and village where Jews lived, and in most places the destruction was total. On seeing the ruins of a destroyed civilization the natural response is to think about what went before, how these places must once have looked in their heyday. And the natural response to that is to engender a profound sense of mourning for the magnitude of the loss.

Seeing the ruins of a destroyed civilization is deeply saddening and makes one realize the magnitude of the loss

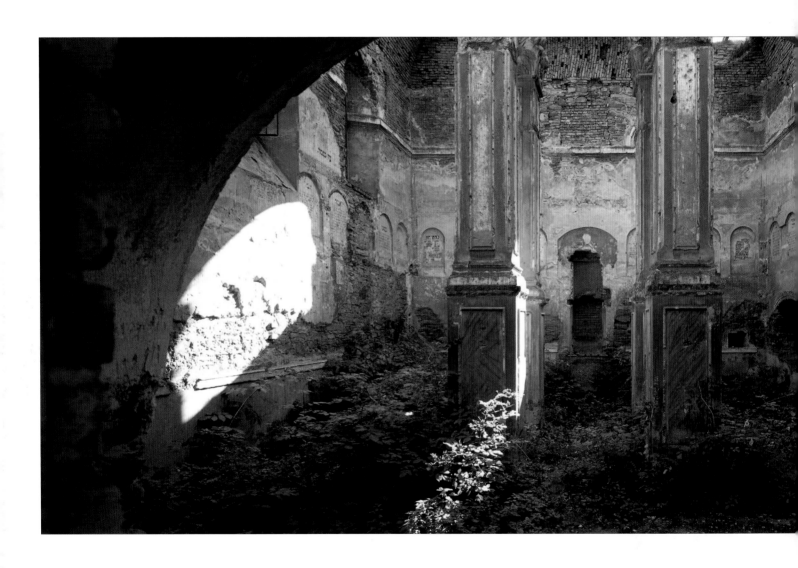

JEWISH LIFE IN RUINS

7 Melancholy ruins of a devastated synagogue

For sixty years after the end of the war, this melancholy ruin was all that remained of a magnificent, sumptuously decorated synagogue built at the end of the eighteenth century. On the right-hand wall is the picture of a lion, reminding worshippers that they should be as strong as lions in the duties of their faith. The small town of Rymanów is famous among hasidic Jews to this day because of the saintly R. Menahem Mendel, one of the earliest hasidic masters in Galicia, who lived here from about 1795 until his death in 1815; he is personally said to have been as strong as a lion in his devotion to prayer. Shame that his synagogue was still in ruins finally spurred a descendant to undertake restoration work here, beginning in 2005.

SEE NOTE ON P. 138

8 The devastated sanctuary ironically still carries the prayer for renewal and return

This synagogue of Rymanów was in its heyday an architectural gem, complete with wall paintings and arched niches containing ethical and liturgical Hebrew inscriptions. Its devastation, testimony to the destruction of a great civilization, is deeply expressive of the Holocaust. In such a context, the liturgical text in the arched niche on the far right of the photograph, glimpsed through the columns of the vaulted central *bimah*, seems tragic in its unintended irony: 'Return, O Lord, to the countless thousands of Israel. . . . Turn us back, O Lord, to yourself, and we shall gladly return; renew our days as of old.'

SEE NOTE ON P. 139

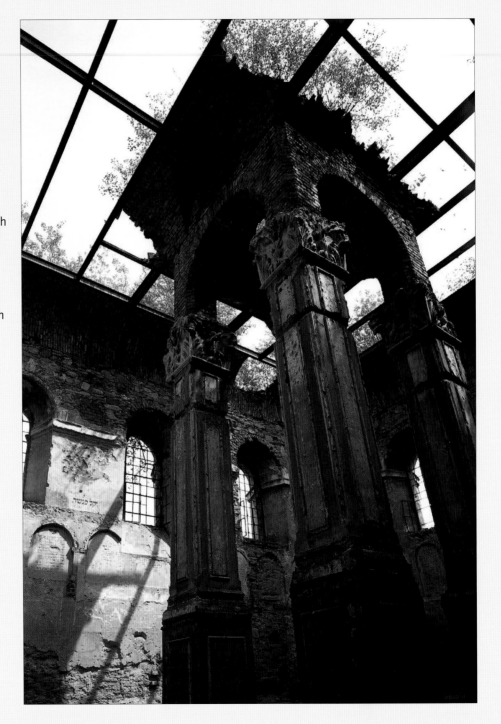

JEWISH LIFE IN RUINS

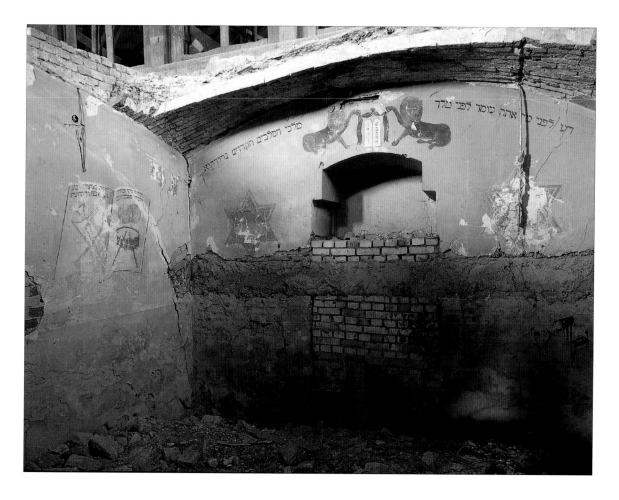

9 Derelict Jewish prayer-room, the worshippers long since gone

A prayer-room inside the ruined synagogue of Dąbrowa Tarnowska. The *aron hakodesh* (the holy ark where the Torah scrolls are kept) is now a gaping hole, partially bricked up. With evident antisemitic intent, someone has scratched the word 'Polska' (Poland) over one of the Stars of David. This little prayer-room was clearly once quite an elegant place of worship, with its wall paintings of the Ten Commandments and of the musical instruments used in the Temple in Jerusalem in ancient times. The Hebrew inscription is still intact: 'Know before whom you are standing — before the supreme king of kings, the Holy One, blessed be he.' But the space is a ruin; the worshippers who used to come here are long since gone.

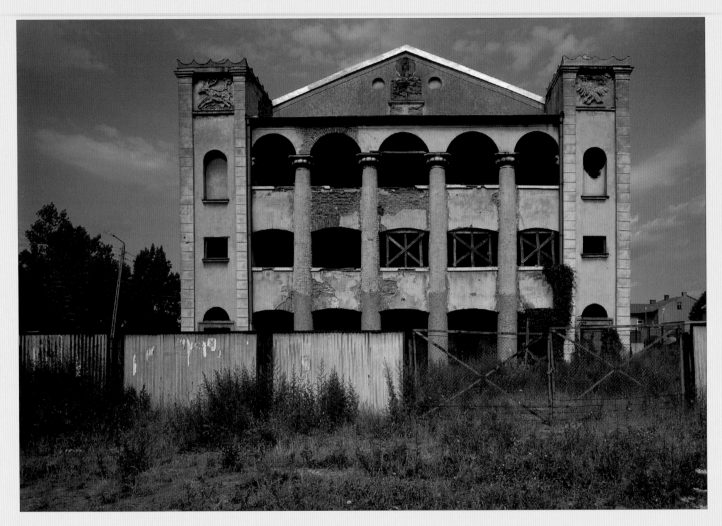

10 The stature and visibility of the Jews in Polish Galicia—all now in ruins

This magnificent, massive nineteenth-century structure, located on the main street of the small town of Dąbrowa Tarnowska and not more than a hundred yards from its main square, illustrates something of the stature, visibility, and proud identity of the Jews in Polish Galicia. That it is now in ruins is likewise a powerful public statement of the devastation inflicted on the Jews during the Holocaust. The carvings of the deer and eagle at the top of the building, symbolizing the devotion that Jews should have to their faith, have survived the ravages of time; the tablets of the Ten Commandments, in the centre of the gable, have not.

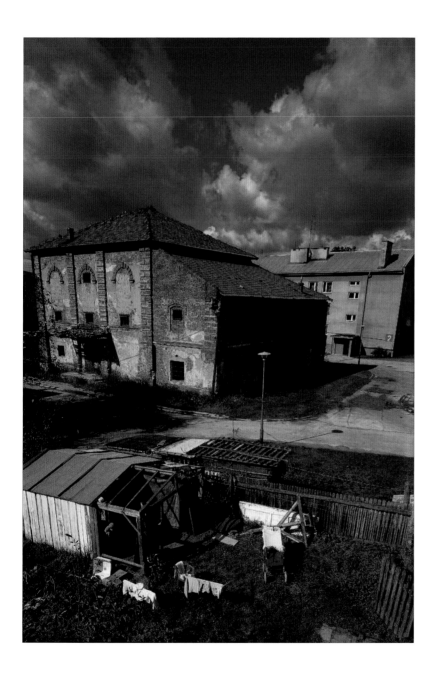

11 Bricked-up synagogue: the presence of a world that is no longer present

Ruins of the synagogue in Cieszanów. Now totally derelict, its windows largely bricked up, this late nineteenth-century building is situated one street away from the main square of this large village near the Ukrainian border. About nine hundred Jews — 40 per cent of the local population — lived here in 1921, largely in poverty because of the considerable damage inflicted on the region during the First World War: during the ten years between 1910 and 1921 the Jewish population had declined by 50 per cent. Today an atmosphere of ruin and desolation, bordering on squalor, surrounds this monument to the Jewish past here — the presence of a world that is no longer present.

12 An abandoned synagogue in central Kraków

Tucked away in a courtyard two hundred yards from the magnificent main square of Kraków is this former *beit midrash* (small private synagogue). It was established in 1913 by Mordechai Tigner, a wealthy furrier, for the benefit of Jews such as himself then living or working in the city centre. (Most of the Jews of Kraków lived in Kazimierz, a district about a mile away.) After the war the building was used for a while as a musical theatre, but now lies empty and deserted.

SEE NOTE ON P. 140

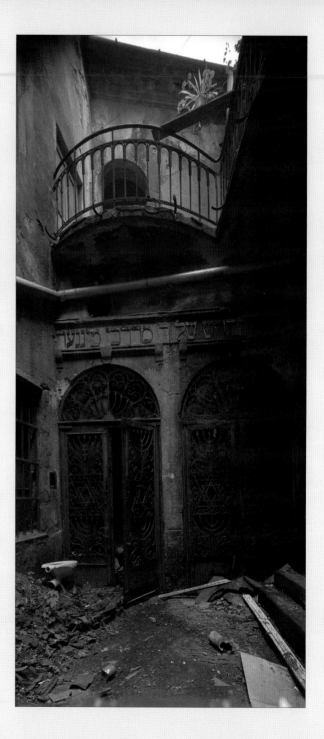

13 Not a *mezuzah*—just the trace of where a *mezuzah* once was

From its first mention in the Hebrew Bible, Jews have fulfilled the religious duty of fixing a small parchment scroll of biblical texts known as a *mezuzah* on the doorposts of their homes. The trace of where such a *mezuzah* once was can be clearly seen in this photo: the slanting incision into the upper right-hand side of the doorpost is a clear indication that this was once a Jewish house. Even today, sixty-five years after the end of the war, such *mezuzah* traces can still be seen at the entry to private homes in many towns in Galicia and occasionally even in small, remote villages. These traces disappear as doorframes are renovated, but where they can still be seen they provide a poignant, public statement about the disappearance of the Jews from their original homes. The nothingness of this gaping hole in the Polish architectural landscape is now literally a scar, physically marking their absence today.

SEE NOTE ON P. 140

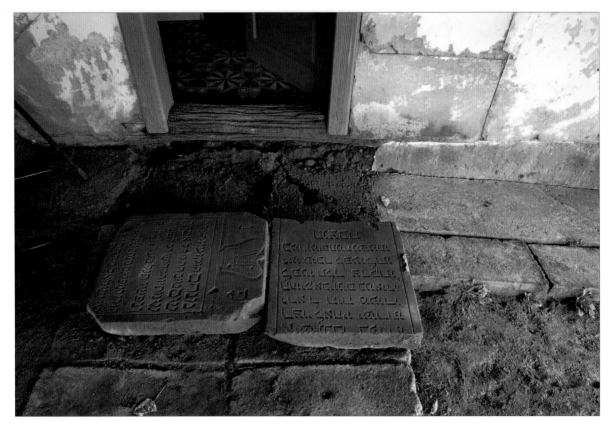

14 A Jewish tombstone used as paving material

On German orders, tombstones were commonly removed from Jewish cemeteries during the war for reuse as paving or building materials. The ransacking of Jewish cemeteries was often undertaken before the Jews were deported from their home towns, thereby adding to their grief at seeing the destruction of their world before their eyes. But local Poles would also help themselves to the stones, especially after the war, long after the Jews had been taken away.

Many years later the past yields up the dead. Here, in the remote village of Wielkie Oczy, a local farmer showed the photographer a tombstone his father-in-law had taken from the Jewish cemetery to use as paving in front of the entry to his house; he was uncomfortable about what had been done and wanted to return the stone to the cemetery. Turning over the slabs for the benefit of the photographer revealed a single tombstone carefully cut into two pieces, with a perfectly preserved Hebrew inscription—a funerary poem written in memory of a pious and well-respected man, Menahem Shimshon ben Aryeh Leib. But unfortunately the stone is incomplete and the date is missing. The damage to the historical record is permanent.

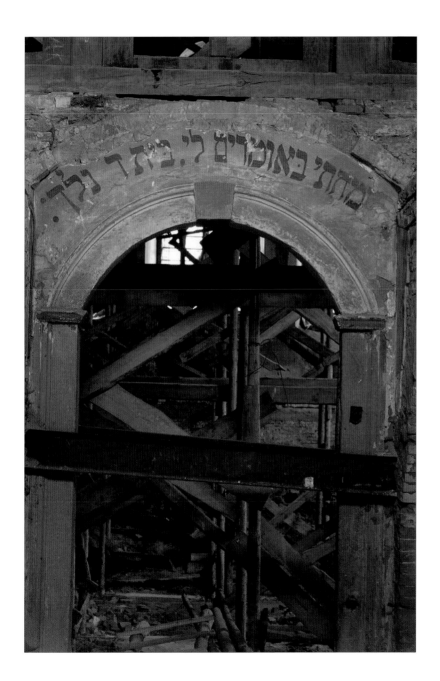

15 A faded synagogue inscription—a muffled voice from the past struggling to be heard

The inscription over the main entrance to the synagogue in Dąbrowa Tarnowska is a quotation from Psalm 122: 'I rejoiced when they said to me, "Let us go to the house of the Lord."' In Poland this verse was often placed over the entrance to a synagogue to encourage a sense of spiritual exultation. But the opportunity for such exultation is now gone: the building is surrounded by padlocked fences, discouraging all visitors from entering. In the context of the dilapidated interior beyond, buttressed with rough-and-ready scaffolding, the survival of this inscription is especially poignant.

SEE NOTE ON P. 140

16 A devastated Jewish cemetery

Poland as seen through Jewish eyes is largely a landscape of ruins, one vast graveyard. The totally devastated Jewish cemetery of Rzeszów — a very large burial-ground that once served an important community dating back to the sixteenth century — fits this image well. With one sole exception (a stone in memory of Dawid Weiser, who died in 1935), not a single upright tombstone has been left standing; only the severed stumps and foundations remain. Jewish life flourished in this city: at the beginning of the 1930s the community numbered eleven thousand, or 40 per cent of the local population; but its history came to an abrupt end in tragedy, catastrophe, and ruin.

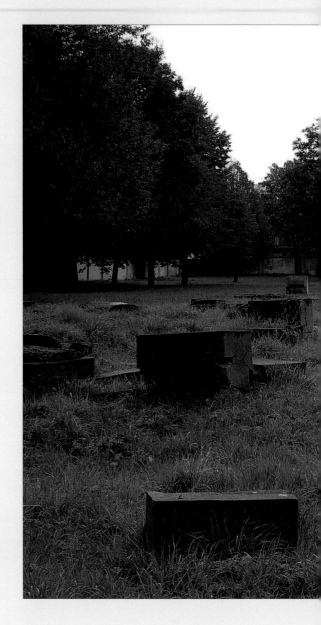

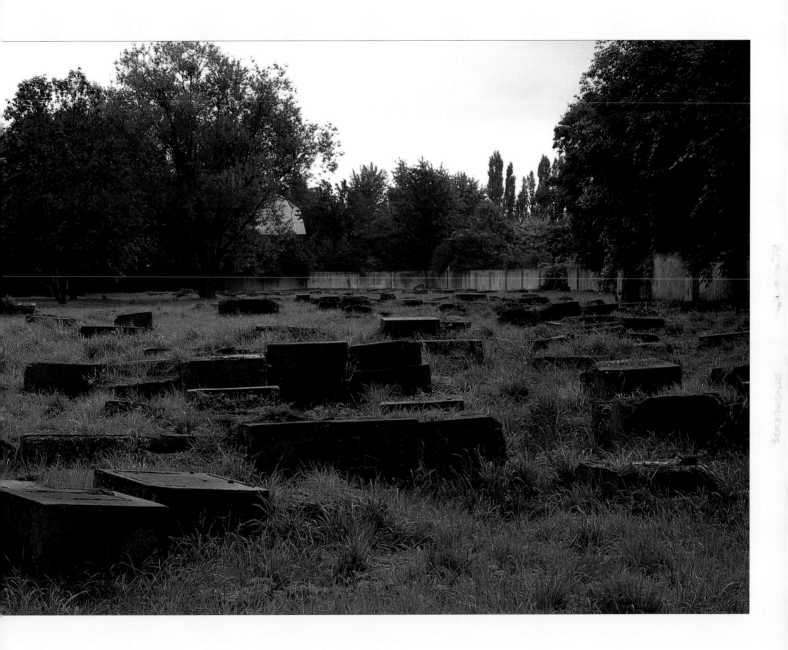

JEWISH LIFE IN RUINS

JEWISH LIFE IN RUINS

17 Traces of Jewish gravestones in the mountains

Part of the abandoned Jewish cemetery of Zakopane, at the foot of the Tatra mountains in southern Poland. From the middle of the nineteenth century the town was an important resort for tourism, sanatoriums, and winter sports. Jews were well represented among the visitors, and Zionist youth movements from all over Poland also held summer and winter camps there. The resident Jewish population was quite small, consisting of just a few hundred people in 1921. They finally established themselves as an independent community only in 1939, just months before the German invasion. Zakopane was captured on the first day of the war. In mid-1940 all the Jews were deported, and this fledgling community ceased to exist. But the ruins of its cemetery demonstrate that there once was a Jewish presence in this area, even if the memory of Jewish Zakopane has all but disappeared—the synagogue was destroyed, and the location of this cemetery is not even marked on local city maps.

SEE NOTE ON P. 140

2 Jewish Culture as It Once Was

This second section, focusing on Jewish culture as it once was, stands in powerful contrast to what we have seen in the first section. In the towns and villages of Polish Galicia today one also finds many traces — even quite vivid traces — of the strength and splendour of Jewish culture before its destruction during the Holocaust.

There are synagogues and Jewish cemeteries which escaped being substantially damaged by the Germans, or, if they were damaged, which have been meticulously restored. In other words, it is still possible to find in this region some remarkable buildings and monuments which, far from being desolate, abandoned, and in ruins, are on the contrary in good enough condition to offer some excellent insights into the Jewish world that existed in Galicia before the catastrophe.

Substantial, even monumental, synagogues — in village settings as well as in the major cities — are evidence that Jewish communities were strongly rooted in their Polish environment. The art and architecture of the Galician synagogue came to be strongly influenced by mystical ideas, which encouraged a richness of decorative features both inside and out. The synagogue art that flourished here is almost nowhere to be found in the United States, Israel, Britain, or the other countries where Jews of Polish origin now live, which is another reason why the surviving traces of the Jewish heritage still to be found in Poland are particularly precious.

No less important are the tombstones. Many have ornate lettering, pictorial carving, and a highly developed literary style, including the use of rhymes and acrostics. The tombstones still standing in Galicia are evidence of a rich culture and an elaborate civilization. Here one can find

The strength and splendour of pre-war Jewish culture can still be seen in many places today

the graves of great rabbis, outstanding talmudic scholars, mystics, painters, Zionist leaders, university professors, Jewish socialists and communists. The graves of a number of the founders of hasidism are to be found here today as well, alongside the simple memorials of poor village Jews. The tombstones reveal a whole society: scholars and artists, merchants and traders, as well as the ordinary people who formed the thick fabric of Jewish life in Poland over many centuries. The older tombstone inscriptions are in Hebrew, and only in Hebrew; but as Jewish society integrated more deeply into its local environment one begins to find inscriptions in German and then in Polish, evidence of a changing social history.

Jewish life in Galicia in fact changed very substantially during the nineteenth century. The first half of the century saw the dramatic rise of hasidism, which by mid-century came to dominate the Jewish religious life of the province. The second half of the century saw many other changes, including substantial growth in the size of the Jewish population, new political and constitutional arrangements which granted important freedoms for Jews, changes in the educational system, and economic hardship and the rise of modern forms of antisemitism (two factors which encouraged the mass Jewish migrations out of Galicia, especially to America). Together, these developments in the second half of the nineteenth century and the early twentieth century all contributed to a new diversification within the Jewish world, marked by the rise of a number of new movements: socialism, Zionism, and religious reform. Jews also began to attend university and to become oriented towards Polish culture. Traditional Orthodox Judaism was also changing—notably in the rise of new Orthodox political parties and a new school system for the education of girls. After the First World War Poland regained its independence, and the Jews of Galicia now had to adapt—albeit for a period of only twenty years—to quite new circumstances, down to the outbreak of the Second World War and the German invasion. The Jewish culture that existed in Poland on the eve of the Holocaust had thus become extremely diverse,

Polish Jewish society was evolving and modernizing itself before the war, and the evidence of that still survives

including a high proportion of Jews who were secularized, but in both religious and secular sectors it was a remarkably vigorous and creative society, supported by a wide range of newspapers, libraries, political and artistic activities, charitable organizations, and youth movements.

It is still just possible to find glimpses of all this in the surviving synagogues, inscriptions on tombstones, street names, and public Hebrew inscriptions. On the other hand, what is often conceptualized as the Jewish culture of pre-war Galicia, by visitors as well as by local Poles, are the classic forms of traditional Jewish life—principally its religious character. In the perspective of Orthodox Judaism, particularly that of hasidism, what characterized the traditional Jewish culture of Poland was its exceptional spirituality, as personified by its outstanding rabbis. Their sanctity was such that it is considered still to hover above the places where they lived, and likewise the places where they were buried. In particular, it is believed that by visiting their graves it is possible to reconnect with the spirituality that they embodied, and this is why their graves and mausoleums have been so carefully restored—for the benefit of the many thousands of religious Jews from all over the world who continue to come on pilgrimage.

If, by way of example, one had to choose just one personality from this rich religious history, a good candidate would surely be R. Moses Isserles, known as the Rema, the sixteenth-century rabbinical scholar after whom the Rema Synagogue in Kraków is named. The Rema's edited version of a codification of Jewish law was so well done that Orthodox Jews throughout the world still regard it as the decisive basis of the entire Jewish legal and cultural system. It is largely because of him that the city of Kraków became an exceptionally important centre of Jewish learning, attracting distinguished rabbinical scholars for many generations. The Rema's synagogue and gravesite have survived, and for very many they are the most important landmarks of the physical Jewish heritage of present-day Polish Galicia.

Jewish literacy, art, learning, leadership, and mystical and political thought: the traces of all this, and much more, are still to be seen in Polish Galicia today. By focusing only on ruins, as in Section 1, one misses an important part of the story. Yes, one may feel mournful at seeing the ruins of a civilization, but when one sees material evidence of its greatness, one may feel uplifted and a sense of respect for what it achieved. So Section 2 approaches the traces of the past from a quite different perspective.

Focusing on the traces of Jewish cultural achievements offers the opportunity to reconnect with a vigorous and vibrant civilization

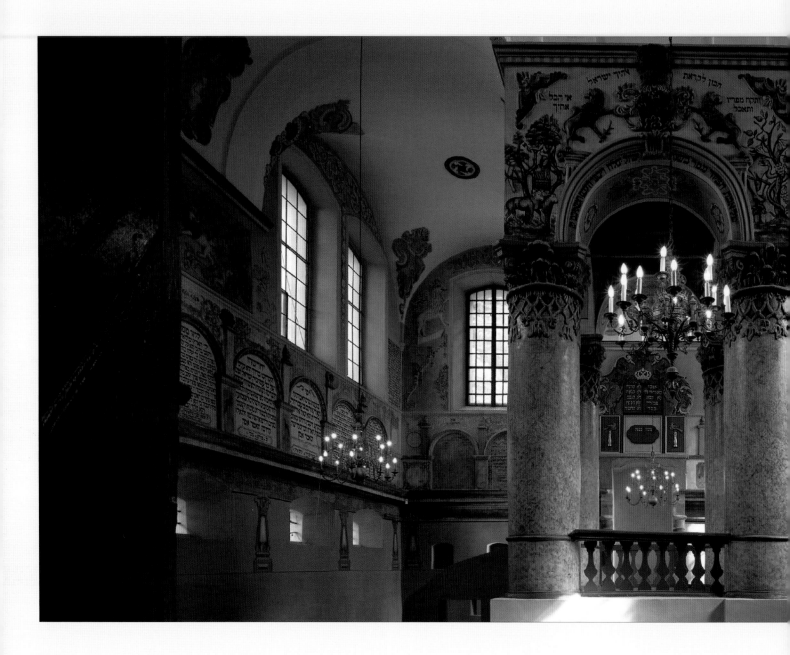

JEWISH CULTURE AS IT ONCE WAS

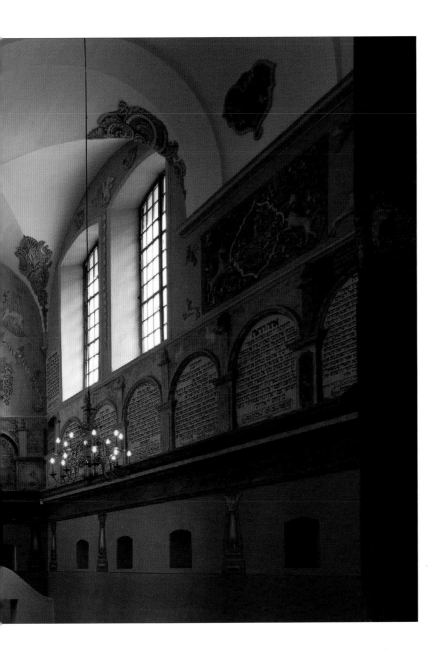

18 A beautifully decorated, meticulously restored eighteenth-century synagogue

Not all the Jewish cultural heritage in present-day Poland lies in ruins. Far from it: this astonishing eighteenth-century synagogue in the town of Łańcut gives a good idea of the dense ornamental style of the synagogue art, with its strong use of colour, that was typical throughout the region before the Holocaust. The ruined synagogue of Rymanów (see photos 7 and 8) would once have looked like this too. The Torah was read from the central *bimah*; its architectural dominance emphasizes the honour and elevated status accorded to the Torah. The *bimah* is profusely decorated with representations of biblical scenes, and all the way round the walls of the synagogue are arched niches filled with the texts of prayers, as well as paintings of animals, signs of the zodiac, and floral ornamentation.

SEE NOTE ON P. 141

19 'How awesome is this place. It is none other than the house of God, and this is the gate of heaven.'

The synagogue in Lesko, dating from the eighteenth century, is perhaps the most striking architectural example of its kind still surviving in Polish Galicia. The western facade still bears an intact piece of stonework representing the Ten Commandments. Underneath is a sentence in Hebrew from the book of Genesis quoting the patriarch Jacob: 'How awesome is this place. It is none other than the house of God, and this is the gate of heaven.' These are powerful sentiments to express publicly, on the front of a synagogue. Jacob is described in the Bible as dreaming of a ladder connecting heaven and earth. In the Jewish mystical tradition, the gate of heaven is the point through which divine blessings pass to earth, and a synagogue, as a 'house of God', is a storehouse for these blessings.

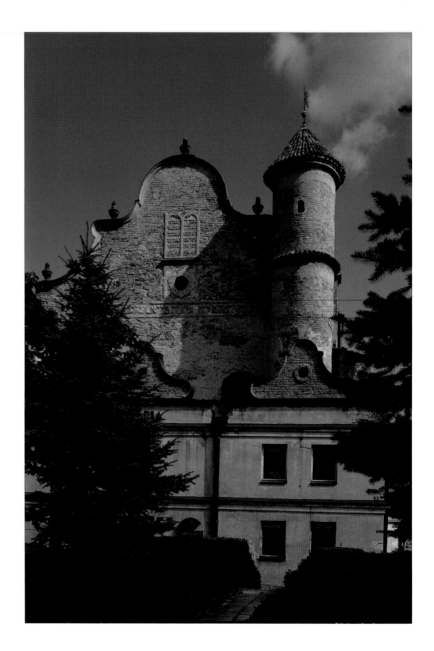

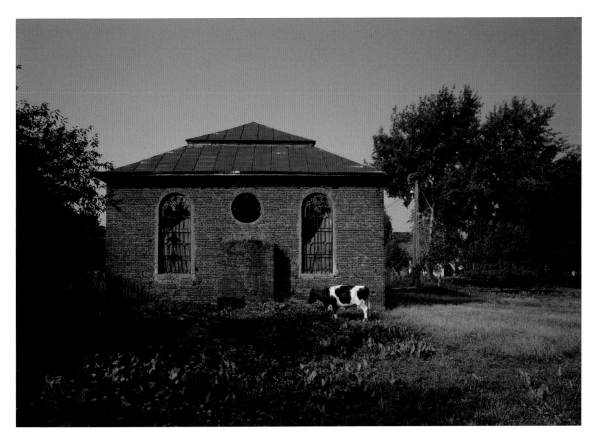

20 A simple village synagogue

This is a good example of a simple but well-built early twentieth-century synagogue still surviving in a small village, in this case the village of Medyka, near the Ukrainian border. No Jews live here any more, and the building is thus no longer in use as a synagogue; but it does give a fair impression of how even a very small rural shtetl community, which numbered just 132 people in 1921, was capable of putting up a synagogue of this kind.

Jewish life in Galicia was thus not confined to the large cities. On the contrary, in the nineteenth and early twentieth centuries there were Jewish communities in literally hundreds of small places; even quite small hamlets were often home to a few Jewish families. Small communities like that of Medyka might not have had their own cemetery but would often have had a rabbi, and by the 1930s also a full range of modern Jewish cultural activities, including local branches of Zionist organizations and their affiliated youth movements.

SEE NOTE ON P. 141

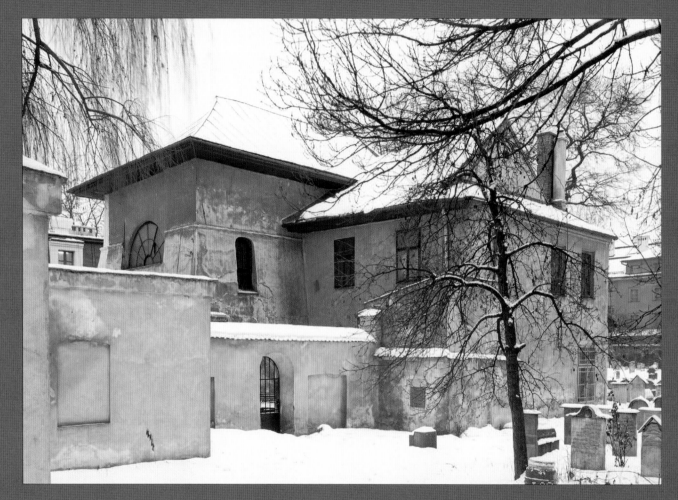

21 **A famous sixteenth-century synagogue, the oldest in Poland still in regular use**

The Rema Synagogue, Kazimierz (Kraków). Founded in 1553, this is the oldest surviving synagogue in Poland (and one of the oldest in Europe) still in regular use. It is named after R. Moses Isserles (known by the Hebrew acronym 'Rema' or, in the local Polish Jewish pronunciation, 'Remu'), who was the most outstanding rabbinical scholar of his time. His codification of the details of Jewish law are still considered the decisive definition of the entire corpus of Orthodox Jewish law and culture. It was largely because of him that Kraków became an exceptionally important centre of Jewish learning, and in the centuries after him there were a considerable number of distinguished rabbinical sages and scholars who came to live here. The Rema Synagogue is one of the very few synagogues anywhere which has a cemetery immediately alongside it.

SEE NOTE ON P. 142

22 **Grave of distinguished rabbinical scholar visited by pilgrims**

In the old cemetery next to the Rema Synagogue (see previous photo). There is a certain patina and aura of antique authenticity about this tombstone, with its long, monolingual Hebrew inscription, a small collection of pebbles on the top (a traditional Jewish custom symbolizing respect for the grave site), and candles and slips of paper with petitionary requests left at the foot of the stone (a custom practised by pilgrims to the graves of saintly rabbis). It marks the grave of the great seventeenth-century rabbi and talmudic scholar Joel Sirkes, commonly known by the name of his most important work, the *Bayit ḥadash* (often abbreviated to *Baḥ*). He was a scholar of independent judgement who made many controversial decisions; he remains well known, particularly because his textual emendations to the Talmud are reprinted to this day in the standard edition of the Talmud—the only Kraków rabbi to have achieved this distinction.

SEE NOTE ON P. 143

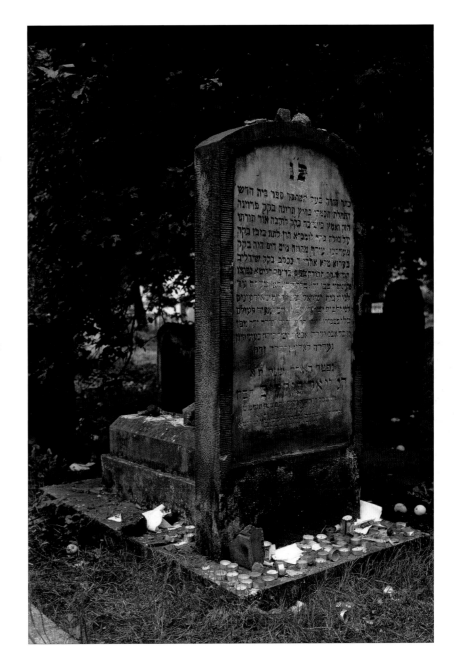

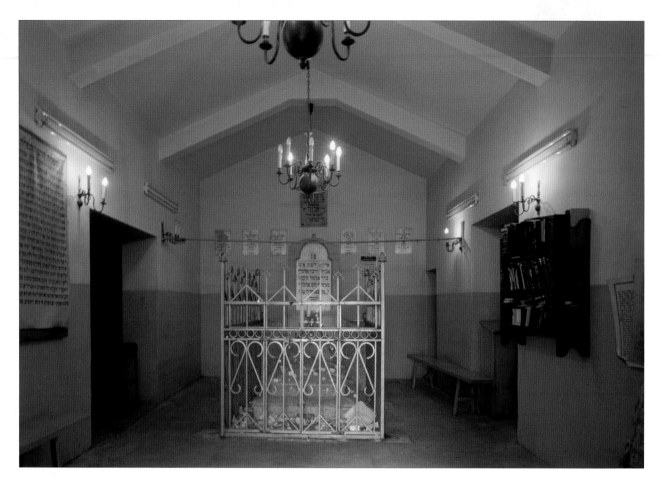

23 **Reconnecting with spirituality: the *ohel* (mausoleum) of the founder of hasidism in Galicia**

Few places in Polish Galicia can give as clear a sense today of pre-war Jewish religious life as this restored *ohel* of R. Elimelekh of Lizhensk (1717–87), the saintly figure who is widely acknowledged as the founder of hasidism in Galicia and commonly known by the title of his main published work, *No'am elimelekh*. By day and night throughout the year this mausoleum, in the Jewish cemetery of the town of Leżajsk, is thronged with Jewish pilgrims from many different countries, mostly but not exclusively hasidim and other strictly Orthodox Jews. Many thousands arrive here on the anniversary of the rabbi's death (21 Adar in the Jewish calendar), a time when according to the mystical tradition the soul of the deceased is especially accessible in the vicinity of the grave. For such Jews, Poland remains even today a country containing sites of exceptional spirituality, just because of the saintly personalities who once lived there and because of the opportunity to have the sense of reconnecting with that spirituality by visiting their graves. The prayers of the pilgrims may be for material things such as good health, prosperity, or a successful marriage, or simply for greater spirituality and closeness to God.

SEE NOTE ON P. 143

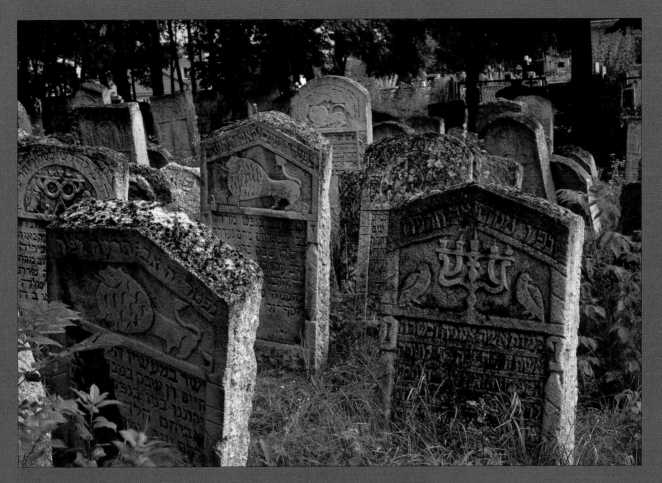

The astonishing art of the traditional Jewish tombstone of Galicia

Even if many Jewish cemeteries in Poland have been badly vandalized, if not completely destroyed, a few are in excellent condition. The Jewish art of the tombstone, as seen in the Jewish cemetery of the town of Lubaczów, is simply astonishing. Such art is no longer found in the Jewish world. In that sense these relics, in memory of perhaps quite ordinary people, form an important part of the Jewish cultural heritage. This group of elaborately carved tombstones, all from the early twentieth century, contains highly literary, poetic texts, in elegant Hebrew lettering, in praise of the moral virtues of the deceased, as well as images of animals, birds, flowers, fruit, ritual objects, objects from everyday life, and other motifs. The lion, evocative of strength of character and commitment to moral virtue, is commonly found, especially in its folk representation through the use of a human face. The candlestick represents female virtue because women traditionally light candles for sabbaths and festivals, and also symbolizes the tranquillity and spirituality she thereby brings to the home. The art of the Jewish tombstone, with its imaginative use of text and image to convey Jewish values, demonstrates the elaborate nature of the civilization.

SEE NOTE ON P. 144

25 Hilltop Jewish cemetery in Bobowa continues to attract hasidic pilgrims

The existence of Jewish cemeteries testifies that Jews once lived even in quite small villages and market towns. Often, the cemetery is all that is left in the landscape as a memory of the local Jewish past, and many of them are in quite reasonable condition — despite the absence of a local community to look after them.

In small communities the Jewish cemetery was usually a short distance (perhaps half a mile) from the village. Sometimes, though, they were further away, a function both of the availability of land and the status of the local Jewish community when the cemetery was established. This cemetery, perched high on the hill above the village of Bobowa, was doubtless extremely inconvenient for mourners and hard to reach in winter when the snow lay deep on the ground. But it is not as desolate as it might look: because the cemetery contains the *ohel* (mausoleum) of R. Shlomo Halberstam (d. 1905), founder of the hasidic community still known as 'Bobov' (the name of the village in Yiddish), it attracts many hasidic pilgrims. The hasidic dynasty he founded has spread around the world, and the major community in New York is still led by his descendants.

SEE NOTE ON P. 144

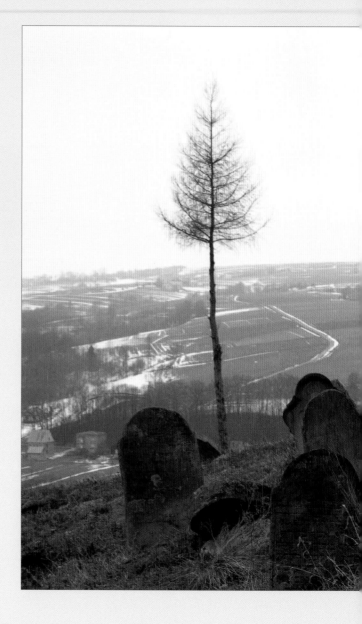

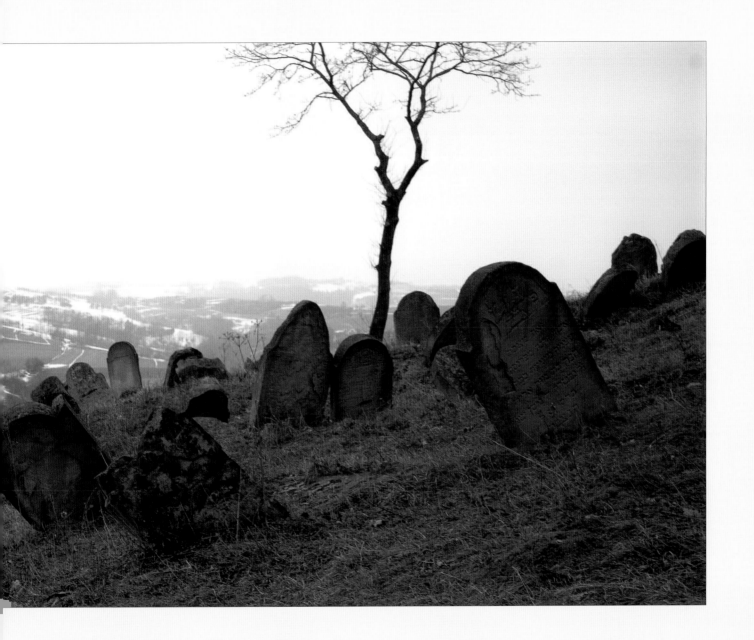

JEWISH CULTURE AS IT ONCE WAS

26 A traditional urban Jewish courtyard

A courtyard in the former Jewish quarter of Kazimierz (Kraków). Courtyards are a common feature of urban architecture in Poland, many with balustraded balconies giving access to the apartments on each floor. Apartment buildings of this sort created a great sense of shared community living, and they were certainly characteristic of Jewish neighbourhoods in many cities in Galicia. Jewish memoirs often refer, with some nostalgia, to social, romantic, and political activities that took place in these courtyard enclaves.

This particular courtyard is probably one of the most famous single images of an urban shtetl scene, perhaps because of its picturesque archway: drawings, paintings, and photographs of it have appeared many times in the last hundred years. The celebrated pre-war Jewish photographer Roman Vishniac published a photo of this place after his visit to Kraków in 1937, presumably because he felt it conveyed a strong sense of a setting typical of ordinary urban Polish Jewish life. But one other feature of this setting is important: the misty presence of the fifteenth-century church in the background (Bożego Ciała, or Corpus Christi). Kazimierz was far from being exclusively Jewish.

SEE NOTE ON P. 145

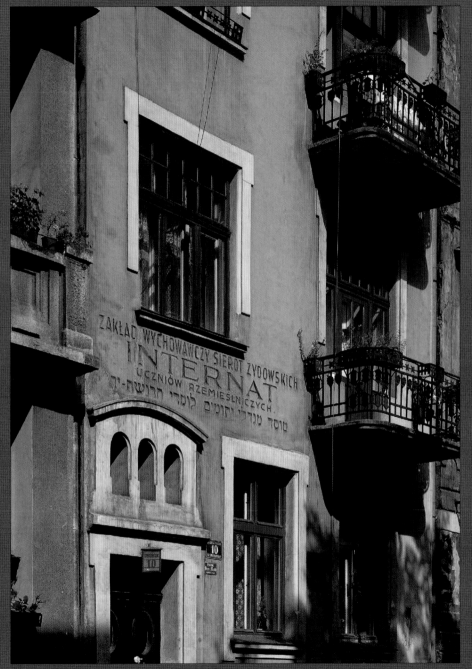

27 Hebrew inscription on former trade school for Jewish orphans

Pre-war photographs show that Hebrew and Yiddish signage was regularly found on Jewish commercial enterprises and secular Jewish institutions. However, such signs were all banned by German decree as early as December 1939, which is one reason why so few have survived. This inscription, which has somehow survived in a quiet Kraków side street some distance from the main Jewish district of Kazimierz, marks the building as an *internat* (boarding facility) of a trade school for Jewish orphans. The sponsoring organization, Beit Megadlei Yetomim, was founded in 1847 to provide orphans with shelter, clothing, food, and a practical education. It was one of many Jewish philanthropic institutions that functioned in pre-war Kraków; others provided dowries for poor brides, took care of the sick, assisted in burying the dead, and so forth. There was also a Jewish hospital.

SEE NOTE ON P. 146

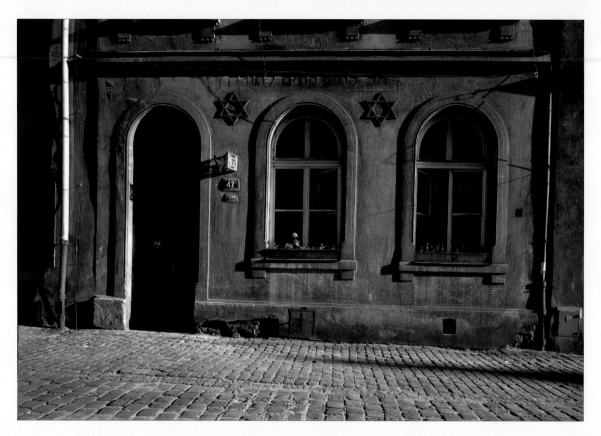

28 Hebrew inscription on former place of Jewish prayer and study

The Hebrew inscription *ḥ"k kove'a itim latorah*, meaning 'the religious association which fixes times for sacred study', shows that there was once a *beit midrash* in this building. Traditional Judaism is not content with a casual interest in religious study but calls for time to be specifically set aside on a regular basis for this purpose.

Only a small handful of Hebrew inscriptions are still to be seen in the streets of Galicia; chancing upon them offers not only a reminder of the former presence of Jews here but also a glimpse into their world and its values. In that sense, this inscription, in Kazimierz (Kraków), is an important Jewish cultural treasure. According to old Cracovians, the *beit midrash* here was open for prayer and study twenty-four hours a day. Traditional religious Jewish life in Poland centred more on such places than on the formal, purpose-built synagogues; there are thought to have been as many as eighty in Kraków alone before the war. This is one of the very few whose former identity as a centre of Jewish study and prayer is still publicly visible.

SEE NOTE ON P. 146

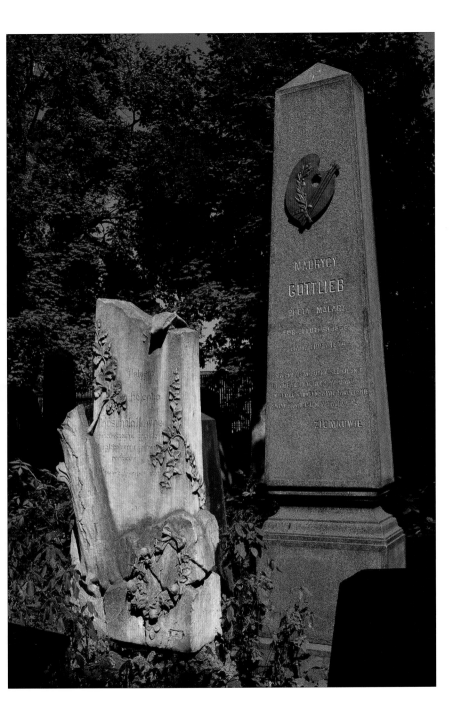

29 Restored tombstone of important nineteenth-century Jewish painter

The Jewish cemetery in Miodowa Street, established in 1800 and still often known as the 'new' cemetery, offers a panorama of the social history of the Jews of Kraków in the generations before the Holocaust. This includes clear signs of the cultural assimilation that took place during the nineteenth and twentieth centuries. While most tombstone inscriptions remain traditional and are only in Hebrew, some have epitaphs in German (the language of culture for much of the 150 years when Galicia was part of the Austrian and later the Austro-Hungarian empire), and, from the late nineteenth century onwards, there are also epitaphs in Polish. After 1918, when Poland regained its independence, German epitaphs become much more infrequent, as Polish was now the language of the state and commonly used among Jews; by the 1930s many epitaphs are entirely or almost entirely in Polish, with very little Hebrew at all. Both the use of languages other than Hebrew and the inscriptions themselves show how diversified Jewish society had become, including a new class of intelligentsia (doctors, pharmacists, journalists, politicians, artists, lawyers, etc.), all university-educated; by the late 1890s as many as 20 per cent of the students at the Jagiellonian University in Kraków were Jewish.

This is the restored tombstone of Maurycy Gottlieb, a painter who died in 1879 at the tragically young age of 23 after a very short but prolific and distinguished career. Some of his works are considered masterpieces, including his well-known painting *Jews Praying in the Synagogue on the Day of Atonement* of 1878.

SEE NOTE ON P. 147

30 Restored interior of the Tempel (Progressive) Synagogue, Kraków

Fully restored to its pre-war splendour and still in occasional use, this synagogue, founded in the 1860s, originally served the city's Progressive Jewish community. Consisting largely of intellectuals, university professors, doctors, lawyers, and other professionals, as well as wealthy individuals with assimilationist leanings, the fledgling community was from the start fiercely opposed by the Orthodox rabbis of the city, who regarded it as heretical and a threat to the unity of the Jewish people. But the Progressive outlook slowly became more widespread, and the Tempel Synagogue attracted graduates from the new, modern Jewish schools that were established during the course of the nineteenth century. It became an important institution for those Jews who believed that Jews should become better integrated into the wider society: even the sermons for which its rabbis were famous were not given in Yiddish (the traditional everyday language of the Jews) but rather in German, and, from the late nineteenth century, in Polish. However, even before the First World War many Progressive Jews, disturbed by local outbreaks of antisemitism, slowly turned to an interest in Zionism instead. The Tempel's distinguished pre-war preacher, Rabbi Ozjasz Thon, was both a member of the Polish parliament (Sejm) and the unquestioned leader of the Zionist movement in Kraków.

SEE NOTE ON P. 148

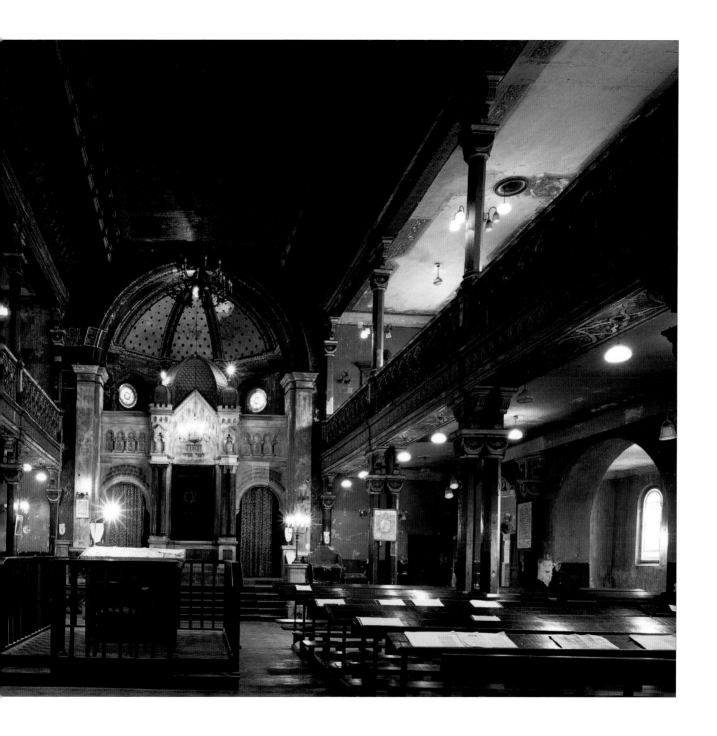

The hunting down and murder of the Jews took place absolutely everywhere: no village was too remote, no Jewish community too small, to be immune from the destruction

The Holocaust: Sites of Massacre and Destruction

The focus now shifts to what happened in Polish Galicia during the Holocaust. The hunting down and murder of the Jews took place absolutely everywhere: no village was too remote, no Jewish community too small, to be immune from the destruction. Chris Schwarz's photographs, taken at little-known locations as well as the infamous death camps, are powerful and unconventional images. The pictures included here were selected with the intention of helping readers understand more about what happened and where it happened.

The photographs from Auschwitz are testimony to the huge force, scale, and mechanics of the systematic mass murder that took place there. The ruins of the gas chambers give a powerful sense of the horrifying historical realities and the appalling fate of the terrified victims. Gazing at the winter scene of bleak wooden barracks stretching in deep snow to a distant horizon, one cannot avoid trying to imagine what it was like for those who were there then, imprisoned as slave labourers behind the barbed wire.

We need these photographs so as to be able to remind ourselves that the destruction was brought about in real places, places that can still be visited today. They shock us into asking how it could have happened at all. But what has been left behind today are just silent fragments. The entry gate, the barbed wire, the watchtowers, the surviving barracks, and all the other physical installations at the site are certainly important because they help us connect with the place and ask the questions; but they tell us very little about the world that Auschwitz destroyed or about the nothingness that it created, let alone the agony of the victims. Too much happened in Auschwitz, to each

individual person who suffered and died there, for the relics to provide even a remotely adequate record. And physically the place has changed: where there was mud, there is now neatly cut grass. Today's realities are all that we have; but in looking at the photographs of the sites as they are now, we need to remember that to read a landscape such as this requires special effort.

This becomes very clear from a consideration of the case of Bełżec, the death camp in south-east Poland to which some 450,000 Jews were deported and then gassed immediately on arrival. Bełżec is the cemetery of the Jews of Galicia: countless Jewish communities throughout Galicia met their end in this place. But there is nothing original left to see in Bełżec, at least above ground: the entire camp, complete with its mass graves, was demolished by the Germans after it had served its evil purpose. What remained behind was precisely a nothingness—and it is this which we are left with to meditate on, in contemplating the incomprehensibility of the mass murders and the mental gap that separates us today from the world of the death camps.

Too much happened in the Holocaust even for Auschwitz and Bełżec, taken together, to represent it adequately. The targeted mass murder of Jews also took place in countless atrocities at countless locations throughout the territory of Galicia, in or near the villages, cities, or towns where the Jews actually lived. This is why Jews often think of Poland as one vast Jewish graveyard. The massacres took place in open countryside, in city centres, in cemeteries, in forests, on hilltops, beside rivers—and photographs of a small sample of such locations have therefore been included here. Some of these places seem serene and charming, even quite beautiful, as if they could not possibly have provided the setting for the horror of mass murder and mass graves. But one of the aims of this section is to give a glimpse of the full range of such sites—including the relatively well-preserved concentration camp at Auschwitz, which today is a fully functioning museum; the nothingness of Bełżec, although today a

The destruction was brought about in real places that can still be visited today, engendering a sense of mourning and reminding us of the appalling suffering and the vast loss of life

31 Mass grave in a forest for eight hundred Jewish children

The Holocaust was unprecedented, and it came like a thunderbolt. The thriving Jewish life that existed before the war was savagely crushed and systematically destroyed.

 It was as if the clock suddenly stopped.

This forest, near the village of Zbylitowska Góra a few miles outside the city of Tarnów, was the site of a massacre. About seven thousand Jews were brought here by the Germans in June 1942, mainly the very old and the very young, and shot to death. Among them were eight hundred children from the Jewish orphanage in Tarnów, whose mass grave this is. The mass murder of children is the defining mark of a genocide.

SEE NOTE ON P. 148

32 Grave marking the mass murder of the entire Jewish community of one village

On 10 August 1942 the three hundred Jews of the village of Rzepiennik Strzyżewski, about twenty-five miles south of Tarnów, were taken by the Germans to a nearby forest and shot. This operation brought an entire Jewish community to an end in a single day. Their mass grave has become their monument. It bears the simple inscription '364' in memory of the 364 men, women, and children who were murdered there. Among them were a few dozen Jews who had previously been deported to the village from smaller places nearby.

SEE NOTE ON P. 149

33 Grave marking the mass murder of Jews in the open countryside

Mass murder of the Jews also took place in the open countryside, as evidenced by this small stone monument near the village of Pruchnik, in memory of sixty-seven local Jews who were shot here. No precise date is given, but it happened very probably in the summer of 1942, which was a time when the Germans were systematically destroying Jewish life in the smaller towns and villages of Polish Galicia. Countless atrocities took place in many locations during those fateful months.

In mid-March 1942 some 75 or 80 per cent of all victims of the Holocaust were still alive, while 20 or 25 per cent had perished. A mere eleven months later, in mid-February 1943, the percentages were exactly the reverse. At the core of the Holocaust was a short, intense wave of mass murder—principally in Poland in 1942.

SEE NOTE ON P. 149

34 An original piece of the wall built by the Germans to create the ghetto in Kraków

The Jews of Kraków were forced out of their homes by the Germans, separated from their normal surroundings, and condemned to imprisonment behind walls specially built to confine them within a small area of the city in the district of Podgórze. There they stayed, in exceptionally cramped and unhygienic conditions—until the moment came when with savagery and violence they were taken away to their deaths. This is one of the last remaining fragments in Poland of a ghetto wall; for many, the arched tops of the wall resemble Jewish tombstones.

SEE NOTE ON P. 150

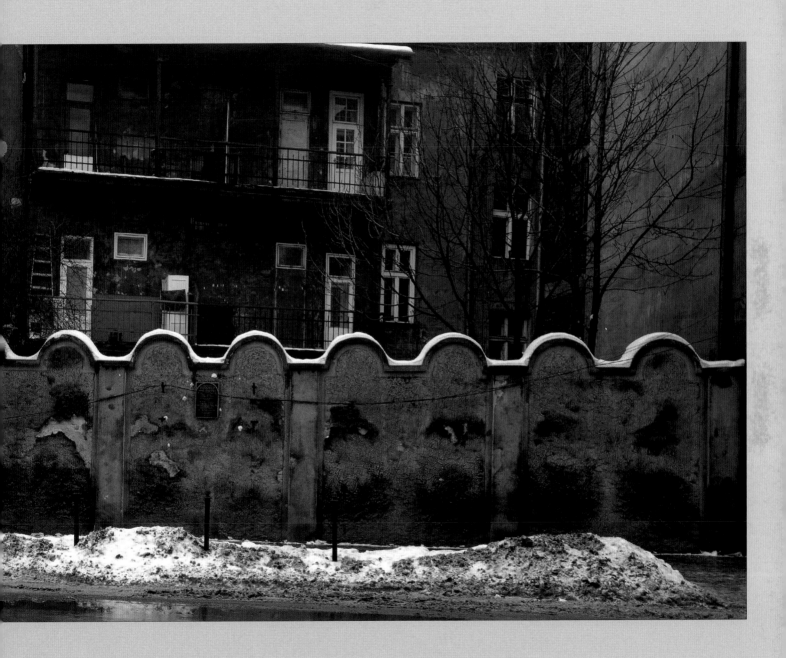

W NOCY Z 24 NA 25 XII 1942 R
GRUPA ŻOŁNIERZY GWARDII LUDOWEJ
I ŻYDOWSKIEJ ORGANIZACJI BOJOWEJ
DOKONAŁA AKCJI NA MIESZCZĄCY SIE TU
NIEMIECKI LOKAL „CYGANERIA"
ZADAJĄC OKUPANTOWI POWAŻNE STRATY

TABLICE TĘ
KU CHWALE BOHATERSKICH ŻOŁNIERZY
WMUROWANO W 10 ROCZNICĘ
POWSTANIA PPR

35 A plaque commemorating Jewish armed resistance against the Germans

The extreme terror, horror, and physical brutality experienced by Jews while they were imprisoned in the ghettos limited their will to resist and the opportunities to do so. There was nevertheless a small Jewish fighting organization in Kraków that undertook sabotage and assassination operations. This plaque records an attack on a café popular with the SS in the centre of the city, well outside the ghetto walls. It took place on Christmas Eve 1942: seven German officers were killed.

SEE NOTE ON P. 150

36 The River San: a hazardous escape route to survival in the USSR

View of the River San, near the small town of Lesko. The river formed part of the border between German-occupied Poland and Soviet-occupied Poland between 1939 and 1941. Prior to the German attack on the Soviet Union in June 1941 the hills in the rear of the photo were therefore in Soviet territory and offered freedom from Nazism. Although it was extremely hazardous and many were killed, tens of thousands of Jews from southern Poland managed to get out of German-occupied Poland by escaping across this river, and a substantial number of them thereby survived the Holocaust.

SEE NOTE ON P. 151

37 Bełżec: the principal graveyard of the Jews of Galicia

Even on a bright summer's day there is a strong sense of gloom and foreboding that pervades this otherwise innocent-looking field. It is the site of the death camp at Bełżec, where about 450,000 Jews were murdered by gas in 1942; there were fewer than ten survivors. Because hardly anyone came out alive to tell the story, and because the evidence of the crimes committed here was deliberately covered up by the Germans so that no trace could be seen, Bełżec is still, even today, a place which is little known. Many people today do not even recognize the name. But this is the principal graveyard of the Jews of Galicia. It is the place where a large part of every important Jewish community in Galicia came to a final end.

SEE NOTE ON P. 151

38 Entrance to the main Auschwitz camp

Prisoners arriving at Auschwitz were greeted with the following words by its commander: 'You have not come to a sanatorium here but to a German concentration camp. The entrance is through the main gate with the inscription *Arbeit Macht Frei* ['work makes you free']. There is only one exit: through the chimney of the crematorium. If there's anybody who doesn't like that, he can walk into the [electrified] wire [fence of the camp] right away. If there are any Jews in the transport, they have no right to live longer than two weeks, priests for one month, and the rest for three months.'

SEE NOTE ON P. 152

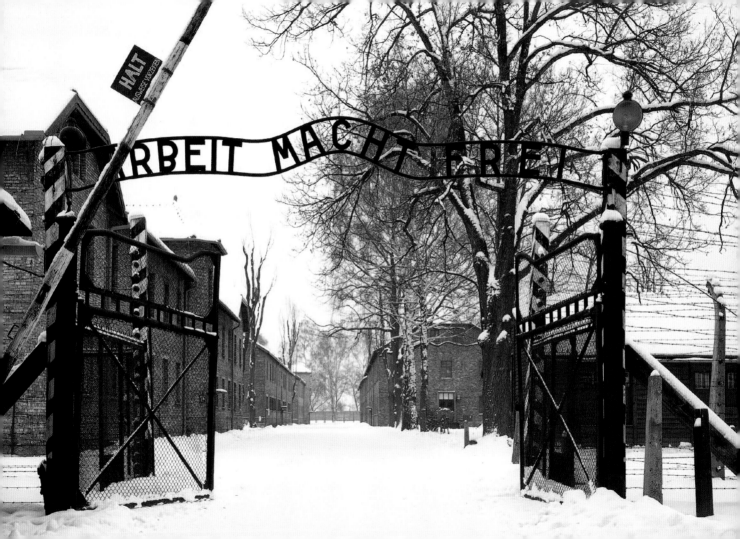

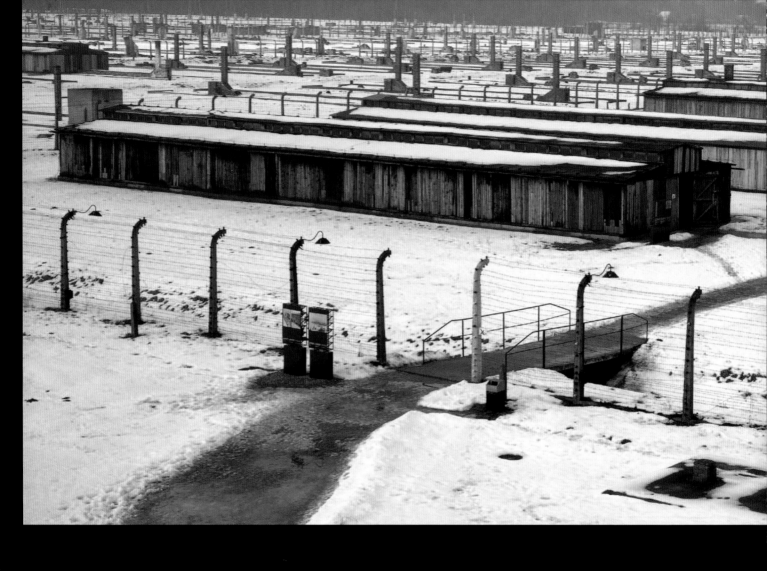

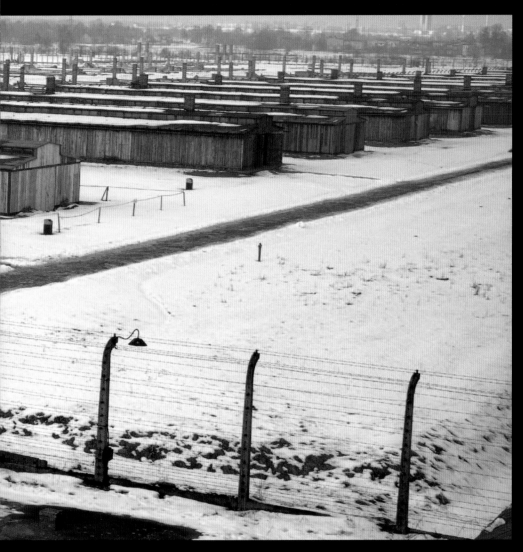

39 Auschwitz-Birkenau: the vast expanse of the labour camp

Part of the labour camp at Auschwitz-Birkenau as seen from the main watchtower. Prisoners who were set to work as slave labourers in this camp suffered and died in the most appalling conditions—overwork, starvation, sadistic beatings and other punishments, exhaustion after prolonged roll-calls in all weathers, torture, shocking sanitary conditions, being used for so-called medical experiments, or arbitrary execution. Those too weak or sick to work were picked out by the SS and sent to their death in the gas chambers. The sheer size of the place, the unimaginably vast number of victims, the depths of the depravity of the perpetrators—these things, and more, are what has made Auschwitz synonymous with the evil of the Holocaust.

SEE NOTE ON P. 153

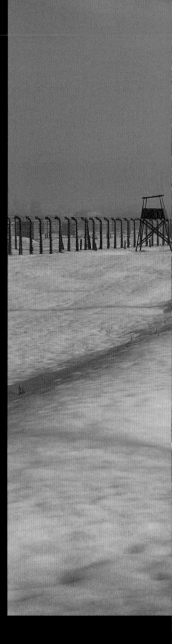

40 Auschwitz-Birkenau: the end of the railway line

The railway siding inside Auschwitz-Birkenau is a place that witnessed
particular anguish. Jews were deported to Auschwitz not as individuals but
usually with their whole families, and they arrived there by train often after a
long and arduous journey, with little food and inadequate sanitary facilities.
Here they were unloaded, to be immediately divided: the men were separated
from the women and children, and then those to be sent to the labour camp
(usually a small number) were divided off from those deemed incapable of work
(the great majority, including all the old people and young children) and so sent
straight to the gas chambers. Here, then, the lives of families were ripped apart.
This was commonly the place where those who survived last saw their loved
ones, in heartbreaking scenes of farewell—or, as often happened, without
any awareness that they would never see each other again.

SEE NOTE ON P. 154

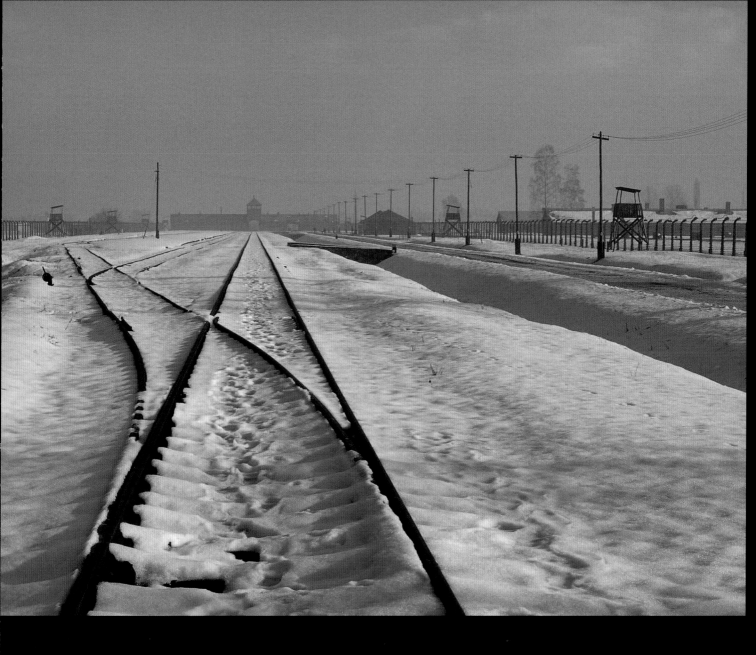

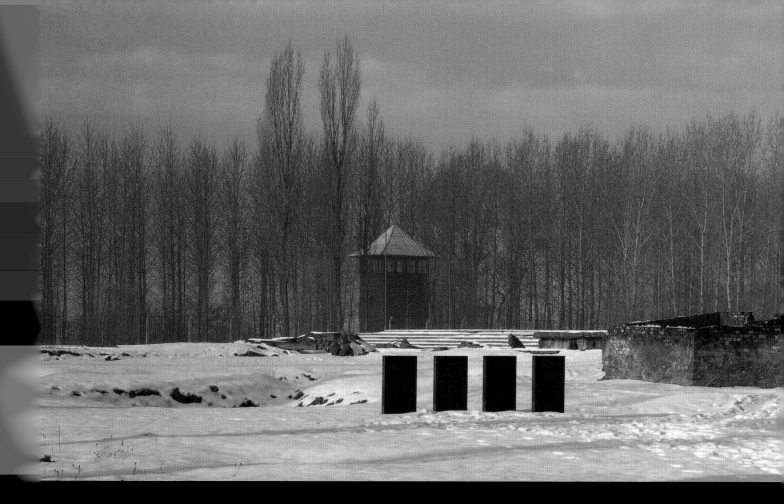

41 Auschwitz-Birkenau: at the ruins of one of the gas chambers and crematoria

As the crematoria devoured their murdered victims, their chimneys constantly belched forth flames and smoke. Can it be that the sun shone and was not ashamed?

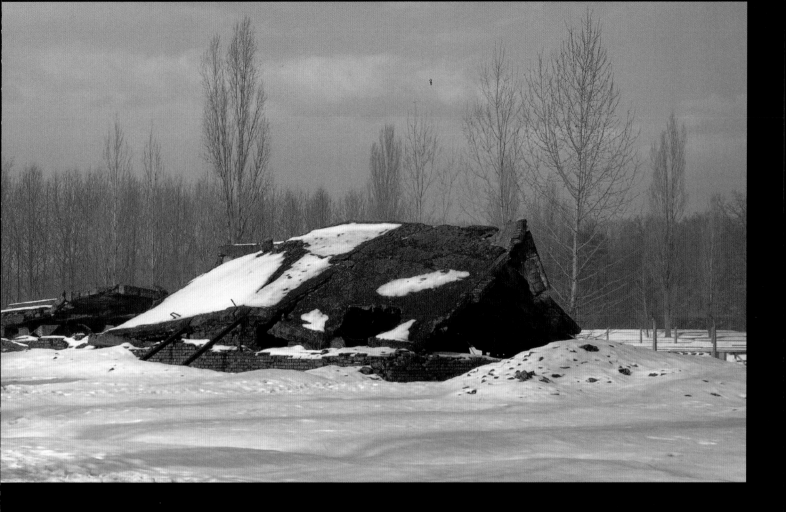

'Never shall I forget that smoke. Never shall I forget the little faces of the children, whose bodies I saw turned into wreaths of smoke beneath a silent blue sky' (Elie Wiesel, *Night*)

SEE NOTE ON P. 154

42 **Interior of a gas chamber in the main Auschwitz camp**

'"Mummy, when they kill us, will it hurt?"

"No, my dearest, it will not hurt. It will only take a minute."

It took only a minute—but it is enough to keep us awake till the end of time'

(Rafael Scharf, *Poland, What Have I To Do With Thee* . . .)

SEE NOTE ON P. 155

4 How the Past is Being Remembered

The purpose of the last two sections of this book is to present some of the ways in which the massive destruction wrought during the Holocaust — which brought nearly all Jewish life in Poland to an end, and certainly changed it beyond all recognition — has been commemorated locally. How is that past being remembered?

The process of memorialization has been protracted, and is still ongoing. In some places it started immediately after the war, but it was hampered by widespread trauma not only among the surviving Jews but also among the local Polish population (which had itself suffered devastating losses in the war), a lack of even the most minimal resources, and also the imposition of a communist regime. All this made the effort to cope with memories of what had happened during the Holocaust itself extremely difficult. In addition, there was the problem of what to do with the material traces of the Jewish past: in city after city, village after village, local people found themselves having to deal with the synagogues, cemeteries, and personal property that the Jews had left behind. Much of what is left is in ruins, as we have seen in Section 1, but some is in relatively good condition, as described in Section 2. The focus of this section is not so much on the buildings and artefacts themselves but rather on the *desire to remember* and how it expresses itself; in contrast, the next section focuses on some of the people who are *doing the remembering* — that is, making the concerted effort to revive and restore the memory of Jewish civilization in post-war Galicia.

There are many monuments commemorating the local events of the Holocaust. The work of the museum at Auschwitz, established two years after the end of the war, is the prime example of how the Holocaust is

memorialized *in situ*. But Holocaust commemoration has also taken place in many other locations. Monuments were erected immediately after the war by survivors who either knew or found out what had happened in their home town and who set about putting up appropriate memorials at the places where the atrocities had happened. There are monuments erected more recently by survivors now living abroad or their descendants, whether by individuals remembering family members or organizations remembering whole communities. There are Holocaust monuments erected by the local municipal authorities as well as by individual Catholic Poles, including tombstones of Poles that indicate that they rescued Jews during the war. Through the photographs of this range of monuments and the different styles of commemorative inscriptions we can see the wide variety of ways and contexts in which the memory of the Holocaust is kept alive in Poland today.

As for the surviving Jewish heritage, a colossal amount has been irretrievably lost—not only during the war itself but even since the end of the war—and there is evidence everywhere of organic decay and cultural abandonment. On the other hand, there is also evidence of cultural continuity and of the attempt to deal constructively with the ruins and relics. For example, in one city centre the ruins of a fine synagogue have been carefully preserved inside a small park, and concerts of Jewish music are performed there in tribute to the Jewish past. Three places of worship and a small number of cemeteries are still in use in Polish Galicia, the latter sometimes also being used by survivors to put up a commemorative inscription or a new tombstone in order to preserve the memory of family members who died in the Holocaust and have no known grave. The photographs here display some of the results of the regeneration and restoration undertaken to conserve the traces, recapture the past that was lost, and pay respect to it. Synagogues are being restored, a few for Jewish worship though mainly to house museums and libraries. Abandoned cemeteries are being reconsecrated, often at the initiative of foreign Jews, and their walls and gates reconstructed; they are being cleaned, also by

There is a wide variety of ways and contexts in which local memory is being kept alive, concerning both the pre-war Jewish past and the events of the Holocaust

Polish youth groups nostalgic for the multicultural past of their country; and mausoleums are being constructed to protect the tombs of distinguished rabbis that continue to serve as sites of pilgrimage. Museums are displaying whatever they have of Jewish interest; schools mount art exhibitions on Jewish themes, and plaques are being installed outside the former homes of famous Jews. The filming of *Schindler's List* on location in Kraków in the 1990s stimulated the recovery of hitherto unrecognized Jewish and Holocaust memory sites in the Polish landscape. All this work of reconstruction is slow, difficult, and not without controversy. Many of those who devote themselves to it feel that they are reconnecting with a vital part of their Polish or Jewish past, or perhaps even that they are contributing to a process of healing and reconciliation as a way of coping with the universal moral lessons of the great catastrophe. Others, seeing that the reconstruction has facilitated the substantial growth of Jewish heritage tourism complete with Jewish-style cafés and restaurants, attribute less public-spirited motives to the private and public entrepreneurs behind these efforts.

Memory is not something that can be taken for granted; it needs to be assembled, transmitted, and fed into the educational system. There is indeed a wide variety of memory-making processes that have developed since the war, though they are still 'under construction', random, and uncoordinated, and how they all coexist in reality raises a number of problems. Sometimes it seems that the past is simply being forgotten, such as when an abandoned synagogue has been turned into a bakery or cinema, without any commemorative plaque attached to the building. Local residents may still know what the building once was, but is that enough? The Auschwitz museum certainly makes a substantial effort to educate its vast numbers of visitors about the history of the place, but does it do enough to acknowledge the site as a cemetery? There is no clear model here, nor is it easy to suggest just what should be done globally with the vast amount of debris that was left behind after the genocide. What is to be done, for example, with all the smashed

tombstones? The section begins with a photograph of one creative solution from Kraków (but found also in a number of other places in Galicia), which was to build a lamentation wall that literally pieces together these fragments, so that the fragments themselves seem to lament the shattered world they now represent. Such projects may be understood in more than one sense: a Holocaust memorial garden made up of the last surviving tombstones of the local Jewish cemetery may serve both to commemorate the Holocaust and also as a tribute to the pre-war Jewish past of the place.

On the other hand, signs of antisemitic feeling are also present and complicate the picture. Moreover, the legacy of Polish national suffering during the war still casts a shadow over the Polish recognition of the Jewish catastrophe—an erasure of memory that was accentuated during the communist regime before its downfall in 1989, as the surviving monuments from that period clearly indicate; nor have Jews collectively accepted a memory of shared tragedy. There is still no coherent, inclusive narrative that would link the three parts of the story—the long history of the Jews in Poland, the Holocaust, and Polish suffering during the German occupation. Different parts of the story are to be seen in different places, and much of the history is still contested and remembered differently. What are the implications—for Poles, for Jews, and for European society as a whole—of what it is that is remembered about a great culture destroyed in the Holocaust? Most towns and villages still have no monument to their deported Jews. Too much has been forgotten, or at least gone unrecorded; there is much memory work still to be done.

Much memory work remains to be done; too much has been forgotten, or at least gone unrecorded

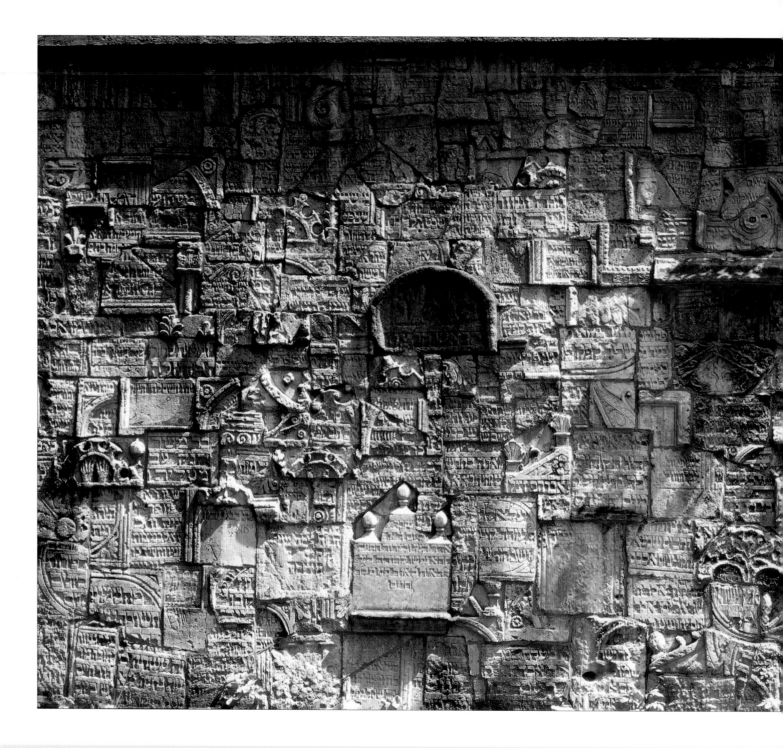

HOW THE PAST IS BEING REMEMBERED

43 Image of a shattered world: a memorial made of fragments of smashed Jewish tombstones

After Poland was finally liberated from German tyranny in 1945, those few Jews who had managed to survive the Holocaust slowly began to piece their world back together and to memorialize their dead. It was an impossible task. Their communities had been completely devastated; all they were left with were shattered fragments of a shattered world.

These fragments of smashed tombstones, put together into a memorial wall—a modern-day wall of lamentation—line the historic sixteenth-century cemetery adjacent to the Rema Synagogue in Kraków. It represents the utterly ruptured history of this great Jewish community. But in paying tribute to the past in this robust and aesthetically imaginative use of the relics, perhaps the wall also demonstrates the survivors' powerful need to find the energy to deal with the challenges of the broken world in which they now found themselves.

SEE NOTE ON P. 155

44 A single tombstone records the fate of an entire Jewish family

After the end of the war the survivors came to the ghastly awareness that not only had their entire families perished during the Holocaust but also that their loved ones had no known grave. In the attempt to come to terms with their terrible loss, some therefore returned to the cemetery where their last known ancestor or other relative had been buried before the war and erected at their grave a new tombstone to commemorate the family members who had been murdered. This tombstone in the Miodowa Street cemetery in Kraków records the fate of the family of Zechariah Basak, who died in 1928. Of his descendants, Leibish Basak died in Auschwitz in 1944, and his wife Esther in the labour camp of Skarżysko-Kamienna in 1944; thirteen of their children and grandchildren—their names and the dates and places of death are given—died in the death camps and slave-labour camps of Auschwitz, Ravensbrück, Ebensee, Güsen, Stutthof, and Bełżec.

SEE NOTE ON P. 156

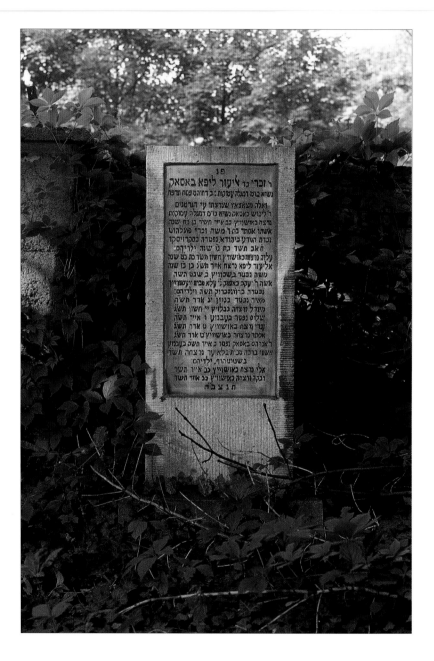

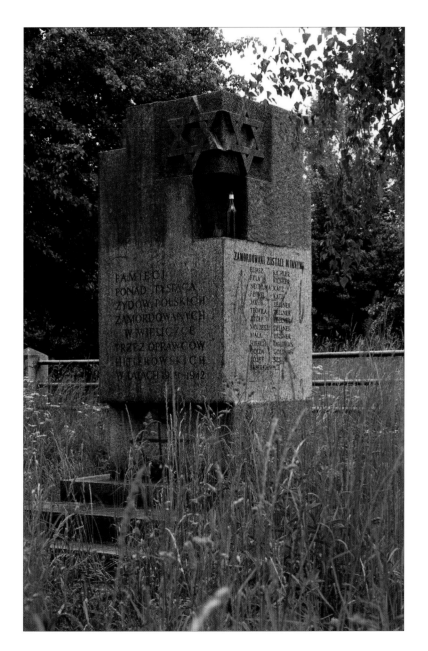

45 A Holocaust monument in a Jewish cemetery

Substantial Holocaust monuments, like this one in the town of Wieliczka, are to be found in many Jewish cemeteries across Polish Galicia. They are often quite different from each other in their architectural style and tone of inscription. This one simply states in Polish, 'In memory of more than one thousand Polish Jews murdered in Wieliczka by the Hitlerite butchers in the years 1939–1942'. More commonly, inscriptions are in two languages: Polish and either Hebrew or Yiddish. Sometimes the language is more enraged. The monument in Biecz refers in the Hebrew version to how 'the inhabitants were murdered in a total destruction by Nazi murderers who did not spare their lives'. Some inscriptions are just in Hebrew. But in all these cases a Holocaust monument in a Jewish cemetery represents private Jewish mourning; public Holocaust monuments in city centres are still very rare in southern Poland.

SEE NOTE ON P. 156

46 Carefully preserved fragment of a seventeenth-century synagogue

As we saw in Section 1, there are still synagogues in Polish Galicia that are standing in ruins and totally abandoned. This is a ruined synagogue, but it is not abandoned. It is the last surviving fragment of the magnificent Old Synagogue in Tarnów, built in the seventeenth century but burnt down by the Germans in November 1939. This fragment—the central *bimah*, from where the Torah was read to the congregation—has been carefully preserved, even as a ruin. Since 1987 it has been surrounded by protective bollards and ornamental chains, and shielded from the weather by a specially constructed wooden roof. Nothing remains of the rest of the building; the site it occupied is today a small park in the very heart of the city. Nor is there any Jewish community left in the city. Past greatness, present desolation: the contrast is powerful. This act of preservation reminds people of what was destroyed and allows them to imagine the site thronged with worshippers, with sounds of prayer and singing filling the air. The worshippers have gone, but the sounds still echo: concerts of Jewish music are regularly performed here as a way of honouring and preserving the memory of the past.

SEE NOTE ON P. 157

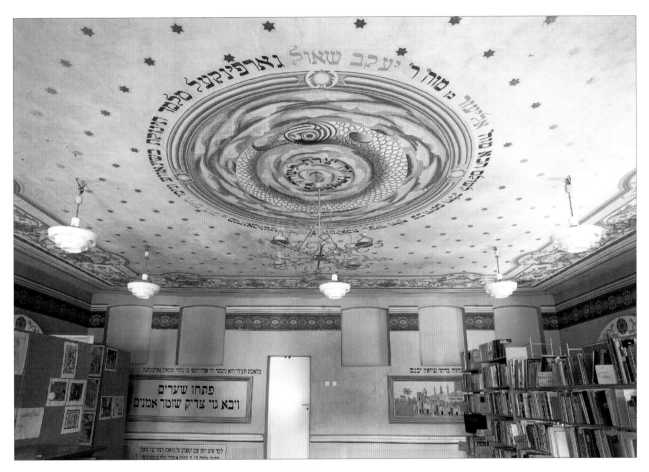

47 Reuse of former village synagogue as the local public library

There was no town or village in Poland, however remote, where the Germans did not systematically round up the local Jews and murder them. The destruction of the Jewish cultural heritage, however, was less systematic. While synagogues were commonly destroyed, some were requisitioned for use as warehouses or as stables, and in that way the buildings often survived. In consequence the remaining Jewish architectural and artistic heritage in Poland is today dotted around the country unevenly and unpredictably, often in quite out-of-the-way places. This building, once the synagogue of the small village of Niebylec, is now the local public library. Notwithstanding the curious cohabitation of former sanctity, spirituality, and worship with popular literature, schoolbooks, and reference books, the striking decoration of this village synagogue has been carefully preserved.

SEE NOTE ON P. 157

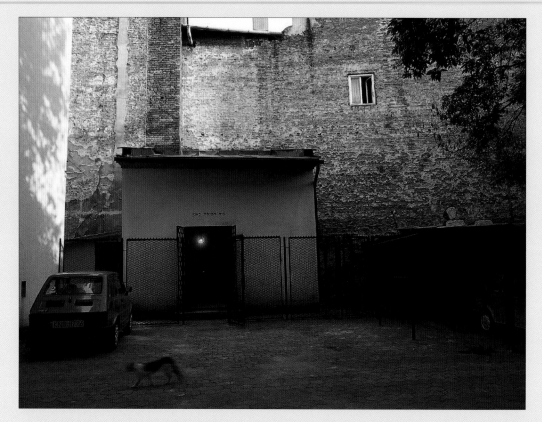

48 Pathos of the remnant: the last functioning synagogue of the city of Nowy Sącz

49 The splendid former main synagogue of Nowy Sącz, now an art gallery

In the aftermath of the Holocaust, the Jewish architectural heritage in Polish Galicia sometimes stands in stark contrast to what remains of Jewish life. The contrast between these two photos is heart-wrenching. On the right is the splendid city synagogue of Nowy Sącz; today it is an art gallery called 'The Former Synagogue Gallery'. The photo above shows a tiny functioning prayer-house, the only place left in this city where Jewish prayer services are held; the sign in Hebrew over the door declares that it is 'the synagogue of Nowy Sącz'. Each of these two buildings has its own story, but seeing them together one can immediately sense the colossal tragedy of the Holocaust at the local level, and the pathos of what remains.

SEE NOTE ON P. 158

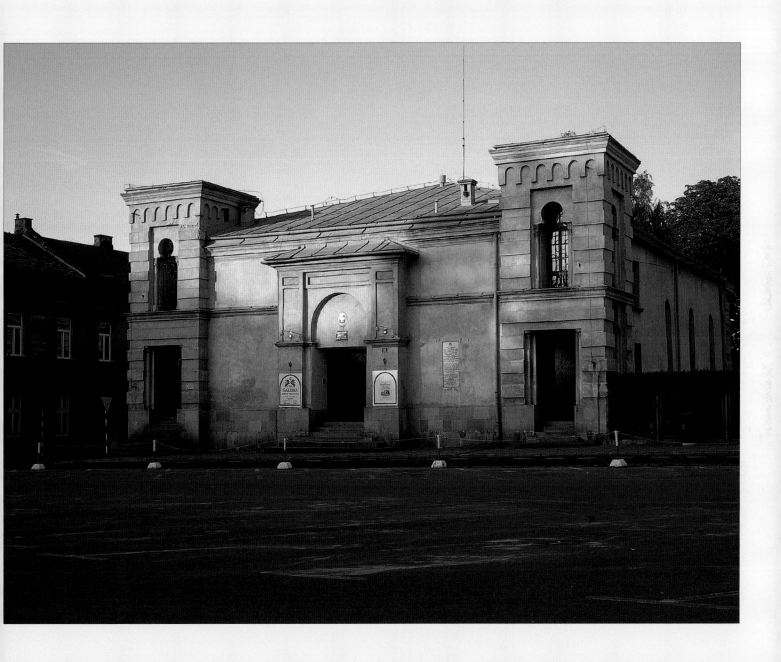

50 Restored fifteenth-century synagogue, now a Jewish museum

The efforts that have been made to preserve the Jewish heritage in Polish Galicia can be best seen in the Old Synagogue in Kraków. The building was largely in ruins at the end of the war, but in the 1950s it was fully restored and then turned into a Jewish museum as a branch of the Historical Museum of the City of Kraków—an appropriate acknowledgement of Jewish history as an element of local history more generally. The setting for this museum could hardly have been more appropriate: the Old Synagogue is the oldest surviving synagogue building in Poland. It was first constructed in the fifteenth century, although much of its present form dates from the latter part of the sixteenth century. The museum has substantial holdings of Jewish textiles, Jewish ritual objects, paintings and lithographs on Jewish themes, Hebrew books, and Torah scrolls; in addition to its permanent displays of these in showcases, there are also frequent temporary exhibitions on many different aspects of Jewish history and culture.

SEE NOTE ON P. 158

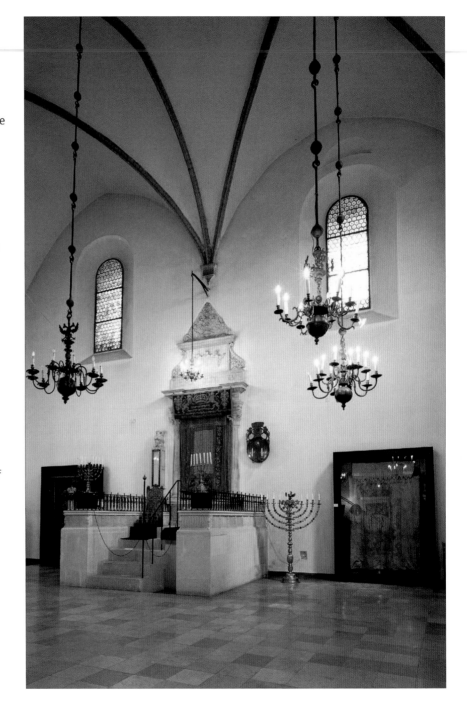

Display of prayer-shawls in a showcase commemorating the Holocaust

This is a simple museum display of *taleisim*, prayer-shawls worn daily by Jewish men at morning prayers. They are large *taleisim*, worn by central and east European Jews, and one of them has an ornamental silver collar, typical of the hasidic tradition. But this display is in no ordinary museum—it is in the museum at Auschwitz.

These *taleisim* on display in Auschwitz make a powerful statement: amongst those who were murdered were many religious Jews. When leaving their homes they would have done all they could to make sure they brought their *taleisim* with them, for use at morning prayer. Now the last traces of their religion are simply left hanging in a showcase as museum artefacts, silent witnesses to the prayers of those who were murdered.

SEE NOTE ON P. 159

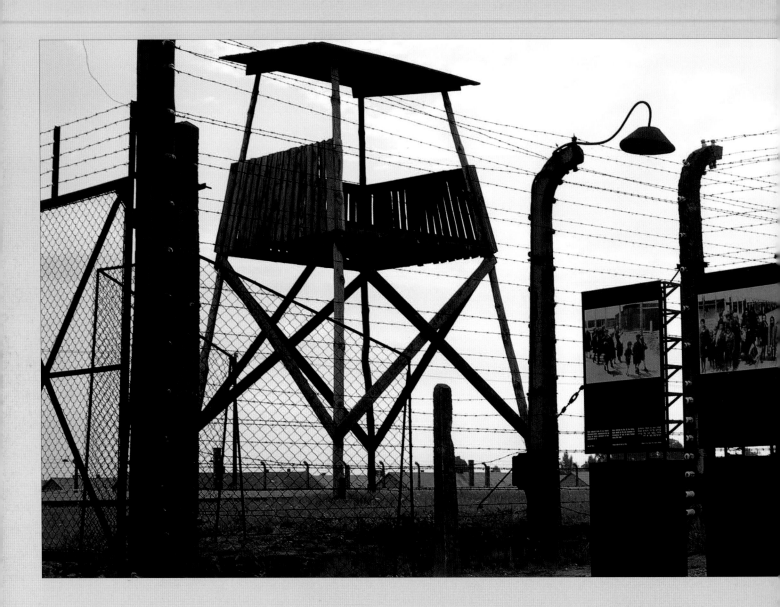

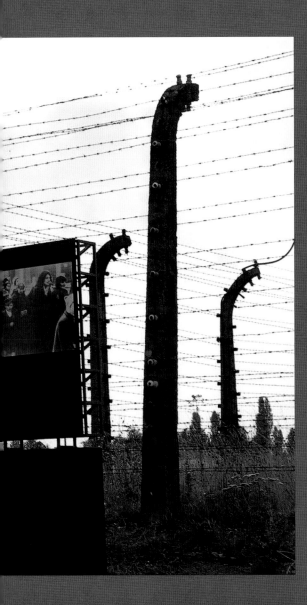

Preserving the memory of what happened at Auschwitz

The site of Auschwitz-Birkenau has for the last sixty years been preserved as a vast open-air museum, which together with the main camp of Auschwitz today receives more than a million visitors a year. The remains of the structures at Birkenau could have been left quietly to sink into the ground, but the museum decided to conserve as much as possible as testimony to what happened there. The wooden watchtowers and elevated sentry-posts have been subject to careful conservation, the barbed wire (highly susceptible to rusting) has been renewed, and photographs taken by the SS of Jews arriving in the camp have been mounted on weatherproof display stands so as to give visitors a sense of what the place looked like when the camp was in operation. There are many problems, especially when conservation begins to encroach on the authenticity of the site and its relics; but preserving the memory of what happened at Auschwitz is a fundamental duty for our generation and the generations to come.

SEE NOTE ON P. 160

A focus of Jewish commemoration at Auschwitz

There is no official Jewish monument as such at Auschwitz. Many Jews would probably say that there is no need for such a monument—the whole of Auschwitz is itself a monument to the Holocaust. However, there is one former barrack at the Auschwitz main camp, Block 27, which has a historical exhibition on two floors devoted to 'Jewish martyrdom' (as it is called), and it is this building, in addition to the ruins of the gas chambers in Auschwitz-Birkenau, that Jewish visitors often treat as the focus of their visit—for speeches, prayers, and quiet meditation. Additional weight to the importance to Jews of Block 27 was provided by the erection in 1998 of a memorial stone immediately outside it, to commemorate the official visit to Auschwitz of the president of Israel. For many Israelis and diaspora Jews, emotionally numbed by the visit to Auschwitz, the sight of an Israeli marker stone, with its brief, apt inscription, undoubtedly provides some measure of comfort.

SEE NOTE ON P. 161

54 Entry to the new monument at Bełżec

The site of the death camp at Bełżec, which for decades had
fallen into complete neglect, overgrown and forgotten, with
not a single original structure left behind, finally came to be
marked in 2004 with a memorial which is perhaps one of the
most emotionally powerful Holocaust monuments ever built.
The photograph shows the monumental wall at the entry to
this new memorial. It is an extensive site, completely covered
with large, irregular-shaped boulders marking the mass graves
where the victims lie buried; quite intentionally, they appear
as a scar on the landscape. A single narrow pathway cuts
through this landscape, deeper and deeper into the hillside;
the visitor walking along it gets the feeling of being more and
more closed in. The pathway follows the route taken by the
victims as they were herded from undressing rooms to the gas
chamber. At the end of the pathway is a towering granite wall
with the same inscription from Job as at the entry. All around
the site, framing the perimeter of the camp, is a walkway
along which have been placed the names of every town, city,
and village from which Jews were deported to Bełżec.
There is also a historical museum immediately adjacent.

SEE NOTE ON P. 162

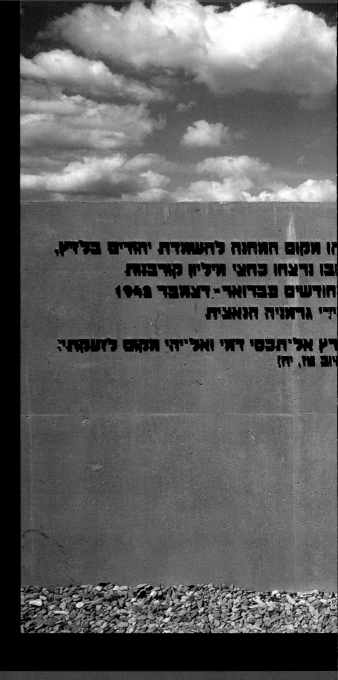

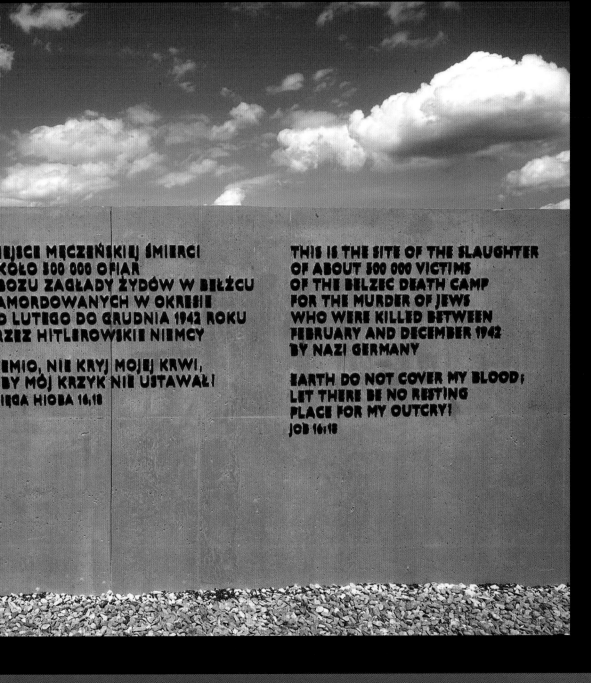

MIEJSCE MĘCZEŃSKIEJ ŚMIERCI
KOŁO 500 000 OFIAR
OBOZU ZAGŁADY ŻYDÓW W BEŁŻCU
AMORDOWANYCH W OKRESIE
O LUTEGO DO GRUDNIA 1942 ROKU
RZEZ HITLEROWSKIE NIEMCY

EMIO, NIE KRYJ MOJEJ KRWI,
BY MÓJ KRZYK NIE USTAWAŁ!
IĘGA HIOBA 16:18

THIS IS THE SITE OF THE SLAUGHTER
OF ABOUT 500 000 VICTIMS
OF THE BELZEC DEATH CAMP
FOR THE MURDER OF JEWS
WHO WERE KILLED BETWEEN
FEBRUARY AND DECEMBER 1942
BY NAZI GERMANY

EARTH DO NOT COVER MY BLOOD;
LET THERE BE NO RESTING
PLACE FOR MY OUTCRY!
JOB 16:18

55 Restoration work at Jewish cemeteries

There have been numerous private Jewish initiatives to restore Jewish cemeteries in the small market towns and villages throughout Polish Galicia, in co-operation with the local Polish authorities and sometimes also with local Polish volunteers interested in preserving the memory of the Jews. Broken tombstones have been repaired, the mausoleum shrines of revered hasidic rabbis have been rebuilt, tombstones taken away by the Germans during the war or by Poles after the war have been returned, the overgrown vegetation has been cut back, and fine new fences have been constructed around the perimeters. One of the first of these initiatives, which began in earnest in the late 1980s and early 1990s, was the American Society for the Preservation of Jewish Cemeteries and Historic Objects in Poland. It has been active in a number of towns, including the work seen here in Dynów. There have been many other such projects, and work continues. There is much to be done.

SEE NOTE ON P. 162

שרה שנירר ע"ה
נפטרה כ"ו אדר תרצ"ה

THIS BUILDING, BUILT AND DEDICATED IN 1927, WAS THE
HOME OF THE BETH JACOB TEACHERS SEMINARY FOUNDED IN
1917 BY SARAH SCHENIRER. IT WAS HERE THAT DAUGHTERS OF
ISRAEL, FROM MANY CORNERS OF CENTRAL AND EASTERN
EUROPE, CAME TO STUDY TORAH
A SPARK KINDLED IN KRAKOW GREW TO A FLAME THAT
RADIATED THROUGHOUT POLAND AND ACROSS THE OCEANS. THIS
LIGHT OF TORAH CONTINUES TO ILLUMINATE THE HEARTS AND
MINDS OF JEWISH GIRLS THROUGHOUT THE WORLD.

W. BUDYNKU TYM MIEŚCIŁA SIĘ ŻEŃSKA SZKOŁA BET JAKOW,
ZAŁOŻONA PRZEZ SARĘ SCHENIRER W ROKU 1917. BUDYNEK
WYBUDOWANY W 1927 ROKU BYŁ MIEJSCEM DLA DZIEWCZĄT
ŻYDOWSKICH, KTÓRE PRZYJEŻDŻAŁY Z RÓŻNYCH STRON
ŚWIATA, ABY STUDIOWAĆ TORĘ.

REDEDICATED BY THE SARAH SCHENIRER COMMEMORATIVE COMMITTEE
AGUDAH WOMEN OF AMERICA
MAY 2001

UL. STANISŁAWA
10
DZ. ŚRÓDMIEŚCIE

56 Street plaque in tribute to Sarah Schnierer, founder of schools for Jewish girls

Restoring the public memory and visibility of Jewish life in the Polish urban landscape is another project which has taken root in recent years. Several substantial plaques have been erected in Kraków, by private Jewish subscription, at the former home or workplace of important Jewish personalities. This plaque commemorates Sarah Schnierer, a remarkable woman who had the vision and the energy to establish the first seminary for Jewish girls. This was in 1917, a time when in the Orthodox Jewish world religious schooling existed only for boys. It was a revolutionary step, and one that has decisively affected Orthodox Jewish life ever since. The plaque was erected in 2001 by American women graduates of the Beth Jacob (or Beis Ya'akov) school system that developed on the basis of the Kraków model founded by Sarah Schnierer, and has since spread throughout the Jewish world. Fixed to the wall of the five-storey seminary building that was opened at 10 Stanisława Street in 1927, it says: 'A spark kindled in Kraków grew to a flame that radiated throughout Poland and across the oceans. This light of Torah continues to illuminate the hearts and minds of Jewish girls throughout the world.'

SEE NOTE ON P. 163

57 Two monuments — two narratives of the Second World War

Jews and Poles have been encouraged to remember the catastrophes of the Second World War quite differently. The atrocities that were perpetrated against each population under German occupation have tended to belong to separate spheres of consciousness that hardly intersect with each other. Neither side has been particularly interested to learn about the other or to develop a concern with shared memory. Things have begun to change in recent years, but Jews still often see the Holocaust in Poland as having been perpetrated with antisemitic Polish connivance or at least tacit support. This is something vehemently denied by Poles, who for their part are concerned to remember the sufferings endured by their own people.

The two narratives are here memorialized in stone. In this forest near the village of Zbylitowska Góra a few miles outside Tarnów, where both Jews and Poles were brought (on separate occasions) to be shot into mass graves, the Polish state erected a substantial monument in memory (as it says) of its murdered citizens. The small community of Jewish survivors in Tarnów had previously erected its own commemorative stones, in memory of the Jewish victims. To this day, the two monuments sit alongside each other in uneasy coexistence.

SEE NOTE ON P. 164

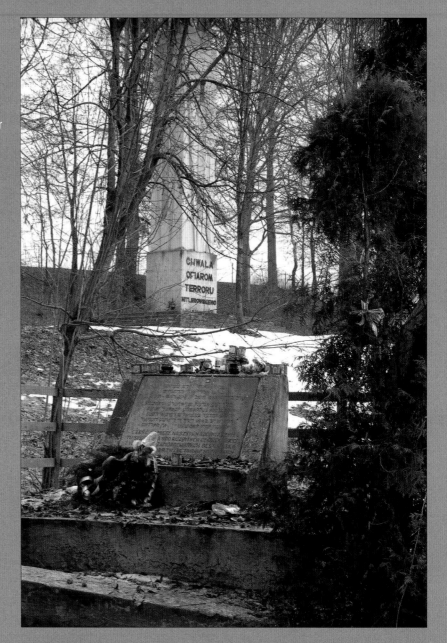

58 Memory of a Jewish cemetery preserved by local Poles

Every now and again in the Galician countryside, a clump of trees in the middle of farmland
a short distance from a village marks the site of the local Jewish cemetery — as for example
here in Stary Dzików, a remote village about thirty miles north of the town of Jarosław.
All the tombstones have disappeared from this unfenced cemetery, but in the minds of
the local villagers it is still the Jewish cemetery and they let the site remain undisturbed.
The memory of the Jews thus lives on, even where there may be nothing that has been
physically left behind, let alone a monument giving an official narrative of the past.
On the contrary, local Poles who remember the war remember the Jews and what happened
to them. As time marches on, of course, these memories are steadily disappearing.

SEE NOTE ON P. 165

59 Rescue: a Jewish woman remembers the Polish woman who saved her life

The story of the creation of the world, as narrated in the Hebrew Bible, states that God created one human being, Adam, as the ancestor of all humanity. The Talmud offers an important comment: the story of Adam teaches us, it says, that to destroy a single life is to destroy a whole world, including that person's yet unborn descendants; to save a single life is thus to save a whole world.

In the small town of Tuchów, south of Tarnów, there is no physical evidence of any kind that there was once an active Jewish community — no synagogue, no preserved Jewish cemetery; it is all gone. The only trace to be found is an inscription on a tombstone in the Catholic cemetery, signed simply 'Basia—Israel'. Basia here records her thanks to Maria Dzik for having rescued her and saved her life during the Holocaust. It is the one physical trace that Jews once lived in the town of Tuchów.

SEE NOTE ON P. 166

60 Rescue: Oskar Schindler's factory and *Schindler's List*

The gates of the Emalia factory in Kraków, a sight now associated across the globe with the Holocaust in Kraków. It was here that Oskar Schindler, a German industrialist, employed a large Jewish workforce from the nearby ghetto, thereby saving them from deportation to the concentration camps. For those who worked there it was an oasis of peace and human dignity. Then in 1944 he succeeded in moving his factory, together with more than a thousand Jews, out of Poland altogether. The story of this remarkable rescue became immortalized in Steven Spielberg's film *Schindler's List*, shot on location in Kraków in 1993. Awareness of the Holocaust has spread extremely widely as a result of this exceptionally well-known film. Nowadays there are so many visitors to Kraków wishing to retrace the places where the film was made that this entry building to the Emalia factory has been made into a museum.

SEE NOTE ON P. 167

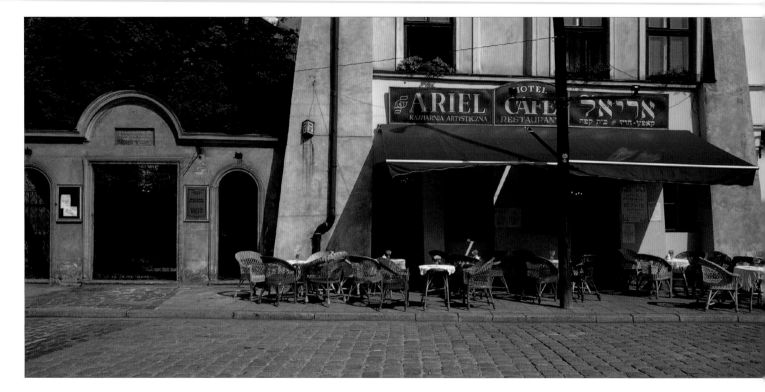

61 Heritage tourism in a regenerated Jewish Kazimierz

The former Jewish quarter of Kazimierz in Kraków became something of a ghost town after the end of the Second World War. Emptied of its Jewish inhabitants, the area was derelict for decades. Its buildings became slums, their windows rattling in the wind, symbolizing, perhaps, the Jewish absence. Since the fall of communism in 1989 Kazimierz has been steadily transformed, through planned urban regeneration schemes focusing in particular on the restoration of synagogue buildings, and through organic private development. Fashionable cafés, hotels, restaurants, and boutiques thus operate alongside Jewish heritage tourism. New Hebrew signs have appeared above shopfronts inviting tourists to consume kosher-style foods and listen to east European Jewish folk music in a historic Jewish setting. The memory of the Jewish past has been reconstructed, principally for the benefit of tourists, both Jewish and non-Jewish.

SEE NOTE ON P. 167

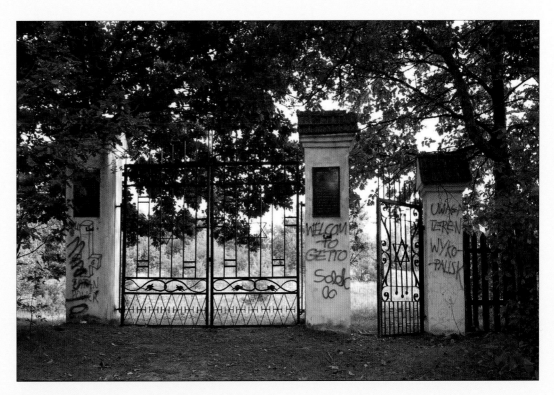

62 Anti-Nazi graffiti 63 Antisemitic graffiti

Graffiti relating to Jews or to the Holocaust are frequently to be seen in Poland. The trauma of the Second World War, for Poles as well as for Jews, lingers. Graffiti with a swastika or a reference to Auschwitz may thus be as offensive to Poles as they are to Jews. Perhaps that is the anti-establishment intention of the youth who daub these graffiti. But the daubing of 'welcome to the ghetto' on the gates of this restored Jewish cemetery in the remote town of Ulanów is particularly aggressive, since it is accompanied by the use of occult Satanist symbols (on the left of the gates). Expressing social and political ideas through graffiti has become so widespread in post-communist Poland that graffiti 'conversations' are commonplace. The image of a swastika being dumped into a trash-can, found on the wall of the Miodowa Street Jewish cemetery in Kraków, is reportedly the work of a local Polish Jewish student group. These graffiti 'conversations' are hardly typical of Polish society at large, but they do show that the memory of a very troubled past is far from being laid to rest.

SEE NOTE ON P. 168

64 Painting by a Polish schoolgirl expressing nostalgia and hope

Since the fall of communism in 1989 substantial energy has been put into the sympathetic teaching of the younger generation of Poles about both the Holocaust and the Jewish past of their country, and these subjects are now part of the regular curriculum in state schools. Among the special projects that schoolchildren are encouraged to take up are art competitions, with paintings on such topics as the former synagogue in their home town, Jewish ritual objects, or some aspect of Polish–Jewish coexistence. Interestingly, the emphasis in such artworks is often on dialogue and reconciliation. This painting, made in the mid-1990s by a 16-year-old schoolgirl from the town of Oświęcim (Auschwitz), was part of an exhibition by pupils from local schools on Jewish subjects that was shown in the restored synagogue of the town. It seems to combine nostalgia for the past and hope for the future — the two major themes that in fact dominated the speeches given a few years later at the formal rededication of the synagogue, which is not much more than a mile from the Auschwitz camp.

SEE NOTE ON P. 170

5 People Making Memory Today

The focus of attention in the previous section was what has been done in Polish Galicia to memorialize both the Jewish life that existed there for centuries and the enormity of the Holocaust during which it was destroyed.

This final section is dedicated to the same subject, but instead of looking at monuments, buildings, and commemorative plaques, the photographs here focus on the people who have been responsible for creating and sustaining that memory today. Seeing those people — most of them too young to have known the realities of pre-war Poland — making a concerted effort to revive the local memory of the Jews who were murdered and the culture that was destroyed gives a feeling of hope. To remember the past is to shape the future and give it some sense of direction. It is an upbeat message, communicating at the very least a sense of simple humanity and cultural understanding.

Making memory takes many forms, and the photographs show something of the wide range of people who are involved. They express a similarly wide range of emotions — not only grief at the horrors of the Holocaust, the feeling of the need to mourn, and the expression of formal respect for the dead, but also serious interest in Jewish culture and a pleasure bordering on exuberant excitement at the opportunity to rediscover and reconnect with the lost Jewish world of Polish Galicia.

Who are all these people? There are several thousand Jewish teenagers from around the world who come to Poland in the annual 'March of the Living' — for an act of remembrance at Auschwitz, where they are accompanied by Holocaust survivors, Holocaust educators, and leading rabbis. There are heads of state and other VIPs who make their own, more formal, visits to Auschwitz and Kraków, particularly for the elaborate ceremonies held on the major anniversaries, such as the fiftieth and

Confronting the memory of the Jewish past involves many emotions: grief, mourning, and respect—but also nostalgia and hope for the future

sixtieth anniversaries of the liberation of the camp (in 1995 and 2005). Then there are the regular visitors to the Auschwitz museum, whose numbers are now well in excess of one million per year, double the number of visitors a decade ago; Polish survivors of Auschwitz, who continue to play a significant role in maintaining the memory of what happened there, for example by their close links with the staff who work at the museum; local scholars, with both Polish and international students, working at new institutes and departments of Jewish studies and Holocaust studies at universities in Kraków and other Polish cities; authors and readers of the very substantial number of new books that are being published in Poland nowadays on Jewish themes; local and foreign visitors benefiting from the considerable expansion of Jewish heritage tourism in Poland, causing throngs of people daily to visit Jewish sites, such as the Rema Synagogue in Kraków; strictly Orthodox Jews coming as pilgrims to the graves of saintly rabbis, in expression of their belief that the sanctity of such graves never diminishes; visits by Jews of Polish origin to reconnect with their roots more generally; routine annual visits by Polish schoolchildren to their local Jewish cemetery on All Souls' Day to light candles and in that way to remember the Jews who once used to live in their locality, as well as 'days of remembrance' in a growing number of towns, specifically arranged as memorial events for the same purpose; and—last but not least—the remarkable Jewish Culture Festival held annually in Kraków, which draws huge crowds at concerts, lectures, and special exhibitions. It is indeed a long list, and constantly expanding.

Moreover, there is still a small but functioning Jewish community in Kraków, well supported by rabbis, kosher facilities, and a community centre. Compared to the great traditions of pre-war Galicia, these activities are very modest; but Jewish life in almost every country that endured the German occupation is deeply scarred and traumatized, and in that sense cannot be anything other than a pale shadow of its former self. But there is indeed evidence of what can rightly be called a Jewish revival, not only in Kraków but in Poland more generally. It derives both from the regained

freedom after the fall of communism in 1989 and also (and allied with that) from a rediscovery of Jewish identity among the younger generation. These new local stirrings of Jewish life, supporting the ongoing Jewish community which has existed uninterruptedly since the war, give an important additional dimension to the notion of memory-making. Jewish life does continue, here in southern Poland as elsewhere in central and eastern Europe; and it is right and proper to acknowledge that it has found new sources of inspiration, as well as being in continuity with the past. In that sense we can indeed conclude on a note of hope and confidence in the future. The Galicia Jewish Museum is proud of its own part in contributing to this future.

New sources of inspiration, and new stirrings of Jewish life in Kraków, are contributing to a new awareness of the meaning of the past and the potential for the future

65 A girl expresses her grief at the ruins of one of the gas chambers and crematoria in Auschwitz-Birkenau

Formal prayers for the souls of those who were murdered during the Holocaust have become standard Jewish practice several times a year, but making the personal visit to Auschwitz has greater immediacy. It gives people an opportunity to mourn, to develop a sense of personal relationship with the reality of the destruction and loss, and to reflect on the identity of the victims and their appalling suffering.

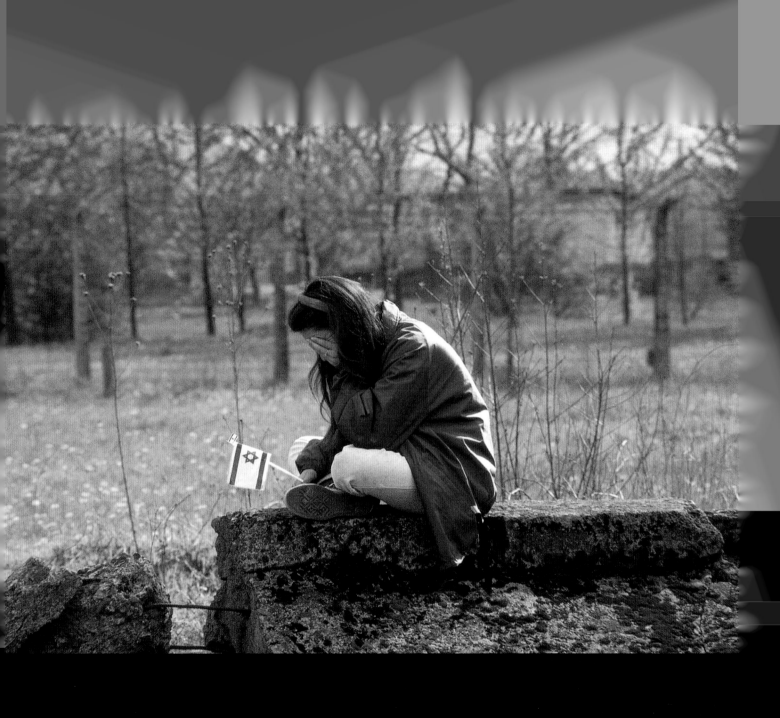

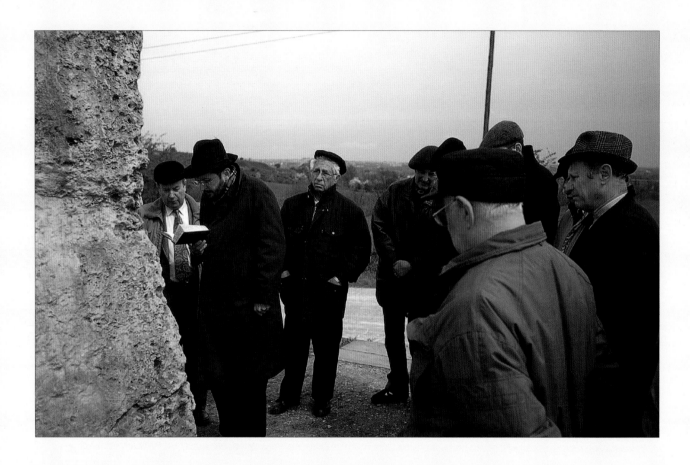

66 Jews reciting memorial prayers at the site of the Płaszów concentration camp in Kraków

Each year on the anniversary of the liquidation of the Kraków ghetto in March 1943, memorial prayers are recited at the Płaszów site by members of the small Jewish community of the city, following a commemorative march from the site of the ghetto. Nowadays large numbers of survivors, as well as several hundred local Polish city residents, accompany this march. On the left of the photo is Tadeusz Jakubowicz, president of the Kraków Jewish community; leading the prayers is Rabbi Sacha Pecaric.

SEE NOTE ON P. 171

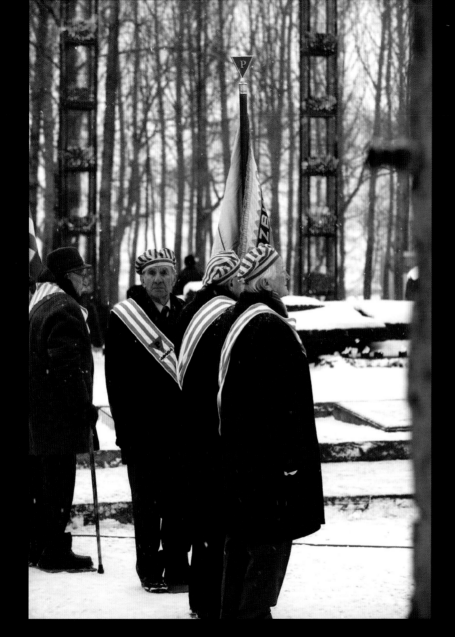

67 A group of Auschwitz survivors at the annual remembrance ceremony in Auschwitz-Birkenau

Each year a remembrance ceremony is held at Auschwitz-Birkenau on 27 January, the anniversary of the camp's liberation by Soviet forces in 1945. The ceremonies held on the fiftieth and sixtieth anniversaries (in 1995 and 2005) were major international, intercommunal, and interfaith events, attended by large numbers of survivors, heads of state, and winners of the Nobel Peace Prize. The group of survivors seen here at the ceremony in 2005 are former Polish political prisoners, wearing newly made copies of their old prisoner uniforms.

Polish survivors of Auschwitz have played a significant role in maintaining the memory of Auschwitz. Many of the staff who have worked at the Auschwitz museum since it was first established by the Polish government in 1947 have been survivors, and to this day a large number of the two hundred staff who work at the Auschwitz museum are close relatives of Poles who were murdered in the camp.

SEE NOTE ON P. 171

68 Visitor at the children's exhibit in the Auschwitz museum

It is estimated that about 185,000 Jewish children were murdered in Auschwitz. Some of their photos have been recovered, as has some of their clothing, and there is a substantial exhibition room in the museum devoted to describing the fate of children in Auschwitz. The prams and push-chairs in which parents brought small children to Auschwitz are particularly distressing to see (if one can single out a single exhibit in Auschwitz as 'particularly distressing'); they are currently not on display, but it is intended to exhibit them when all the museum's exhibitions are revamped in the next few years.

SEE NOTE ON P. 172

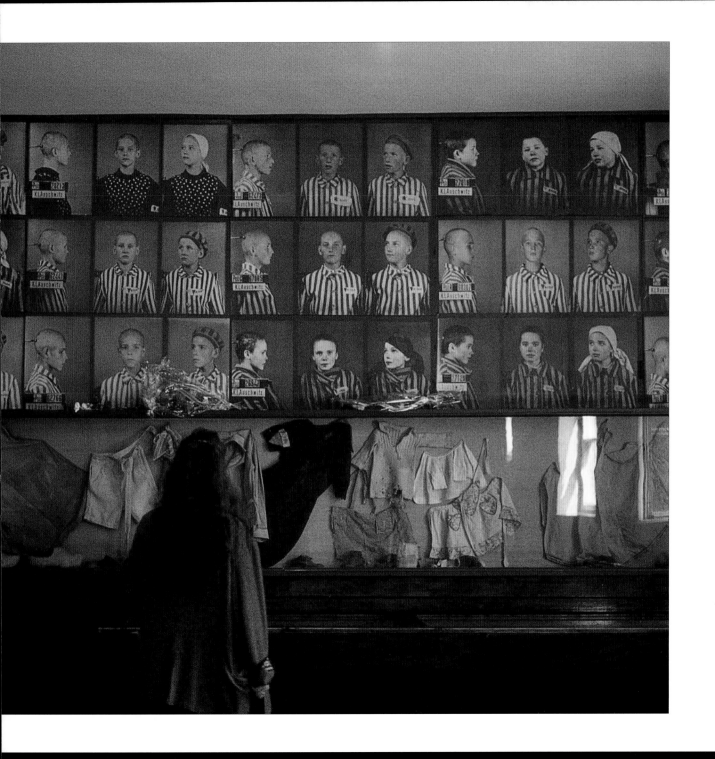

69 March of the Living parade in Auschwitz

The March of the Living, an annual event since 1988, is held on Yom Hashoah (Holocaust Remembrance Day, which in Israel and diaspora Jewish communities is in April). Several thousand Jewish high-school students from around the world, accompanied by Holocaust survivors, Holocaust educators, leading rabbis, and other VIPs from Israel and the Jewish diaspora, march from the Auschwitz main camp to Auschwitz-Birkenau, where remembrance ceremonies are held. The participants usually wear a special uniform and carry Israeli flags; when the groups march out of Auschwitz, they are commonly led by a rabbi carrying a Torah scroll. The purpose of the march is to strengthen the identity of Jewish teenagers by enabling them to internalize the memory of the Holocaust through a personal visit to Auschwitz, where they listen to the words of survivors as eyewitnesses of the events of the Holocaust. Altogether it is a two-week educational programme, including visits to other death camps in Poland as well as to cities such as Kraków where Jewish communities flourished before the Holocaust. In the second part of the programme participants continue on to Israel so as to be there for the celebration of Israel Independence Day, thereby giving them the opportunity to take pride in the existence and achievements of the Jewish state. The intense emotional experience of encountering the reality of both Auschwitz and present-day Israel in a single, structured trip is unquestionably powerful and life-changing for these young people.

SEE NOTE ON P. 172

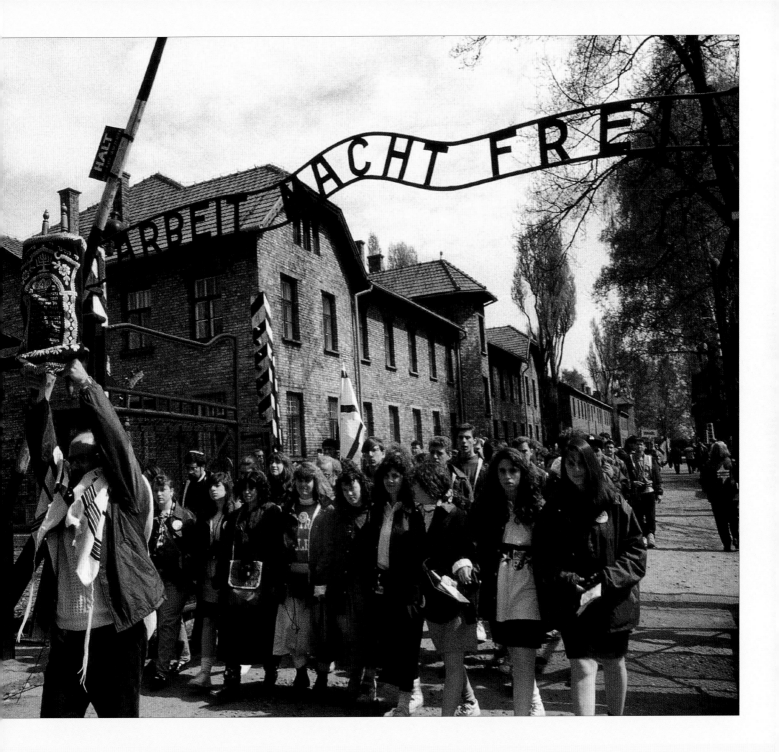

PEOPLE MAKING MEMORY TODAY

70 The Chancellor of Germany visits Kazimierz, the former Jewish quarter of Kraków

Many heads of state have come to Auschwitz to pay their respects in remembrance of the victims. Chancellor Helmut Kohl made an official visit in 1995. After visiting Auschwitz, Kohl continued on to Kraków to pay homage to its Jewish past; he was accompanied there by Sigmund Nissenbaum, a Polish Jewish businessman living in Germany active in philanthropic support for Jewish heritage projects in Poland. The delegation is seen here in the main street of Kazimierz, outside the old cemetery next to the Rema Synagogue. Kohl's tenure as chancellor was marked by a determined effort to normalize relations with Poland. From the 1980s there have been a number of German initiatives to promote Holocaust education and foster reconciliation, notably the creation of a large residential youth centre and teaching facility in the town of Oświęcim, near the former Auschwitz camp.

71 Formal opening of an international conference on Holocaust studies at the Jagiellonian University, Kraków

The grand setting of Collegium Novum for this Holocaust conference in 1995, and the opening speeches of the university's rector and the dean of the Faculty of Philosophy, indicate the recognition given to the subject. A new institute of Jewish studies was in fact opened at the Jagiellonian University in the 1980s; it continues to attract a large body of students and sponsors a wide programme of research and publications in all aspects of Polish Jewish history and culture, including its own English-language scholarly periodical, *Scripta Judaica Cracoviensia*. In 2007 the university opened an institute of Holocaust studies as well. Holocaust institutes are still relatively rare at Polish universities, but Jewish studies at undergraduate and graduate level are available at a number of other universities, including those in Lublin, Warsaw, and Wrocław, and there are Polish scholars in Jewish studies who have achieved wide international recognition for their work.

SEE NOTE ON P. 172

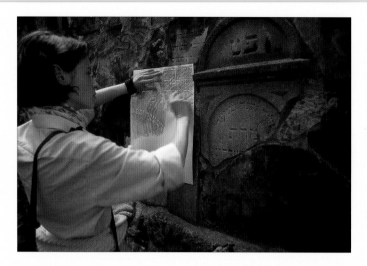

72 Tombstone rubbing during the Jewish Culture Festival in Kraków

Thousands of young Poles participate in this annual week-long festival, which offers a couple of hundred different events covering an exceptionally wide range of activities—concerts, lectures, book launches, special exhibitions, films, and guided tours of Jewish Kraków and vicinity. The first festival was in 1988, and it has been an annual event since 1994. While most of the artists, lecturers, and performers are Jews invited from North America, Israel, and elsewhere, an increasing number are Polish, both Jewish and non-Jewish. Tombstone rubbing is more than a fun artistic pastime. Guided by Polish experts on the subject, it is literally a close-up, hands-on activity, enabling participants to become familiar with Jewish culture through the symbolism and workmanship of the inscriptions and decorative carvings.

SEE NOTE ON P. 173

73 Open-air final concert of the Jewish Cultu[re] Festival in Kraków

Held in the main street of Kazimierz, this annu[al] concert attracts a huge, exuberant crowd, singing, dancing, and clapping until well into the night. Most of them are not Jewish. Janusz Makuch, the organizer of the festival, himself not Jewish, is thus in the curious situation of directing a Jewish culture festival for other non-Jews in an area that today is considered b[y] many Jews a Jewish ghost town. He says that t[his] is his mission—to bring Jewish artists to perfo[rm] in a country which is the world's largest Jewish graveyard, as a way of both honouring the dead and demonstrating Jewish survival. Such, then, are the paradoxes of making Jewis[h] memory in present-day Poland. There is certainly a fascination with the Jewish culture that has otherwise been lost from the Polish landscape and a desire to find ways to celebra[te] it and bring it to life. It may be, in part, a fashionable, exotic form of entertainment, but behind the fascination rests the awareness of tragic past and a genuine, deepening interest [in] the history, culture, and religion of the Jews. It is not the revival of traditional Judaism (although that is also taking place in Poland); rather, it a complex, subtle phenomenon which has been called 'virtually Jewish'.

SEE NOTE ON P. 173

Epilogue

74 Leaving Dobra . . .

In memory of all those places where Jewish life was struck out, leaving no trace behind

The purpose of this book has been to honour the memory of the Jews who lived in the towns and villages of Polish Galicia and to acknowledge those who perpetuate that memory today. There are many, many places such as Dobra where Jewish life was struck out, leaving no trace behind; where there is nothing Jewish left to photograph.

Leaving Dobra . . . In memory of all those places where no trace is left of a Jewish past.

A Note on Galicia, Place Names, and Sources

'Galicia' and 'Polish Galicia'

This book focuses on southern Poland — very roughly, an area bisected by the main road linking Kraków in the south-west with Poland's eastern border (see map on pp. 10–11). From 1772 until 1918 this territory was officially known as Galicia — or, more technically, as the kingdom of Galicia and Lodomeria, a name which is medieval in origin. During the last thirty years of the eighteenth century Poland steadily lost all of its territory to its three powerful neighbours, the empires of Russia, Austria, and Prussia. In 1795 it ceased to exist as a sovereign state and disappeared altogether from the political map of Europe. During the whole of the nineteenth century most of Poland was in Russia (and known as the 'Kingdom of Poland' or 'Congress Poland', though Jews often called it 'Russian Poland'), while the south of the country was a province of the Austrian empire called Galicia ('Galizien' in German, or 'Galicja' in Polish). The borders of Galicia changed at various times during the period (Kraków, for example, was incorporated into Galicia only in 1846); from 1873 it was an autonomous province of the Austro-Hungarian empire that had been

formed a few years earlier. In 1918, at the end of the First World War, Poland regained its independence, and this time it was Galicia that disappeared from the map as a distinct political entity; its territory was incorporated into the newly independent Polish Republic. After the upheavals of the Second World War the boundaries were changed once again. The territory of old Galicia was divided in half: eastern Galicia was given to Ukraine (then part of the USSR), and Poland kept only the western half.

The term 'Polish Galicia' as used in this book thus refers to that western part of the old province of Galicia which since the end of the Second World War has been part of Poland. The name will not be found on any present-day political map, as there is no political or administrative territory in Poland known as Galicia. But this invisibility of Galicia conceals other realities: the memory of Galicia is largely a positive one and it still remains fairly strong. This is true both among local people in southern Poland (for example, nowadays one may frequently encounter a 'Hotel Galicja' or references to 'Galician cuisine') and also among the descendants of Jews who come from there (many of whom continue to be conscious

and indeed proud of their identity as 'Galitzianers', i.e. of Galician Jewish origin). The Jewish memory of Galicia has thus survived for several generations after its disappearance as a political entity (and despite a brief reappearance during the German occupation), and it resonates also in local Polish contexts today. There is currently a 'Chief Rabbi of Galicia' based in Kraków, and a student group there which has founded a 'Galicia project' to recover the memory of the region. The naming of the 'Galicia Jewish Museum' fits well with these realities and in that sense is self-explanatory.

Places and Place Names

This book is intended as a very short introduction for the benefit of the general reader rather than for specialists, and I have therefore not imposed a rigorous, formal distinction between 'villages' and 'towns', the difference between which often rested historically on legally defined charters. In referring to places as they were before the Holocaust I have ignored those formalities, simply for the purpose of giving readers a sense of their size: I use the word 'village'

o mean a place with fewer than 2,500 inhabitants; a 'small town' or 'market town' means a place which had between 2,500 and 4,500 inhabitants, and for a place which had more than 4,500 inhabitants I use the word 'town'. For much larger places I use the word 'city'. Many 'villages' and 'small towns' as they were in 1939 are of course today quite different in size; many 'small towns' are now 'towns' and some of them have grown to become substantial industrial cities.

The spelling of place names is a veritable minefield, especially given the frequent border changes in central and eastern Europe and the consequent changes in official names according to the respective national languages used within a particular territory at a particular time. Jews who have inherited the sound of Yiddish place names in their family tradition often say that the village their family came from was so small that it is not or was not on any map. This may be due to a misunderstanding: maps made by local or metropolitan authorities in Galicia would of course not use Yiddish versions of place names at all, but rather the German, Polish, or Ukrainian names instead. People knowing only the Yiddish name may thus well have trouble finding it on a map. This book does not use Yiddish names either, except in the index, where Yiddish place names are cross-referenced to the corresponding Polish name. Otherwise,

given that this book focuses on Polish Galicia, Polish place names, as used on present-day maps of Poland, have been used here throughout, except for Warsaw, which is well established as the English name; however, Kraków is used in preference to Cracow, which is now widely considered archaic.

Sources

A lot of what is often understood to be a 'fact' about Poland, and particularly about the Polish Jewish past, may be contested; the past is often more complex than is usually assumed. This complexity is sometimes hinted at in the text, but readers need to be aware that a great deal of what has been written about in the captions and notes has been subject to a substantial amount of discussion in the scholarly literature. This book does not attempt to survey the totality of such discussion, let alone reach definitive conclusions. What it does try to do, however, is to put the photographs in context by mentioning such issues in the notes (from time to time, as appropriate) and pointing to just a small sample of the relevant literature for the benefit of those wishing to do some further reading. In recent years the body of scholarly literature on the subject has grown very considerably, further augmented by the large number of personal memoirs

published by Holocaust survivors. References to that literature, which are provided only in the notes, have thus been kept to the essential minimum, although a reference is routinely provided where specific information has been drawn from a particular source. However, much of the material covered in the captions and notes has been based on personal observation during the fieldwork I conducted in Poland over a number of years (as described in the Prologue), which means that in such cases no published source has been provided. A bibliography giving details of all references can be found at the end of the book. Again, with the general reader in mind, I have supplied a note at the beginning of the bibliography giving details of standard reference works.

Background Notes

Introduction

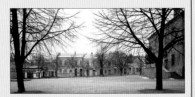

Photo 1

The synagogue of Biecz had two entry doors, as can be seen in the photo: one for men, leading to the sanctuary on the ground floor, and the other for women, leading to a staircase going straight upstairs to the women's gallery. The town is certainly aware of the history of the building housing its library, and in the late 1990s granted permission to the association of former Jewish residents of Biecz, based in New York, to erect a commemorative plaque. Further along the square is a fine mansion dating back to the sixteenth century, now partly used as an elegant café; in the nineteenth century it was owned by a wealthy Jew named Klotz, and this fact is recorded in an inscription near the entrance.

The Jewish cemetery, just over half a mile from this main square, contains a monument to the local Jews who were murdered in the town during the Holocaust, including about 150 sick and elderly Jews; nearly all the others, together with several hundred Jews from nearby villages, were deported to the death camp at Bełżec. After the war, a handful of survivors returned to

Biecz: some had been hidden, some had survived the deportation, some had survived in Soviet territory. They restored the cemetery and erected the monument, but their attempts to revive Jewish life in Biecz did not succeed, and a short while later they left for the USA and Israel. (Unless otherwise stated, all population figures and other historical data given about specific places in the captions and notes in this book, such as those here concerning Biecz, are drawn from volumes 2 and 3 of Yad Vashem's *Pinkas hakehilot: polin* (one volume each on eastern and western Galicia: see Dąbrowska, Wein, and Weiss 1980 and Wein and Weiss 1984 respectively); brief accounts can also be found in Spector 2001. Descriptions of present-day realities, however, are from the author's personal observations.)

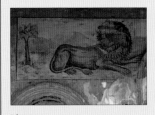

Photo 2

The passage in the Talmud, a saying of R. Yehudah ben Tema, reads in full: 'Be bold as a leopard, light as an eagle, swift as a deer, and strong as a lion to do the will of your father who is in heaven' (*Mishnah pirkei avot*, 5: 23). Synagogues in Galicia were often elaborately decorated (see especially

photo 18), and would commonly have paintings of all these four animals. Worshippers would understand them as encouraging them in their devotions and religious lifestyle. Another example can be seen in photo 10. For an elaboration of the underlying concept, which is the opening theme of the sixteenth-century code of Jewish law *Oraḥ ḥayim* at ch. 1, para. 1 ('Rules of Conduct upon Rising in the Morning'), see Ganzfried 1961: vol. i, ch. 1, paras. 3–4.

The restoration of this magnificent, richly decorated synagogue (see also photos 9 and 10), long overdue, has been the subject of many discussions; the building is in serious danger of collapsing. In 2008 the local mayor and municipality finally announced that funds have been raised for at least some basic conservation works (i.e. to the roof and walls), although as of the time of writing (February 2009) there are still no plans for a full artistic restoration project.

Photo 3

Hochman's bas-relief was sponsored by the Jewish community of Kraków, doubtless as a way of publicly

recording the debt that Jews owed to the medieval kingdom of Poland in general, and King Kazimierz the Great in particular, for welcoming them to the country; Kraków was the capital of Poland down to the end of the sixteenth century, and in that sense an appropriate place to instal a bas-relief referring back to that period. During the German occupation of Poland in the Second World War the bas-relief was taken for safe keeping to the National Museum in Warsaw. Hochman himself went to live in Tarnów, where he was murdered in 1943 during the liquidation of the ghetto (Duda 1999: 52). The bas-relief survived the war intact, and in 1996 it was brought back to Kraków and reinstalled to mark the official visit of Ehud Olmert, then mayor of Jerusalem.

In the middle of the seventeenth century Poland went into political and economic decline, and the Jews suffered major catastrophe during the Chmielnicki massacres of 1648–9. But down to the first half of the seventeenth century Poland was 'heaven for the nobleman, purgatory for the citizen, hell for the peasant—and paradise for the Jew', to quote a common saying of the time. Jews constituted a merchant middle class, often involved in acting as middlemen in collecting government revenues, such as those from salt mines, royal mints, and the estates of noblemen. Jews paid taxes and were entitled to the same rights as others. The leading sixteenth-century rabbinical scholar Moses Isserles of

Kraków wrote in one of his responsa that 'in this country there is no fierce hatred against us as it obtains in Germany. May it so continue until the advent of the messiah.' In another he says: 'Had not the Lord granted us this land as a refuge, the fate of Israel [i.e. the Jewish people] would have indeed been unbearable. But by the grace of God, both the king and his nobles are favourably disposed towards us' (quoted in Lew 1944: 81–2). R. Isserles was also the author of a Hebrew pun on the Jewish name for Poland ('Polen' or 'Poilin') — that it stood for *poh lin* ('here [the Jewish people] shall find rest'), an idea that inspired Jewish writers even down to the early twentieth century to suggest that there were divine blessings in the very presence of Jews in Poland. (The attribution to R. Isserles of the *poh lin* play on words is from Ben-Sasson 1972: col. 711; for the later writers see Bar-Itzhak 2001: 7–44).

Poland was the first country, after the great Jewish centres of Babylonia and Spain, to have had such a substantial concentration of Jews with a broad scope for autonomy that was not far short of self-government. Polish Jewry developed the most elaborate institutional structures in European Jewish history: from artisan guilds and voluntary societies, communal governments, and regional assemblies to a national council or parliament called the Council of Four Lands. In commenting on the idea that Poland was thus a paradise for Jews, Gershon Hundert, one of the senior historians of pre-modern Polish Jewry and editor of the monumental *YIVO Encyclopedia of the Jews of Eastern Europe* (Hundert 2008), writes that 'No generalization, no single adjective would fit such a large and polychromatic group of people, the largest Jewish community in the world from the seventeenth

century on [until the early twentieth century, when the Jewish community in the USA became larger]. They followed spiritual regimens that were at times uniform, at times anarchic. Chastity and licentiousness, fasting and feasting, perfunctory prayer and mystical intensity, proprietary sadness and God-intoxicated joy, vast wealth and dire poverty, orderly patriarchal solemnity and rebellious and impudent youth — all were to be found among these Jews. If one had to choose a single word to reflect the experience of Jews in Polish lands, that word would be *vitality*. Vitality and an indomitable, and indomitably positive, sense of self. The Jewish community was vibrant, creative, proud, and self-confident' (Hundert 2000: 28–9).

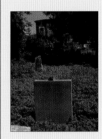

Photo 4

The Hebrew inscription states simply 'Here lie three people who were killed as martyrs in 1637. May their souls rest in peace.' What is also interesting about this stone is that it is not in fact an original seventeenth-century tombstone but rather a replica made after the Second World War, probably in the late 1940s. It would seem that the annual commemorative prayers had indeed caused the event of 1637 to remain etched in the local Jewish memory. Even after the enormous losses that the Kraków Jewish community had experienced during the Holocaust, the community that reconstituted itself in the city after the

war and set about restoring the cemetery wanted to commemorate the violent deaths of just a handful of people more than three hundred years earlier; indeed, another stone in the same cemetery records another incident, also from the seventeenth century. For further details about the 1637 incident, see Dubnow 1916–20: i. 102; Bauminger 1959: 18–19. Both sources refer to seven victims rather than three; the tombstone could theoretically refer to a different incident, but this is unlikely.

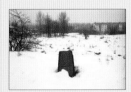

Photo 5

It is strange to think that there can be such a thing as a survivor of a cemetery, let alone a random, sole survivor. The tombstone of Chaim Jakób Abrahamer, who died in 1932, visibly testifies to the fact that this place was once a Jewish cemetery. Roma Ligocka, a Holocaust survivor from Kraków and the author of a well-known memoir, has identified it as the grave of her great-grandfather (see Ligocka 2002: 288). At the time of Abrahamer's death the cemetery of Wola Duchacka had only just been opened, but it rapidly came into use because the main Jewish cemetery in Kraków then in service (in Miodowa Street in Kazimierz) was short of space.

The sight of the lone tombstone cannot in itself reveal the wider history. In fact the Jewish community of Kraków wanted the cemetery to have a monumental appearance, and so erected a substantial funeral hall and chapel. It was to be a magnificent rectangular building topped with a fine central dome, as well as two smaller

domed structures, one at each end. But with the economic crisis of the 1930s the construction of the colonnaded facade that the architect had envisaged was postponed. Then the war broke out. The cemetery was turned into a German labour camp, then into a concentration camp known as Płaszów: the tombstones were dug up and laid flat on the ground as foundations for paving the area. The funeral chapel was eventually dynamited by the Germans in 1944 on the orders of Amon Goeth, the notorious commandant of the camp, and no trace of the building remains today. (See Zbroja 2007: 48; Sabor, Zbroja, and Zimmerer 2007: 107; for a remarkable photo of the chapel actually being dynamited, with barracks and a watchtower of the Płaszów camp clearly visible in the background, see Sabor et al. 2007: 155.)

The story of the Jewish cemetery of Płaszów demonstrates something of the difficulty of our subject. Today the whole site is open land, something like open parkland but not presented as a park; nor is there any trace of the German camp. Here is a piece of land that was consecrated for the dignified burial of the dead but was turned into a setting for the deliberate murder of the living. It is a double graveyard: still a cemetery, with its one tombstone, but also now to be remembered for the horrors of what took place there during the Holocaust — and indeed there are monuments on the site that have been erected in commemoration of the victims of the Płaszów camp. But the tombstone is the only authentic trace of an earlier past. Like so much else in present-day Jewish Poland, all that is left are fragments; and as fragments they cannot tell the whole story, even if in some sense they can be understood as symbolizing it.

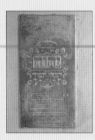

Photo 6

The Auschwitz concentration camp was located in what were then the outskirts of Oświęcim, a town where before the war Jews numbered about 40 per cent of the population (4,950 out of 12,187 in 1921). The town's main synagogue was burnt down by the Germans shortly after their invasion of Poland in September 1939. Smaller synagogues and prayer-houses were steadily destroyed, or converted beyond recognition to other uses. This tablet was in a small prayer-house in the town centre known as Chevra Lomdei Mishnayot (which roughly translates as 'association of those who study the Talmud') that survived because the Germans requisitioned it to store ammunition. After the war, it was used by Holocaust survivors for a short period for prayer services, but in the 1970s (during the period of the communist regime in Poland) the building was taken over by the state and used as a warehouse for carpets. (I am grateful to the Auschwitz Jewish Centre for these historical details.)

The plaque in the picture also has some personal significance. I began my research in Poland in this town, at the invitation of Andrzej Paluch, Professor of Social Anthropology at the Jagiellonian University in Kraków. This was in 1988. We were supervising a small team of research students investigating local memories of the wartime period. (For details of the findings see Paluch 1992.) While walking around the town I came across a building that I suspected might have been a synagogue, though at that time nobody we were interviewing seemed to be aware of it. I recognized the building as a synagogue because of its arched windows, its modest size, and its classic location in a square diagonally opposite the main church. The workers in the carpet warehouse (as it then was) said it had once been a foreign church, perhaps Armenian, as there were inscriptions in a strange language. I asked if they could move the carpets so I could see the inscriptions and they readily agreed, but there were many carpets and it was a long job. After an hour or more, my patience was rewarded: this Hebrew inscription suddenly came into view. It was in the traditional position for such inscriptions, on the eastern wall of the building so as to face Jerusalem. The eager workers, spurred on by my enthusiasm for what they were showing me, then moved more carpets to reveal a second Hebrew inscription, this one recording the names of the officers of the congregation in 1928. The experience was deeply moving, and it was at that moment that I realized that I should research the existence of such traces further. Poland is a large country, and so at Professor Paluch's suggestion the major research project I eventually embarked on was limited to the borders of former Galicia. This book is in large part an outcome of the inspiration I gained from that encounter in this synagogue building.

In a paper published shortly afterwards (Webber 1992) I mentioned this building, suggesting it might be restored and put to use as a centre for prayer and study. Within eight years the task had been accomplished. The former Chevra Lomdei Mishnayot building and a neighbouring Jewish-owned house had been taken over by a new organization, the Auschwitz Jewish Centre, to house a fully restored synagogue and a small historical exhibition and library, which opened in 2000. It was the first synagogue in the country to be restored to the Jewish community following the enactment of a law governing the restitution of Jewish communal property in 1997. (For further details about the Centre see the note on photo 64.)

So this tablet is no ordinary relic. At first glance it seems no more than a standard synagogue *shiviti* with a standard Hebrew inscription, ending with a dedication by the donor. (It is known as a *shiviti* following the first Hebrew word of the phrase 'I have set God before me, always', which is a quotation from Psalm 16; another example can be seen in photo 9.) But this is no ordinary *shiviti*. It takes on additional meaning as a relic of a shattered, fragmented world. In this particular context in a restored synagogue, it may offer comfort and hope to those who mourn for all who suffered and died at Auschwitz.

1. Jewish Life in Ruins

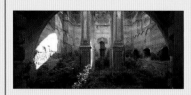

Photo 7

Rymanów was one of just two places in Polish Galicia that before 1800 had become centres of hasidism, the other being Leżajsk, on account of the presence there of R. Elimelekh (on whom see photo 23), and R. Menahem Mendel was in fact his disciple. However, by the middle of the nineteenth century hasidism very substantially dominated Jewish religious life in Galicia.

Hasidism is a Jewish religious revivalist movement which began in the eighteenth century, and was among the most momentous spiritual revolutions ever to influence the life of the Jewish people, certainly those of eastern Europe. Its origins are usually associated with a Jewish mystic, faith-healer, miracle-worker, and story-teller living in Podolia (a region now in central and south-west Ukraine) known as the Ba'al Shem Tov (c.1700–60). His vision was that true faith was not to be found in rational, talmudic knowledge on its own but rather in sentiment, emotion, and religious exultation—in the sincere, steadfast love of God and a belief in the efficacy of prayer, especially when conducted with ecstatic fervour in a cheerful frame of mind. Even ordinary, uneducated people could achieve all this and thus find a way to cleave to, or be united with, the divine source of all life. The truly righteous person, or *tsadik*, was one who had reached the pinnacle of total communion with the divinity and could thus mediate between God and ordinary people, even to influence the will of God as regards daily human affairs. Belief in the power of the *tsadik* (also known as 'rebbe') to draw down the flow of divine blessings to humanity became a central feature of the hasidic world-view (a subject which R. Elimelekh of Lizhensk—as Leżajsk is known in Yiddish—was one of the first to elaborate at length), and it was this belief which encouraged the Jewish masses to identify with a local *tsadik*— if only to benefit from the blessings he could supply.

he speed with which hasidism grew into a popular movement in eastern Europe was astonishing, and it is attributed by historians to many different factors, including the political disruptions of the eighteenth century (notably the partitioning of Poland), the loss of trust in the traditional rabbinate, and the economic and spiritual decline of the Jews of the region. In Galicia there was widespread extreme poverty among the Jews, who in the first half of the nineteenth century suffered from severe government repression, including high taxes on kosher meat and a weekly candle tax. Hence they turned to hasidism. As the Galician Jewish historian Raphael Mahler puts it, 'The hasidic teaching of divine grace and complete faith in God primarily reflects the pitiful, uncertain, and haphazard existence of the Jewish village tavernkeeper, small shopkeeper, or broker of the time who did not know in the evening if he would earn a piece of bread for himself and his family the following day' (Mahler 1985: 12). Hasidic prayer-houses, with their own ecstatic style of prayer and distinctive liturgy, rapidly became established in community after community; and crowds of men and women gathered around a *tsadik* with requests for healing, blessing, and advice in worldly matters. Young men travelling to see their rebbe on sabbaths and festivals became such a common feature that one scholar speaks of a veritable hasidic youth culture (Assaf 2008: 661).

As the movement developed, it became clear that hasidism was not a unified organization with a central authority or formal membership procedures. On the contrary, Jews became hasidim merely by identifying themselves with a particular rebbe (and attaching themselves to his group of followers,

including an acceptance of their distinctive habits, such as their dress code and liturgical customs). The rebbe himself was not formally appointed or elected, but simply accepted as a leader by his followers by virtue of his charismatic personality or spiritual eminence; after he died, the succession would usually pass to a son or son-in-law, thereby establishing a dynasty customarily named after the town or village where the 'courts' of such dynasties were originally established. This is why 'hasidism' is in some respects a problematic term, and in the view of some historians is probably best understood not as a movement as such but rather as a collective label for a great variety of groups and traditions (for a detailed survey article see Assaf 2008). Indeed, to solve this problem, some of the literature on hasidism confines itself to materials about specific groups, rebbes, dynasties, or schools—thus for example Martin Buber's celebrated *Tales of the Hasidim*, which arranges hasidic stories told about the rebbes in precisely this way (for stories about the charitableness and devotion to prayer of R. Menahem Mendel of Rymanów see Buber 1948: 123–37).

On the other hand, nineteenth-century hasidism can indeed be taken as a coherent political force, in that there were conscious strategies used by the rebbes to take over Jewish communities, and they decisively succeeded. Both in ideology and practice, they were not ascetic mystics withdrawn from the world, either in their philanthropic attitude to ordinary people or in their approach to power politics. Opposing rabbis were forced out, meat prepared by butchers other than their own was declared non-kosher, and rebbes began to occupy rabbinic posts in their communities and

do what they could to arrange such posts for their protégés. By mid-century the hasidic struggle for power in Austrian Galicia and in neighbouring Russian Poland had been won; hasidism had been transformed from a popular religious movement into the dominant faith of the majority of Polish Jews. For two important studies of the details of this process see Wodziński 2005 and Dynner 2006.

Given such a history, the lamentable physical condition of the synagogue of Rymanów for so long after the Holocaust provoked a wide sense of dismay. Its ruinous state became an icon symbolizing the destruction. For example a picture just of this synagogue appears on the front cover of all six volumes of Wunder's encyclopedia of the rabbis of Galicia (Wunder 1978–2005).

It should be noted that hasidism met stiff opposition during this period from a rival movement known as the Haskalah (Jewish Enlightenment), a movement which aimed at stronger integration of Jewish society into European culture and saw the hasidim as fanatical, ignorant, and superstitious, and preventing Jewish society from experiencing the benefits of modern reform and renewal. The Haskalah was particularly strong in eastern Galicia in the first half of the nineteenth century, where its adherents—consisting mainly of wealthy merchants, teachers, and doctors—believed in strong loyalty to the government and the Austrian monarchy as a religious duty, supported capitalist ideology (wealth as a natural reward for economic initiative, energy, and education), and were in favour of German-language secular education in Jewish schools as a central pillar of their programme. The

battle was bitter and vituperative: its leaders—notably Yosef Perl from Tarnopol (Ternopil)—repeatedly tried to enlist the support of the state authorities in their fight against hasidism, and published satirical works ridiculing hasidim as grotesque, ridiculous, encouraging idleness, and altogether a 'mockery in the eyes of the nations'; they saw Yiddish as a corrupt language which had to be swept away. In the opinion of Raphael Mahler, Haskalah and hasidism represented two social classes: the rising Jewish bourgeoisie and its associated intelligentsia on the one hand, and the impoverished, petty bourgeois, lumpenproletarian masses on the other (Mahler 1985: ch. 2). The Haskalah, which did have some supporters in western Galicia during this early phase, notably in Kraków and Tarnów, essentially failed to stop hasidism, though its modernizing programme for Jewish cultural renewal certainly left its mark—for example, in the formation of a Progressive Jewish community in Kraków and the founding of its own synagogue in the 1860s (see photo 30), and in the political and ideological transition to Jewish nationalism (Zionism) towards the end of the nineteenth century.

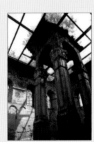

Photo 8

Throughout all the countries of German-occupied Europe there are hundreds of abandoned synagogues,

many of them architectural gems. For an excellent survey of such synagogues in Italy, Croatia and Serbia, Greece, Austria, the Czech Republic, Slovakia, and Hungary (i.e. not including Poland), see Dorfman and Dorfman 2000. The authors take the view that since talmudic law presupposes that abandoned synagogues do preserve some of their former sanctity, they should be left untouched, even with weeds growing around them, 'to arouse compassion in the viewer' and in fulfilment of the biblical curses 'for the land shall be all thorn bushes and thistles' (Isa. 7: 24) and 'I will lay your cities in ruin, and make your sanctuaries desolate' (Lev. 26: 31) (Dorfman and Dorfman 2000: 5).

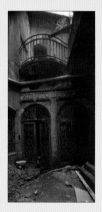

Photo 12

It was not uncommon for wealthy Jews to establish a small synagogue or *beit midrash*, intended primarily for their own family, friends, and associates but also open to others. Jekutiel Hakohen Laska, owner of the local Suchard chocolate factory, established a private prayer-room in his mansion in Kossaka Square. In interwar Kraków there were several other *batei midrash* in the city centre, including Ahavat Re'im in

Szpitalna Street (after the war converted into an Orthodox church) and Dorshei Shalom in Długa Street. According to an original Hebrew-language plaque dated 1932 now in the possession of the Old Synagogue museum in Kraków (see photo 50), Mordechai Tigner died in 1931, leaving the instruction in his will that his *beit midrash* should be enlarged, and the work was completed later that year; in Polish he was known as Markus Tigner, and his *beit midrash* is listed under that name in the Kraków street directory for 1932 (see Księga Adresowa Miasta Krakowa 1932: §3a, 32; §6, 8). (On the use of Tigner's *beit midrash* as a musical theatre after the war, see Duda 1999: 111; on the other city-centre *batei midrash* see ibid. 41.)

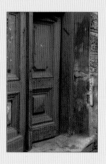

Photo 13

The obligation to fix a *mezuzah* to the doorposts of one's home is mentioned in Deuteronomy 6: 9 and 11: 20, in the context of the idea that the word of God should be present among Jews at all times. In Galicia it was often let into a specially prepared niche in the doorframe. This particular *mezuzah* trace, at 11 Zakątna Street in the city of Tarnów, was still visible in July 2001, but when I returned there in June 2005 the doorframe had been renovated and the *mezuzah* trace had vanished.

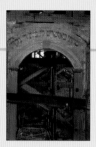

Photo 15

The inscription is intact except for just one Hebrew letter at the beginning of the quotation. The absence of that letter adds yet another layer of poignancy here: instead of the Hebrew word *samaḥti* (I rejoiced), the absence of the initial letter 's' causes it to look as if it reads *maḥiti*, a word meaning 'I wiped out', 'I obliterated'.

Photo 17

The Jewish cemetery in Zakopane, located in what is surely the most picturesque setting to be found in Poland, was consecrated in December 1931 at a ceremony in the local synagogue attended by the mayor, deputy mayor, and other local notables and which included prayers for the president of the Republic of Poland recited by the cantor of the nearby Jewish community of Nowy Targ; after the service the guests travelled out by sledge to the new cemetery (as reported in the Kraków newspaper *Nowy Dziennik*: see www.kirkuty.xip. pl/zakopaneang.htm). But the cemetery was used for only a little more than ten years. In 1942 the Germans

destroyed the wooden fence surrounding it and smashed the tombstones: the intention was that all trace that there was a Jewish community in Zakopane should disappear for ever.

In 2002 Ronald Weiser, the American ambassador to Slovakia, went on a visit to Zakopane. His family had emigrated from the town to the USA before the First World War, and so he decided to restore the cemetery. He re-fenced it and installed a fine Holocaust monument. In 2004 a ceremony was held to rededicate it, in the presence of the current mayor and local notables. Unfortunately there is still no road to the cemetery, which is on a hill some distance from the town centre and very hard to find.

To understand why Jewish communities such as that of Zakopane were not independent it needs to be recalled that being constituted as a Jewish community in Poland was a formal procedure requiring recognition from both the municipal and the Jewish authorities. When Galicia became a province of the Austrian empire at the end of the eighteenth century, there were 141 officially recognized local Jewish religious communities (totalling about 225,000 people); by the end of the nineteenth century the number (in the whole of Galicia) had grown to 257 communities, to accommodate a Jewish population which in the meantime had more than trebled in size (figures from Wynne 1998: 9–10). The Jews of Zakopane had their own rabbi from 1904, but he was appointed by the Jewish community of the town of Nowy Targ, some twelve miles away. The local Jews in Zakopane, who prospered greatly in interwar Poland and increased sixfold in number from the beginning of the 1920s until the end of the 1930s, wanted their independence

from Nowy Targ so as to set up their own community, but it was a long-drawn-out process. The community was finally established just before the German invasion in 1939—only to be destroyed one year later.

Today there is only one Jewish community in Polish Galicia—that of Kraków. (The town of Bielsko-Biała, which also has a Jewish community today, was a border town before the First World War; its main section, that of Bielsko, was then not in Galicia.)

2. Jewish Culture as It Once Was

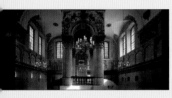

Photo 18

The sumptuously decorated interior of this synagogue offers a glimpse of an important Jewish value: the need to bring beauty into religious life for the purpose of glorifying God. Visual beauty in a synagogue is thought to provide an aesthetic source for the sense of awe that all people should have before God as their creator. In the Jewish mystical tradition a synagogue is understood to be a celestial palace in miniature, based on the biblical idea (Ezek. 11: 16) that in the lands of the diaspora where the Jews live God will dwell among his people in a 'small sanctuary'.

Specialists on the architectural history of the Polish synagogue speculate that both the architectural creativity in Polish synagogues in the seventeenth and eighteenth centuries and the artistic creativity in decorating their interiors can be attributed to the influence of the sixteenth-century kabbalist R. Yitzchak Luria (Piechotka and Piechotka 1959: 29). But it is not known when, where, or by whom the idea of surrounding the bimah with four columns was first introduced (Piechotka and Piechotka 2004: 26 n. 4), though it goes back to the second half of the sixteenth century. In the territory of Polish Galicia, synagogues of this structure were to be found for example in Tarnów, Przemyśl, Przeworsk, and Rzeszów (Piechotka and Piechotka 2004: 21; see also Loukomski 1947: 92; Piechotka and Piechotka 1999: 274–8). It might have been an architectural replication of the vision of Ezekiel (1: 4–28), where the throne of the Lord is described as having four supports. At any rate, the style of eight bays around a central tabernacle became typical of Polish synagogues down to the end of the eighteenth century. The codes of Jewish law throw only modest light on this: all that the Rema says (Oraḥ ḥayim 150: 5) is that the bimah should be placed halfway between the entry door and the aron hakodesh, so that the congregation will be able to hear the Torah reader properly. In modern times synagogues in the reform movements (such as the Tempel in Kraków; see photo 30) have tended to place the bimah next to the aron hakodesh, something which traditionalists found unacceptable as an unnecessary imitation of non-Jewish architectural styles.

There are two kinds of decorative element around the walls that the worshippers at this synagogue could gaze at, or even allow themselves to feel enveloped by: pictures of animals representing spiritual virtues (see for example photo 2 above) and texts of the liturgy. The very presence of Hebrew-language texts emphasizes the strongly literary quality of traditional Jewish culture, as conveyed not only through the Hebrew Bible but also through the compilations of the Talmud and the vast literature of its associated commentaries. Prayer in the Jewish tradition is also very much text-based rather than spontaneous, and relies on many layers of literary association and meaning. As for the depiction of animals (for example the pair of winged gryphons on the far wall, commonly found in Galician synagogues and on Galician tombstones, variously understood as signifying either the messianic age or the biblical sanctuary), it seems that not all rabbinical authorities were stringent in the application of the second of the Ten Commandments, which explicitly prohibits 'graven images', although certainly there were rabbis who did disapprove. Some rabbis even allowed into the synagogue representations of the human body, provided that the body was somehow incomplete, and on one side of this bimah in Łańcut there is a depiction of the biblical patriarch Abraham, about to offer up his son Isaac as a sacrifice—but their faces are concealed by branches. (For further reading on the art and architecture of the Polish synagogue, see Krinsky 1985 and Wischnitzer 1964; both of these books have good coverage of the synagogue of Łańcut.)

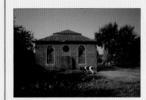

Photo 20

The word 'shtetl' (from the Yiddish for 'small town') is often taken as symbolic of village or small-town Jewish life in eastern Europe before the Holocaust, and it is the key word in the popular Jewish memory of this past. The image of a shtetl summons up a small-scale, cohesive, Yiddish-speaking Jewish community with daily life centring on a marketplace and its neighbouring streets, usually unpaved, with single-storey wooden houses and a small synagogue. The sheer quantity and density of such shtetls throughout eastern Europe, and the possibility of travelling by cart in one day from one shtetl to another, created the feeling of interconnected Jewish territory, particularly in Jewish nostalgic recollections.

The Jewish community of Galicia was certainly a 'Jewish territory' in that sense. It was one of the largest in nineteenth-century Europe, numbering 871,895—just under 11 per cent of the total population of 8,025,675 as recorded in the census of 1910 (the last census that was taken of Galicia as an autonomous political entity), and amounting to 66 per cent of all the Jews in the Austrian part of the Austro-Hungarian empire in that year. Jews were very substantially town-dwellers: in 1900, 71 per cent of Galician Jews lived in towns (mainly small market towns), as against 29 per cent in villages. This proportion was almost directly the opposite of the Christian populations (including Poles and, in eastern Galicia, Ruthenian-Ukrainians), who were largely rural or agrarian: only 16 per cent lived in towns, while 84 per cent lived in villages. On average, every third person in a Galician town in 1900 was a Jew, but there were large differences between individual places: there were many towns with very few Jews as well as many towns where the inhabitants of the Jewish shtetl constituted more than half or even

three-quarters of the population. The highest proportions in 1880 were in the small towns of Dukla and Tarnobrzeg, where 80 per cent of the population were Jews; in Kraków Jews then made up about 25 per cent of the population.

This high density of Jews in the towns was commonly mentioned by foreign visitors: for example, the 1905 edition of Baedeker's guidebook to Austria-Hungary, which devotes just fourteen pages to Galicia, has only one short introductory paragraph of general remarks about Galicia but draws attention in it to the fact that most of the inns, taverns, and shops belonged to Jews, and that 'the horse-dealers and carriage-owners are always Jews' (Baedeker 1905: 275). In a tourist guidebook to Galicia published in Lwów in 1914, the point is made that because trade in the small towns is largely in Jewish hands, visitors should be aware that on Saturdays all the shops are closed and the towns look deserted (Orłowicz 1914: 48).

Note that most of the Jews of Galicia lived in the larger, eastern Galicia (nearly all of which is today in Ukraine); only a quarter of Galician Jews (roughly 212,750) lived in western Galicia in 1910. For detailed demographic information on nineteenth-century Jewish Galicia, including analysis of the 1910 census figures, see Gąsowski 1992; his definition of 'towns' follows the legal or administrative specification rather than the looser usage based on size that is used elsewhere in this book. Probably there were thus more shtetl Jews living in 'villages' than he states.

During the latter part of the nineteenth century the shtetl was far from being a disappearing world, although it was undergoing considerable change. In fact the Jewish population in Galicia increased very substantially at that time: according to Gąsowski, in the thirty years between 1850 and 1880 the number of Jews actually doubled, from 333,451 to 686,596 (1992: 208). It was a faster rate of increase than among Christians — for many reasons, including better health, better diet, a younger age of marriage, a lower rate of heavy work among women, and because relatively more Jews lived in towns, where improvements in hygiene came earlier than in the countryside. But at the beginning of the twentieth century the Jewish growth rate in Galicia went into decline, probably because of the rise of emigration, whether to the large metropolises of the Austro-Hungarian empire such as Vienna or Budapest (by 1880 there were perhaps 10,000 Galician Jews in Vienna) or to the USA (well before the First World War there were perhaps 60,000 Jews from Galicia and neighbouring Bukovina in New York alone). The reasons for emigration were largely economic, rather than the violent antisemitism which triggered the large-scale emigrations from Russian Poland at that time. About 9,500 Jews would emigrate each year, with a total of as many as 300,000 between 1880 and 1914. The majority of Jewish migrants were artisans, especially tailors; it was largely the poor and the wealthy who stayed behind.

Thus at the end of the nineteenth century and the beginning of the twentieth the old cohesiveness of shtetl life began to disintegrate, not only because of the migrations to more prosperous places but also because of the beginnings of secularization in the Jewish community, reflected principally in the rise of political parties, notably Zionist and socialist, even in the smallest shtetls. The rabbis were no longer the sole source of communal authority and knowledge: lectures and cultural events, as well as a daily newspaper, now became common features in the shtetl, as were sports clubs, amateur theatres, libraries, modern Jewish schools, and youth movements, usually sponsored by the various Jewish political parties. But even as late as 1939, about two-fifths of all Polish Jews were still living in a small-town shtetl. For general descriptions of life in the shtetl, based on recent sociological research in Polish Galicia, see Orla-Bukowska 1994, 2004; and see also the note on photo 26 below. Samuel Kassow, in a very useful survey article (2008), makes the point that the shtetl was still such a potent symbol among Jews that in 1936 the Kraków poet Mordechai Gebirtig used the word as a symbol of Polish Jewry in his famous song 'Dos shtetl brent' (see the note on photo 56 below). Nowadays the word 'shtetl' has come to symbolize a lost world that was brutally destroyed in the Holocaust.

The village of Medyka, where this photo was taken, was in eastern Galicia. The southern part of the present-day international border between Poland and Ukraine roughly corresponds to the former administrative boundary between western and eastern Galicia, although included in Poland today is a small sliver of land formerly in eastern Galicia. Other than Medyka, all the places in 'Polish Galicia' referred to in this book were in western Galicia, except for Bełżec, Cieszanów, Lesko, Lubaczów, Narol, Przemyśl, Stary Dzików, Ustrzyki Dolne, and Wielkie Oczy, all of which were in eastern Galicia (and on which source material is to be found in volume 2 rather than volume 3 of Pinkas hakehilot: polin).

Photo 21

The city of Kraków emerged from the Second World War largely unscathed as far as its magnificent architectural heritage was concerned. Seven substantial synagogue buildings, as well as a number of batei midrash (prayer houses or private synagogues) are still standing in Kazimierz, the former Jewish quarter, and photographs of three of them can be found in this book: the Old Synagogue (photo 50), the Tempel (photo 30), and the Rema Synagogue (seen here). The remarkable survival of these synagogue buildings in a fairly small geographical area makes it possible for the present-day visitor to obtain a powerful sense of the reality of the Jewish past.

First and foremost among these historical landmarks is the synagogue of the Rema. Visitors familiar with his outstanding contribution to Jewish religious history often report a profound emotion on having the opportunity to pray in his synagogue and thereby to reconnect themselves with their spiritual heritage. No less emotional is the encounter with many of the graves in the adjoining cemetery, which dates from 1551 and is one of the oldest preserved Jewish cemeteries in Europe. Many famous rabbis, including the Rema himself, are buried here. The inscription on the tombstone of the Rema says of him that 'from Moses to Moses there was none like Moses' — meaning that until the time of the Rema, R. Moses Isserles, there was no

ne of a stature comparable to that of the ancient Jewish lawgiver Moses, as described in the Hebrew Bible (or perhaps the intention was to refer to R. Moses Maimonides as the Rema's illustrious twelfth-century predecessor).

In the Polish Jewish tradition it is normal for tombstone inscriptions to include lengthy elegies in praise of the deceased. On the tombstones of the leading rabbis buried in this cemetery these elegies often use particularly elevated language—for example, the seventeenth-century mystic R. Natan Nata Spira, known as the Megaleh Amukot (revealer of the depths), 'of whom it is said that [the prophet] Elijah spoke to him face to face'. The inscription on the tombstone of his wife Rosa has this to say: 'I will burst into tears a bitter cry, for the dear and modest woman, the rabbi's wife Rosa, daughter of Moses, an outstanding woman, a foundation stone. Who can describe her righteousness? [...] There was none like her, and her wisdom may not be found. At the time of our rejoicing, on [the Jewish festival of] Shemini Atseret, the diadem was removed and the crown taken away, the royal and glorious lady [...] her light was gathered, may God speedily comfort us.' (For the original Hebrew text see Alter 1987: ii. 332.) Amongst other important seventeenth-century rabbis buried in this cemetery are R. Yomtov Lipmann Heller, known as the Tosafot Yomtov; Joshua ben Joseph, known as the Meginei Shelomoh; and R. Joel Sirkes (see next photograph).

The cemetery also makes a vivid impression because of the extraordinary richness of the decorative stonework on the tombstones: fluted pilasters, Renaissance braids, cone-shaped pinnacles, rosettes of acanthus leaves, and stylized fruit, flower, and vegetable motifs, as well as representations of classical Jewish themes, such as outstretched hands (the gesture of priestly blessing), crowns for rabbis to symbolize their learning, mythical animals as messianic symbols of the eternal happiness promised for the world to come, and birds to symbolize the human soul on its way to God.

For brief details about this cemetery see Duda 1999; 82–95, a text which has been reprinted several times as a separate pamphlet; for more substantial details, including spiritual biographies, there is a useful guide written by the present rabbi of Kraków, Boaz Pash (Pash 2008), and for detailed scholarly studies see Hońdo 1999a, 1999b, and 2000. The cemetery was in use until 1800, when a new cemetery was opened in Miodowa Street (see photo 29); the art of decorative stonework continued into the twentieth century (for an example see photo 24).

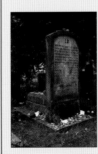

Photo 22

The standard edition of the Talmud used today was first printed in Vilnius by the Widow and Brothers Romm in the 1880s. The typical page has the Talmud text in the middle, surrounded on the left and right (and sometimes also at the foot) by two main commentaries of medieval French and German origin. The notes of R. Sirkes (*Hagahot habaḥ*) are one of a further dozen or so additional commentaries printed in the outer margins of the page. For a detailed description of the classic layout of a page of Talmud, see Steinsaltz 1989: 48–59.

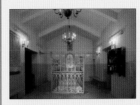

Photo 23

Each year, the Orthodox Jewish press routinely reports the anniversary pilgrimage as a newsworthy event, and there is little doubt that it is the largest annual Jewish pilgrimage to be found anywhere in Europe today. It attracts Jews particularly from Britain and Belgium (which contain the main centres of Orthodox Jewry in present-day Europe) and even from the USA. They usually stay in Poland not more than twenty-four hours, though in addition to the visit to the grave of R. Elimelekh of Lizhensk (as Leżajsk is known in Yiddish) the pilgrims make the most of their journey by travelling in taxis and minibuses through the night so as to visit the graves of other hasidic masters of Galicia in the nearby towns of Rymanów, Sieniawa, Dynów, Ropczyce, Łańcut, and Nowy Sącz.

Throughout the twenty-four hours of the anniversary the area immediately surrounding the Jewish cemetery at Leżajsk is lined with fleets of buses and full of human activity: crowds of pilgrims scurry on their way to the informal prayer-rooms set up for the purpose in neighbouring buildings for the recitation of the ordinary daily prayer services; huge quantities of hot kosher food are served up by volunteers in temporary canteens, and there are numerous vendors of religious souvenirs as well as men and women collecting money for Jewish charities. Inside the tiny *ohel* itself, there is an intense heat because of the large number of memorial candles and the crowds of pilgrims. There is quite a hubbub as they jostle each other in order to get close to the grave of the rabbi so they can recite psalms and other prayers, leave their petitionary requests written on slips of paper, and often use their mobile phones so as to allow their families back home to offer their own prayers direct to the source of the blessings.

To judge from memoirs, the scene is indeed highly evocative of how such occasions would have been before the war (albeit then without the mobile phones or the day-trippers from the USA), although unquestionably on a smaller scale. The recollections of Rabbi Zalman Lehrer of the pre-war pilgrimage to the grave of the hasidic master R. Hayim Halberstam in Nowy Sącz on the anniversary of his death do suggest a very similar picture, particularly on how transnational the pilgrimage was, attracting crowds of people from all over Europe (Lehrer and Strassman 1997: 75–80; on R. Hayim Halberstam, also known as the Tsanzer rebbe, see the note on photos 48 and 49 below). But in those days there were people selling special memorial candles next to the cemetery, as well as ritual specialists who wrote out pilgrims' petitionary requests on the spot (nowadays the pilgrims tend to bring all such things with them from home). Synagogue beadles from local communities were present to recite memorial prayers on behalf of those uneducated Jewish pilgrims who did not know such prayers by heart (nowadays there are no local Jewish

communities, and today's pilgrims are from circles that have a strong Jewish education). Entire families would come, streaming in from the surrounding villages (whereas today almost all the pilgrims have travelled in from foreign countries and so, perhaps because of the expense, they do not come in families but are mainly the male heads of household, sometimes accompanied by their sons, even if a small proportion come with their wives and daughters). Restaurants and hotels were full to capacity, and evidently there was such a very large range of vendors and market stalls with merchandise including clothing and shoes that local Jewish traders were able to make a living for several months just from the business they made on this one day. Perhaps the biggest difference from those days can thus be characterized in terms of the absence nowadays of local Jewish communities. For example, whereas local families would have arranged to meet each other at this very popular rendezvous in order to discuss marriage proposals, nowadays there are probably few such meetings, as they would normally take place in the pilgrims' home countries.

Still, despite such differences, important though they are, the atmosphere of Leżajsk at pilgrimage time does give a strong sense of a relationship with the past that is felt to be essentially unbroken.

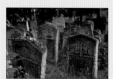

Photo 24

The miraculous survival of this Jewish cemetery of Lubaczów, with its hundreds of elaborately carved

tombstones bearing testimony to a rich Jewish artistic tradition, is the centrepiece of what was probably the first photographic album focusing on post-Holocaust Polish Galicia and in that sense the precursor of this book (see Gostyński 1973). The introductory essays and the commentaries accompanying the photographs draw attention specifically to the poignancy of the realization that (with the exception of the surviving synagogues of Kraków) the creativity and vitality of the Jewish life that existed in Galicia before the war is best seen nowadays in the cemeteries. It is a sad and sobering reflection on the enormous catastrophe, and the title Gostyński gave his book translates as 'It is the stones that tell the story . . .'. The research and photography for Gostyński's book were undertaken in the 1960s and supplemented by some splendid work by the renowned Polish photographer Adam Bujak; its sombre but at the same time uplifting design and style, including the use of apt quotations to accompany the photographs, are similar to those seen in the albums of Monika Krajewska (see the note on photo 72 below).

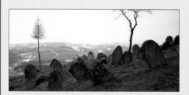

Photo 25

Hasidism suffered major setbacks towards the end of the nineteenth century, not only because of the rise of the competing ideologies of socialism and Zionism, but also because of the drift towards secularization and acculturation among the Jewish masses; gradually, it lost the attraction it had exercised half a century earlier.

Whereas it had originally been received as an innovative force, it increasingly came to be seen as conservative and reactionary. This was a new, unprecedented phenomenon for the rebbes, but they began to take steps to try to halt the erosion (see Assaf 2008: 668–9). At the beginning of the twentieth century a new political party was formed, eventually to be known as Agudas Yisroel, which regarded itself as the guardian of strictly Orthodox Jewry. In the period between the wars the party had several representatives in the Polish parliament, and it succeeded in obtaining a majority in 90 per cent of local Jewish communities in Poland in the 1931 Jewish community elections (Marcus 1983: 332). Another innovation was the founding of hasidic yeshivas (religious seminaries for young men); hitherto yeshivas had been the characteristic institutions of non-hasidic Judaism, which laid the emphasis on talmudic learning as the key to personal development and which (from its stronghold in Lithuania) had spearheaded the religious opposition to hasidism when it first appeared. But beginning in the 1880s the rebbes began to establish their own yeshivas, an initiative which in Galicia was principally the work of R. Shlomo Halberstam of Bobov, grandson of R. Hayim Halberstam of Nowy Sącz (on whom see the note on photos 48 and 49 below). His son Ben-Tsiyon succeeded him as Bobover rebbe and became a greatly admired hasidic leader principally perhaps because of his outreach activities and his concern for young Jews who were drifting away from religious Judaism. By the 1930s R. Ben-Tsiyon Halberstam had established a remarkable network of yeshivas in more than thirty towns and villages across western Galicia (for a full list see Goldman and Beigel 1991: ch. 1).

The trend away from hasidic Judaism, however, was unmistakable. According to one historian, Orthodox Jewry declined by as much as half during the twenty years of interwar Poland (1918–39): the extent of this abandonment of Orthodoxy, if not of religion also, reached a level that was unprecedented in eastern Europe outside Soviet Russia (Marcus 1983: 287). On the other hand, perhaps it was this experience of the challenges of modern twentieth-century life in pre-war Poland that enabled post-war hasidism to renew itself. During the Holocaust the centres of Galician hasidism were completely destroyed. R. Ben-Tsiyon Halberstam was murdered in Lwów in 1941, but his son Shlomo (1907–2000), who had directed his father's yeshivas, managed to escape from Europe and in 1946 reached the USA. There he successfully re-established the Bobov dynasty, making it one of the largest and most influential hasidic groups of modern times.

Historians and sociologists have wondered how hasidism has in fact managed not only to survive into the twenty-first century but also to thrive in new, faraway lands. It is clear that hasidim have developed a remarkable ability to adapt to the modern secular world, including modern forms of capitalism, and it may well be that the pre-war challenges that they valiantly attempted to confront set the pattern for what was to follow. The old east European place names, such as Bobov, live on, as do the characteristic hasidic style of dress, the use of Yiddish as an everyday spoken language, and continuing reference to the published writings of the hasidic masters, which are widely reprinted to this day. These are all, in their own way, signs of the traces of memory. But perhaps the most evident example of the survival of

the east European tradition is the regular pilgrimages made to the gravesites of the rebbes in Galicia (see the note on photo 23). Hence Bobowa still sees a regular flow of foreign Bobover hasidim (principally from the USA, but also from Belgium, the UK, and Israel) coming to the grave of R. Shlomo Halberstam.

The rebuilt *ohel* (mausoleum) in Bobowa is a plain construction, without decorative features. It does, however, possess windows, doubtless echoing the reported request of R. Menahem Mendel of Rymanów, when he was on his death-bed, that there should be windows in his mausoleum so that even after his death he could continue to keep an eye on the townsfolk and intercede for them 'before the Throne of Glory' (Alter 1987: ii. 405).

Photo 26

This courtyard was also used by Steven Spielberg in filming Jewish Kraków for his Holocaust film *Schindler's List*, notably for the very violent deportation scene when books, papers, suitcases, etc. were thrown from the windows and balconies. According to Spielberg's local guide Franciszek Palowski, this courtyard was chosen precisely because of its picturesque quality — as it had been by the Kraków Jewish photographer Ignacy Krieger a century earlier (Palowski [1994] 1996: 8). For Roman Vishniac's photo of the courtyard see Vishniac [1947] 1983: photo 10, where it is captioned 'The

entrance to Kazimierz, the old ghetto of Cracow, 1937'. In fact it was not the entrance to Kazimierz, nor is it correct to describe Kazimierz as a ghetto in 1937, although (somewhat confusingly) Spielberg chose to film the wartime Kraków ghetto in Kazimierz (see the note on photo 60 below). But in stating that this is the entrance to Kazimierz the caption does suggest the quasi-iconic status of this scene. An identical shot appears as photo no. 1 (facing p. 8) in Bałaban 1935, published two years before Vishniac took his photograph. It could be that Vishniac knew the published photo and decided to retake it himself, from a slightly different angle, but he does not acknowledge this in his book.

The proximity of the church is an important reminder that Jews and Christians coexisted in Kazimierz, as elsewhere in Poland, for many centuries; see also photo 24 above, which clearly shows a Christian cemetery directly adjacent to the Jewish cemetery. Jewish sources often convey the impression that in medieval and early modern times, and in some cases even into the twentieth century, Jews lived in a culturally autonomous world, free of outside influences or daily interaction with others; but the reality was more complex. Certainly there were churches even in those towns where Jews constituted the majority of the population. Poles and Jews (especially Jewish women) encountered each other in many contexts — for example, through childhood friendships, as neighbours in shared courtyards, in business dealings, or at the local post office, bank, town hall, or other municipal institution. Other than in contexts relating specifically to intercommunal violence, Jewish memories of life in the shtetl tend on the whole to exclude this aspect of daily contact with non-Jewish

neighbours, while Polish local histories similarly make only passing mention of Jews, even if they were the majority population.

There are very few histories of local towns in Galicia which take into account both Jewish and Christian experiences and points of view. Perhaps neither side knew very much about the other's religion in the theological sense, but they certainly knew about each other's religious festivals and ceremonies — for example, R. Joel Sirkes of Kraków explicitly noted in the seventeenth century that in the interests of good relations Jews have a duty to attend Christian funerals (cited in Rosman 1986: 22). Polish Jewry has often been imagined as the most 'Jewish' of Jewish communities, only minimally affected by its surroundings, but this is far from true, as Rosman has argued. For example, Jews shared with Poles a common attitude to folk medicine and the reliance on wonder-workers and faith healers; the architecture of the Polish synagogue clearly relied on local vernacular styles; Jewish clothing, food, and music were typically variations on conventional Polish styles, and in general for Polish Jews the aesthetic standard was Polish (Rosman 2002: 523–30). To put it in the words of Eva Hoffman: 'In the shtetl, pluralism was experienced not as ideology but as ordinary life. ... Jews trading horses in a small market town, speaking in haphazard Polish — that was the shtetl. Poles gradually picking up a few words of Yiddish and bits of Jewish lore — that was also the shtetl. Jewish bands playing at Polish weddings and local aristocrats getting financial advice and loans from their Jewish stewards — all that went into the making of the distinctive, mulchy mix that was shtetl culture' (Hoffman 1998:

12–13, cited in Orla-Bukowska 2004: 194–5).

Historians now recognize that the nature of the shtetl has thus been considerably mythologized and that there is a need for new social and economic histories of local towns to be written, focusing on both Jews and Christians and their contacts with each other. The shtetl was not, in reality, a 'Jewish town' or a totally Jewish space where Jews had full independence, in isolation from the non-Jewish environment. Legally and politically, there was no such thing as a shtetl anyway — what Jews called a shtetl might be a city, a town, or a village, depending on the law of the land; all localities were in any case run by municipal councils.

The problem may, for some, be confused with the fact that in the early days of Jewish settlement in Poland there indeed were 'Jewish towns', in the sense that Jewish communities could conduct their administrative affairs without any outside interference, and the community leadership or *kahal* (as it was called) was indeed a political corporation, run by an oligarchy of influential families who retained their dominance for generations. The *kahal* had its own judicial system (even its own gaols), collected taxes, and regulated economic affairs. Kazimierz, for example, was in that sense a 'Jewish town', although the definition can be argued. But all that was typical of pre-modern times, down to the seventeenth century, and has very little to do with the legal and political arrangements governing the shtetl as known in Austrian Galicia from the late eighteenth century onwards. From the very beginning of Austrian rule the autonomy of the *kahal* was significantly diminished (through the abolition of its powers or monopoly especially on

matters of taxation, education, and the judicial authority of rabbinic courts), in the interests of integrating Jews into majority society, including the introduction of conscription into the armed forces; in 1817 the *kahal* was formally abolished. The concept of a Jewish community was gradually redefined by central government to mean simply a religious community, whose power and authority eventually came to be limited to religious and charitable matters alone (for further details see the survey articles of Bartal and Polonsky 1999b, Manekin 2008, and Stanislawski 2008).

The idea of the shtetl as an autonomous Jewish cultural world thus rested on what was in fact a very attenuated set of legal and political realities imposed from the outside, although at one level it could perhaps be that Jewish folk memory projected onto the image of the shtetl a remembrance of much grander autonomy from earlier centuries; alternatively, the concept of the shtetl can simply be taken as a popular term for the local Jewish environment, without any conscious reference to this past at all. At any rate, the subject raises many theoretical and methodological questions for historians regarding assumptions about the embeddedness or otherwise of Jewish culture in its non-Jewish environment—whether, for example, diaspora Jewish culture can be understood on its own terms or whether it is essentially hybrid with that of the majority society and thus by definition needs to be understood (at least in part) in its local context. For important reviews of the topic see Polonsky 2004 and Rosman 2007: 82–110; on Jewish–Christian relations in sixteenth-century Kazimierz, see for example Petersen 2002.

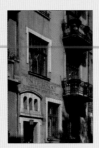

Photo 27

Pre-war Kraków also had numerous political, cultural, and sporting Jewish clubs, societies, and associations. There were altogether more than three hundred registered Jewish organizations in the city—good evidence of the astonishing vitality of Jewish life there, given that the Jewish population numbered only sixty thousand. Information about these organizations came clearly to light during the war, when the Germans systematically demanded declarations of their full details before shutting them down and confiscating their assets—bank accounts, buildings, valuables, furniture, books, and documents. Other than the large synagogues, most of these organizations were fairly small; Megadlei Yetomim, which had four multi-storey buildings in the city as well as substantial financial assets, was one of the more important ones. It was founded after an epidemic left sixty children orphaned. For an overview of the charitable institutions shut down by the Germans see Kielbicka 1986; on the founding of Megadlei Yetomim see Busak 1959: 99, although Busak says it was in 1848, not 1847 as Kielbicka demonstrates. A substantial amount of material has recently been published on Jewish life in pre-war Kraków, including one splendidly illustrated exhibition catalogue (Sabor, Zbroja, and Zimmerer 2007), a detailed scholarly study (Martin 2004), and a collection of memoirs and essays (Scharf 1996).

The Jews of interwar, independent Poland (1918–39) had considerable political liberties—to participate in politics (local and national, as well as their own political parties, including both socialist and Zionist programmes); they had a free press and the freedom to organize their own theatres, schools (Orthodox, Zionist, and Yiddishist), and other cultural activities. Hasidim were free to live the way they wanted, and Zionist youth movements were able to arrange vocational training in anticipation of their members leaving the country in order to live in Palestine (as it then was). Interwar Poland, in short, was a (relatively) free country which facilitated an extraordinary Jewish creativity and, thereby, the entry into modernity for many Polish Jews. On the other hand, Poland had in 1918 only just regained its independence after 150 years of foreign occupation and after the havoc and destruction during the First World War (particularly in eastern Galicia, which was a major battleground of the Austrian and Russian armies); it was determined to become a Polish nation-state, and as a result was unable or unwilling to absorb its very large Jewish population. So interwar Poland was a highly nationalistic, and in many ways an anti-Jewish, country, acting against Jewish interests.

There is a large literature on interwar Poland. For a brief survey that summarizes both sides of the picture as described in the previous paragraph, see an essay by Ezra Mendelsohn with the memorable title 'Interwar Poland: Good for the Jews or Bad for the Jews?' (Mendelsohn 1986); for further reading see Marcus 1983 and the encyclopedic collections edited by Gutman,

Mendelsohn, Reinharz, and Shmeruk (1989) and by Polonsky, Mendelsohn, and Tomaszewski (1994). The articles in the latter two books cover an extremely wide range, including Jewish involvement in national Polish politics, Jewish civil rights, economic issues, Jewish religious life, literary and cultural creativity, the social consciousness of young Jews, attitudes towards Jews in the Polish Catholic press, historiography, the treatment of the period in later memoirs, and Polish antisemitism (the subject of antisemitism in interwar Poland is returned to in the note on photo 63 below). For a full-length monograph on Zionist activity in interwar Poland, see Mendelsohn 1981. A magnificent photographic record of the period, covering religious life, social and political movements, education, trade schools, theatre, and cinema, as well as scholars, writers, artists, and musicians, can be found in Dobroszycki and Kirshenblatt-Gimblett 1977; for reproductions of postcards of the period see Silvain and Minczeles 1999.

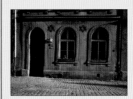

Photo 28

The inscriptions inside the Stars of David state that the Kove'a Itim Latorah *beit midrash* was founded in 1810 and restored in 1912. It is now a dwelling house, no longer in use as a *beit midrash*. A functioning *beit midrash* has, however, survived in the city of Nowy Sącz (see photo 48); another *beit midrash*, in a private apartment in the town of Dąbrowa Tarnowska and in regular use until its owner (Shmuel

Roth) died in 1995, has been turned into a small Jewish museum or 'memorial room' (*izba pamięci*), and one more *beit midrash*, in the town of Oświęcim, has been fully restored and is used for worship by visitors (on which see the note on photo 64 below).

The injunction to fix regular times for study is mentioned in the Talmud (*Shabat* 31a; *Avot* 1: 15). The figure of eighty *batei midrash* in pre-war Kraków comes from Duda (1999: 41).

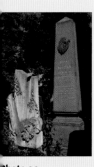

Photo 29

The tombstone seen here was erected in the 1970s (Rejduch-Samkowa and Samek 1995: 85), possibly on the centenary of Gottlieb's death. Another important painter buried in the cemetery is Artur Markowicz (1872–1934); he was born locally, and he specialized in portraying the world of the Jews of Galicia. There were many other Jewish artists active during this period who worked or who had been educated in Kraków, including Abraham Neumann (1873–1942), who studied at the Academy of Fine Arts in the city. Neumann was murdered in the Kraków ghetto (Duda 1999: 52) and therefore was not buried in this cemetery. It is important to recognize that, while the cemetery does give a good sense of the variety within Kraków Jewish society in the nineteenth and early twentieth centuries, nevertheless, because of the deportation and murder of virtually the entire Jewish community during the Holocaust (not to mention the devastation of the site, which was only partially restored after the war), the cemetery is very far from being a comprehensive record of pre-war Kraków Jewish life.

There are, however, a great many interesting and important graves still to be found here. To give a brief illustrative sample, these include the historian Zofia Ameisen (1897–1967), a woman who was both a professor and librarian at the Jagiellonian University in Kraków; Aron Kirschner (1849–1908), head doctor of the Jewish hospital in Kraków; Ignacy Krieger (1817–89), an important photographer who recorded a great deal of local Kraków architecture and many of its inhabitants, including Jews; Józef Sare (1850–1929), an architect by profession who was the first Jew to be vice-president of the city of Kraków (from 1905 until his death), and who has a street named after him; the philologist Leon Sternbach (1864–1940); and the doctor Jonatan Warschauer (1820–88), a firmly pro-Polish assimilationist, who also has a street named after him. In a pre-war publication the Jewish historian Majer Bałaban lists about fifty eminent Jews buried in the cemetery (1935: 103–6), but many of the tombstones he refers to were destroyed during the war; for a more detailed listing of currently existing stones see Duda 1999: 107–9. Prominent rabbis are well represented, including R. Kalonymus Kalman Epstein (1754–1823), a hasidic master known (from the title of his main book) as the Maor Vashemesh, who was a disciple of R. Elimelekh of Lizhensk (see caption to photo 23); R. Shimon Schreiber (Sofer), chief rabbi of Kraków from 1860 to 1883; his grandson R. Josef Nechemiah Kornitzer, chief rabbi of Kraków from 1925 to 1933; and his son R. Shemuel Shmelkes Kornitzer, the last chief rabbi of the city, who was murdered in Auschwitz in 1940 and whose ashes (rather exceptionally) were returned to Kraków and buried in the cemetery. The cemetery is still in use today and contains a fairly large number of post-war graves, as well as commemorative plaques and inscriptions for local people who were murdered in the Holocaust and whose final resting-place is unknown (see for example photo 44).

For statistics on staff and students at the Jagiellonian University, see for example *Pinkas hakehilot: polin* (Wein and Weiss 1984: 24, 31) and also Busak 1959: 99, 116; Duda 1999: 50. From the late nineteenth century there were a number of Jewish professors there, in a range of fields including medicine, papyrology, Greek and Roman law, philology, and biology (Duda 1999: 50). In the 1930s, antisemitic pressure led to the introduction of quotas in a number of faculties, and in 1937 Jewish students were even forced to sit on separate benches in the lecture halls. But in general the university was an important social setting conducive to Jewish students being able to develop friendships with non-Jews and obtain an education that facilitated assimilation into Polish culture.

The use of languages other than Hebrew on a tombstone inscription came about slowly in nineteenth-century Poland and was the source of considerable controversy at the time (see Jagodzińska, forthcoming). Even today, its use is discouraged by strictly Orthodox Jews. Certain compromises, however, were fairly common (and were in use in pre-war Poland, particularly in the smaller, traditional communities), such as restricting such inscriptions to the German or Polish name (and possibly the civil dates) of the deceased, and placing this information on the rear or foot of the tombstone. (Jews traditionally had biblical personal names, without any surname, though in eastern Europe from the end of the sixteenth century Yiddish personal names became commonly used. In 1787 the Jews of Galicia were obliged to adopt an official personal name and surname, usually either a German name or one based on a German word; for details see Wynne 1998: 13–15 or, more generally, Beider 2008.) But as Jews in the larger cities assimilated into wider society, the trend towards fuller use of a language other than Hebrew was unmistakable, and this included new kinds of information about the deceased: whereas Hebrew epitaphs concentrated on their religious virtues and spirituality, these new inscriptions also referred to their achievements in their secular lives — such as their occupations, professions, and public distinctions.

Polish became an official language in Galicia in 1869, following the new Austrian constitution two years earlier which established the Austro-Hungarian empire and granted citizenship and equality to all, including the Jews. Galicia became an autonomous province of the new Austro-Hungarian empire, and so the Jewish community found itself developing a new identity politics. The Jewish intelligentsia had been educated in German, and looked to Vienna for their political and cultural identity. Other politically minded Jews, especially those in Kraków, were less sure, and in the first elections to the Austrian parliament in the 1870s lobbied instead for a pro-Polish orientation; indeed, R. Shimon Sofer,

the chief rabbi of Kraków, who was elected to this parliament in 1879, specifically joined the Polish group there, stating that it was the Jewish religious duty to seek the welfare of the people among whom Jews lived, and that it was important to show gratitude to the Poles for providing a home to the Jews. He was ridiculed for this by his political opponents: one Viennese Jewish newspaper declared in 1870 that 'The Galician Jew neither thinks nor feels in Polish, and is, moreover, consistently opposed to all things Polish.' In fact R. Sofer, who was the son of the distinguished and influential R. Moses Sofer, known as the Hatam Sofer of Bratislava (until 1848 the capital city of Hungary and known as Pozsony or Pressburg), could not speak Polish at all. But his political orientation was ultimately vindicated. After 1869 the schools and universities in Galicia switched to Polish, and as the first generations of Jews emerged from Polish-language schools and began to read Polish-language newspapers and join various Polish-speaking associations, Polish came to replace German as the main cultural influence on the secularizing Jewish world in Galicia (see Manekin 1999).

Politically, Jews held the balance of power in autonomous Galicia. In 1869, out of a total population of 5,450,000 (i.e. including both east and west Galicia), there were three main groups: 2.5 million Poles, 2.3 million Ukrainians (or Ruthenians, as they were then known), and 0.6 million Jews. Whereas the Ukrainians consistently took anti-Jewish positions, the tactical alliances made by Jews, after some initial vacillation, were those of consistent loyalty to the Poles, who courted the Jewish vote in their ongoing struggles with the Ukrainians. At the turn of the century nationalist consciousness affected both Poles and Ukrainians,

and among the Jews a new interest in Zionism, opposed to assimilation, began to take root. Thus, at the beginning of the twentieth century there was polarization among the three main groups living in Galicia, marked by a considerable rise in political activity and the rise of radical political parties, particularly an ultra-conservative Polish religious political right wing, which complicated normal ethnic relations. At the end of the First World War, Poland regained its independence, and Galicia was incorporated into the new Polish state (see Buszko 1999).

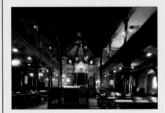

Photo 30

In the latter part of the nineteenth century associations for spreading modern Western culture among the Jews began to be founded in many towns across Galicia. In their growing admiration for local Polish society, some young people educated in Polish in government schools were beginning now even to feel alienated from traditional Jewish culture and wanted to find a place for themselves in wider society; indeed in Kraków there was a significant number of conversions to Christianity, especially among young women, at the rate of about thirty per year during the years between 1887 and 1900. But among those attached to the Progressive community in the city a new movement of national renaissance was beginning to take place, with an emphasis on the use of Hebrew (which

included books and newspapers in Hebrew). News reaching Kraków of the first new Jewish settlements in Palestine, established by Jews from Russia in the 1880s, made a great impression, and from the beginning of the 1890s Zionist associations were established in many places in western Galicia, with their main centre in Tarnów. For example, an association was founded in 1892 in Kraków whose members undertook to speak only in Hebrew to each other. The aims of such associations were to promote national Jewish sentiment and provide an intellectual base for the principle of national existence—on the basis not only of religion as such but rather through knowledge of Jewish history and literature, as well as of the Hebrew language. The appointment of Rabbi Thon in 1899 as preacher at the Tempel inaugurated an important new era in the history of the Zionist movement in Kraków. For further details of this period see Busak 1959: 112–17, and Wein and Weiss 1984: 24–5.

The Tempel was the third largest Progressive synagogue in Galicia, after Tarnopol and Lwów (Ternopil and L'viv, now in Ukraine). The oratory of Rabbi Thon's sermons was legendary, as was the outstanding singing of its cantor Josef Fischer, supported by a fine choir. A memoir from before the First World War reports how crowds used to flock to this synagogue to hear Fischer's singing and Thon's sermons. Even strictly Orthodox Jews would ignore their rabbis' bans on worshipping there and come in their droves to hear these two stars. At New Year and on the Day of Atonement, so the memoir says, the synagogue had such an atmosphere of elevated sanctity when Fischer and Thon were officiating that the worshippers could feel the Divine Presence (Geshuri 1959: 347–8).

Rabbi Thon died in 1936, and his tombstone can be found in the new cemetery in Miodowa Street. Along with many other tombstones from this cemetery, it was removed during the Holocaust period, but after the war it was recovered and then brought back to the cemetery (Duda 1999: 106–7).

The Jewish community of Kraków today is too small to support services except at the Rema Synagogue (see photo 21), and there is no organized Progressive community. The Tempel is thus used—principally for Orthodox services—when there are large groups of visitors in the city (hence the special installation of the central wooden *bimah*, in keeping with Orthodox practice, as seen in the photo), and for occasional concerts (especially during the annual Jewish Culture Festival, on which see photos 72 and 73).

3. The Holocaust: Sites of Massacre and Destruction

Photo 31

There were about 25,000 Jews in Tarnów in 1939 (45 per cent of the total population), though immediately after the outbreak of the war their numbers were swelled by refugees, mainly from Kraków and places further west, fleeing eastwards from the advancing Germans. In November 1939 almost all the synagogues of the town were burnt

own; all Jewish institutions, other than the Jewish orphanage and the Jewish hospital, were closed; and a Jewish council (*Judenrat*) was set up in order to fulfil German demands on the Jewish population, particularly the recruitment of Jews for forced labour. Over the next two years Jews were periodically arrested and killed, but there was no systematic mass murder. On 11 June 1942 came the first major operation of the impending genocide. Aided by units of Ukrainian police and auxiliary Polish police, the Germans rounded up many thousands of Jews in the city's main square; several hundred were killed on the spot through the continuous firing of machine guns. Babies were murdered in front of their parents, their heads smashed against the paving stones. On each of the next eight days, trainloads of Jews were sent off to be murdered in the death camp at Bełżec, and it was during this period that the mass murder in the forest took place.

The remaining Jews, together with Jews deported to Tarnów from neighbouring towns and villages, were then incarcerated in a closed ghetto. Through further deportations to Bełżec, as well as the shooting of several thousand Jews in the local Jewish cemetery, the population of the ghetto was steadily reduced over the next eighteen months, until the last remaining Jews were sent to Płaszów in February 1944 and the city declared *Judenrein* (empty of Jews).

What happened in the Buczyna forest outside the village of Zbylitowska Góra is not only profoundly symbolic of the horrors of the Holocaust; it is also an unsettling reminder of the limits of memory. Not only were those eight hundred children brutally murdered; their killers achieved the complete and intentional erasure of their innocent

lives from all memory. We shall never know anything about those eight hundred children; their memory is lost for ever. They inhabit, as Stephen Smith puts it, 'the forgotten places of the Holocaust' (Smith 2000: 4). Smith was the co-founder of the Beth Shalom Holocaust Memorial Centre, England's first memorial to commemorating the Holocaust; and his book, which explores the traces of memory in Poland, especially southern Poland, opens with a description of the exceptionally strong effect a visit to this forest had on him.

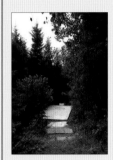

Photo 32

A small black memorial headstone at the top of the monument gives further details about this tragic episode. About thirty young Jewish men from the village were selected for deportation to the labour camp at Płaszów, but otherwise all the Jews of the village were murdered *in situ* by the German gendarmerie sent in for the purpose from the nearby towns of Jasło and Gorlice.

Mass shootings of Jews in forest locations near the towns and villages where they lived was a common occurrence in western Galicia throughout the Holocaust, although deportation to the main death camps of Bełżec in the east of the region and Auschwitz in the west claimed many more victims.

Photo 33

The Polish census of 1921 recorded the Jewish population of Pruchnik as 877 out of a total population of 1,697, or just a little over 50 per cent. In mid-September 1939 the Germans entered the village and immediately set about kidnapping Jews for forced labour, arresting prominent Jewish citizens, imposing large fines on the Jewish community, and looting Jewish shops. They then ordered the closure of all Jewish shops and confiscated four large lumber yards owned by Jews. Shortly afterwards, in November 1939, the Ukrainian mayor of the village ordered the Jews to be deported on carts to Zasanie, a suburb of the nearby city of Przemyśl, on the west bank of the River San, which at that time formed the border there between German-occupied Poland and Soviet-occupied Poland. The mayor had hoped to expel the Jews of his village across the river and out of the country, but the border was closed and the Soviet authorities refused to accept them. After languishing in an open field for two weeks, the Jews were eventually taken by the Germans to Kraków. From there many of them made their way back to Pruchnik, only to find their houses and shops ransacked, and in some cases taken over by Poles. Over the next two years Jews from neighbouring villages slowly made their way to Pruchnik, building up to a total of about six hundred people, living in very cramped conditions and in considerable poverty.

In July 1942, the Germans decided to bring the Jewish history of Pruchnik to an end: the Jews were loaded on to carts for a second time, taken to a transit camp in Pełkinie, and from there to the death camp at Bełżec, from where none returned. The Germans searched Pruchnik systematically for any remaining Jews; those who were found were immediately taken away to be shot. Fifteen Jews were kept behind to bury the corpses, but in September they too were sent away, to the ghetto in the nearby town of Sieniawa.

The above details from volume 3 of *Pinkas hakehilot: polin* (Wein and Weiss 1984: 294–5) make no mention of the shooting of the sixty-seven Jews as recorded on the monument here. A former Pruchnik Jew, seeing this photograph on display at the Galicia Jewish Museum, recognized the site immediately as the former Jewish cemetery, so it could be that the sixty-seven were those who had been discovered by the Germans after the expulsion of July 1942 (or perhaps including other Jews who were discovered in hiding later on in the war) and, following a common German pattern, were taken to the Jewish cemetery to be shot there, or at least to be buried there. This could explain why the account in *Pinkas hakehilot* makes no mention of a special incident.

The signpost on the left of the photograph bears the symbol conventionally used in Poland to mark the location of atrocities committed during the Second World War, particularly those that took place in the countryside.

The percentage figures for 1942–3 given in the caption are from Browning 1992: xv.

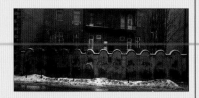

Photo 34

The German army entered Kraków on 6 September 1939. For the sixty thousand Jews who lived there, the world which they knew did not totally collapse overnight. It was a steady, relentless process, beginning with a flood of German edicts of increasing severity—for example, the order that all Jews had to wear armbands with the Star of David, then the marking of shops as Jewish-owned, then the surrendering of money and the confiscation of valuables. Then came the restriction of personal freedom: all Jews had to register; they were forbidden to change their address; they were not allowed to use the railways. All these orders (and scores of similar such edicts) were brutally enforced, and accompanied by harassment, raids, man-hunts, searches, and beatings. Jews were murdered by Germans from the very start of the occupation of Poland, but (in relative terms, i.e. relative to what happened later) the number of victims at that time was small. It was eighteen months, i.e. March 1941, before a closed ghetto was created (there were no such ghettos in pre-war Poland).

The conditions inside the ghetto were harsh and degrading; leaving the ghetto without a permit was treated as attempted escape, punishable by death. Slave labour detachments taken from the ghetto and put to work beyond normal human strength led to a rapidly rising death-rate. The Germans deliberately kept food in short supply, as part of their strategy to starve and dehumanize the imprisoned Jews.

There were two mass deportations out of the Kraków ghetto, in June and October 1942, principally to the death camp in Bełżec. The ghetto was finally liquidated in March 1943, amid rampages of extraordinary cruelty and ferocity, especially against women and children, the elderly and the sick: about a thousand people were killed on the spot and the others deported either to the new, specially built labour camp at Płaszów a mile or so away, or to Auschwitz. Post-war memoirs consistently describe the desolate and heartrending scene of the ghetto after the rampages: the empty flats from which people were dragged away, feathers flying from bedding ripped open (in case there was gold or diamonds hidden there), odd articles of clothing lost or abandoned, corpses of those who were shot or simply unable to keep up, and papers—single sheets or sheaves of pages strewn over staircases or carried off by the wind. After it was over, the corpses were removed and houses were ransacked for valuables; cleaning teams remained behind for several months to remove all traces of the ghetto. The ghetto walls, no longer necessary, were pulled down and the area opened up once again for normal residential living, but this time without its Jewish population.

It is hard to single out any one particular memoir of the many which have been written about the Kraków ghetto, but that of Tadeusz Pankiewicz, the Polish pharmacist who was the only non-Jew permitted by the Germans to maintain a pharmacy inside the ghetto and was thus an eyewitness to all the events that took place there, is a particularly important testimony (Pankiewicz [1947] 1987).

As for the idea that semi-circular arched tops on this wall are reminiscent of Jewish tombstones (a point which is widely made in Kraków nowadays: see for example Duda 1999: 114; Legutko-Ołownia 2004: 30), it is true that rounded tops to tombstones were fairly conventional in pre-war Poland, but the practice was far from universal. Tombstones could also be squared off with a flat top, or alternatively be given a triangulated top—photo 24 shows all three styles present in a single group of tombstones.

Photo 35

The ways in which Jews responded to the harsh conditions and moral dilemmas they faced during the Holocaust are impossible to judge nowadays. Attitudes vary. Some say that the Jews went 'like sheep to the slaughter' (i.e. did not sufficiently resist or try to escape). Others say that they went with dignity to their deaths (for example, religious Jews who believed that they were martyrs for their faith). There are also those who are considered heroes for their part in resistance activities. Some joined partisan groups or underground organizations, such as the Jewish combat organization in Kraków or the uprising in the Warsaw ghetto in 1943. Resistance activities also included making false documents, assisting with escapes, smuggling food into the ghettos, and arranging clandestine political meetings. There was also 'spiritual resistance': contributing to the surprisingly extensive educational, religious, and cultural Jewish life in the ghettos, and maintaining historical records about wartime events.

Given the wide variety of responses, generalizations true of all Jews are hard to formulate, especially regarding the period after the beginning of the mass murders in 1941; but it is likely that hope—the belief of individuals that somehow they would survive—was widespread. Of course, what we know today about the Holocaust was not known to Jews at the time: there was, so to speak, no banner accompanying the arriving Germans stating their intentions. Jews could have had no idea that the Germans would ultimately try to murder all of them, without exception. That was a crime without precedent, and sane people were incapable of conceiving such a nightmarish possibility. The rare survivors of mass shootings (or escapees from Auschwitz and other camps) were met with disbelief, and their stories were treated as the product of disturbed minds. In attempting to explain this, the historian Isaiah Trunk emphasizes that the whole genocidal scheme rested to a great extent on the elaborate German plan to keep it secret by using deceptive, euphemistic, and bureaucratic language throughout—'special treatment', 'resettlement', 'executive measures', and so on (Trunk 1979: 50 ff.). Ghettos were emptied in stages, so as to deceive the Jews into thinking that no total annihilation was intended; ghettos were sealed off, so that the inhabitants had no reliable information about what was happening in other places; even in the murder camps, lies and deceit (such as the fake showers) were used so as to keep the victims from knowing what was in store for them until the very last moment. In addition, the technique at the gathering points for deportation in the

owns and ghettos was to weaken the ictims by keeping them without water, r leaving them in rain or snow or under scorching sun, or else locked up in chools, synagogues, or churches, here they fainted and died because of eat, cold, thirst, or hunger.

raków's Jewish combat organization —known as Żydowska Organizacja ojowa (ŻOB)—was largely made up f young men and women from Zionist outh movements (including a group alled Hehalutz Halohem), whose embers before the war had been tudents, scouts, and sportsmen. he plaque seen here, which is on the treet outside the café (it is still a café), ives the date of their operation as hristmas Eve 1942, although on nother plaque, on the wall of the ewish community offices in Skawińska treet in Kraków, the date is given as 2, not 24, December. The leader of the roup was Aharon ('Dolek') Liebeskind, who together with the rest of the group as caught by the Gestapo early the ollowing month and put to death Duda 1999: 67). They all knew how opeless a battle it was: Liebeskind pparently remarked a few weeks efore his death that 'we are fighting or three lines in the history books' Gilbert 1986: 505–6).

n the words of Tarnów-born Zvi Ankori, he River San at that time separated not only two powers and two armies but also two worlds—the world of life and the world of death' (Ankori 2003: 152). That was certainly true at the time. But unfortunately many Jews who succeeded in escaping across the river, and who for example settled in Lwów (the former capital of Galicia, known in German as Lemberg, and today as L'viv in western Ukraine) enjoyed only a temporary respite: after the German attack on the Soviet Union in the summer of 1941, they once again came under German rule. Many other Jews were more lucky: the Russians deported many of these Polish Jewish refugees to places deeper within the USSR, many even to Siberia, and despite the hardships they endured there such Jews did at least avoid any further encounter with the Holocaust.

It is thought that as many as 250,000 Polish Jews escaped across the rivers Narew, Bug, and San into the USSR during the six weeks after Poland was partitioned between Hitler's Germany and Stalin's Russia in the autumn of 1939. They were not always escaping as refugees, but in many cases (Pruchnik, for example) they were being forcibly expelled from German-occupied Poland. In at least one city relatively close to the border (Tarnobrzeg), the Jews were ordered to assemble in the main square, were robbed of everything they had with them, and then sent east across the River San, many being murdered on the way (Gilbert 1986: 92).

The scene at the River San was a nightmare. Being killed while attempting to escape frequently happened here, as elsewhere, during the Holocaust. As one eyewitness recalled, 'We arrived at the River San on the third day of our exile. What happened there is difficult to describe. On the bank of the river Gestapo-men were waiting and driving people into a boat, or rather raft of two unbalanced boards, from which women and children fell into the river. We saw floating corpses everywhere; near the bank women stood in the water, holding their children above their heads and crying for help, to which the Gestapo-men answered by shooting. Blood, masses of floating corpses. It is impossible to describe the despair, shouts and helplessness of people in such a situation' (Apenszlak 1943: 143, cited in Gilbert 1986: 93).

For Holocaust survivor Mira Hamermesh, the crossing of the River San (which was successful in her case thanks to the assistance of an experienced smuggler) left such a profound impression that she chose to use her recollection of it in the title of her memoir: *The River of Angry Dogs* (2004). What she remembers most about her night-time escape was the chorus of barking dogs: 'the river itself seemed to be barking'. The smuggler had sent one other escapee ahead, a little further upstream, as a decoy. Hamermesh never found out what happened to him, even though she owes her life to him. Swimming across that river, she concludes, was a kind of baptism for her, though not one of purification. Ever since then, close proximity to a river reawakens in her an overpowering sense of guilt as the memory of the decoy resurfaces (2004: 66–73).

Photo 37

Bełżec was built for one purpose only— the murder of Jews by gassing. It is surely one of the most tragic killing fields ever known, the site of the first industrial genocide. Mass murder was committed with military precision on a massive scale, a human abattoir where the victims were delivered straight to their executioners.

The list of places from where Jews were transported to Bełżec, now cast in metal along the perimeter of a new memorial erected over the site in 2004 (see photo 54), reads like a gazetteer of the Jewish population centres of Galicia, both large and small (although Jews were brought to Bełżec also from Germany, Austria, and Czechoslovakia). Bełżec is geographically almost exactly central to the area from which the majority of its victims were deported—a region about 300 miles from east to west and about 200 miles from north to south, from as far as Nowy Targ, Kraków, and Tarnów in the west to Lwów (L'viv), Kołomyja (Kolomyya), and Tarnopol (Ternopil) in eastern Galicia, today in Ukraine. Bełżec began to function as a death camp on 17 March 1942 (a short while before the first transports of Jews came to Auschwitz), and it operated until December of that year, by which time it had become 'redundant'—in the sense that the bulk of the Jews of Galicia had by then been murdered. It was only after the camp at Bełżec had been closed down that the gas chambers in Auschwitz II (Birkenau) began to be put into operation (starting in the spring of 1943); only then did Auschwitz become the primary location of the mass murder of the Jews of Europe. But by then the Jews of Galicia were for the most part already dead.

The true nature of Bełżec was not at all apparent to the trainloads of arriving Jews, of whom there were often about four thousand per day. A 'welcome' speech to the new arrivals, indicating that they had been brought to the place in order to work, and that a delousing

bath was first required, was customarily given by the SS officer in charge. The Jews were told to undress and leave all their personal belongings on the ground. The men went first, ordered uphill to a building, screened off with trees, where the gas chamber was located; in the meantime the women were being shaved of their hair, which was to be recycled as insulation material. By the time the women were sent to be gassed, their menfolk were already dead. Infants whose mothers were not present to look after them, or those too ill or too weak to move from the railway siding, were taken to a reception area camouflaged to look like a field hospital so as to deceive the victims that medical assistance was at hand, when in fact, beyond it, out of sight, there was an execution pit, where they would simply be shot and tossed into a mass grave. There was an orchestra made up of prisoners, who were forced to play music throughout the gassings in order to drown out the screams and anguished cries of the victims.

Little is known in any detail about Bełżec because of the virtual absence of survivors—arriving Jews underwent no 'selection' as at other camps but were sent immediately on arrival to be gassed. One important Jewish source, however, is the testimony of Rudolf Reder, one of the very few who managed to escape and later gave a full report to the Jewish Historical Commission that was set up in Poland immediately after the war (the report was first published in Polish in 1946; for the full English-language text, together with historical notes by the translator, see Reder [1946] 2000). Chaim Hirszman, another survivor, joined a communist partisan unit and after the war worked for the NKVD (the Soviet secret police), but he was murdered in Lublin by members of a Polish anti-

communist, antisemitic organization before he completed his testimony about Bełżec. Other than R. Israel Spira, the hasidic rebbe of Bluzhov (Błażowa) in western Galicia (Eliach 1982: 114–16), there were very few other survivors. According to Robin O'Neil, a British scholar who has specialized in the subject, by the end of 1946 only six of the Jews taken to Bełżec were still alive (for this point, as well as for the description of the Bełżec camp given above, see O'Neil [2004] 2008: ch. 10).

It will never be known how many Jews were murdered in Bełżec, given that there was no registration procedure on their arrival. There have been many wild guesses, based mainly on the number of recorded transports (two hundred of them during those nine months) from specific railway embarkation points and speculations about the number of Jews in each such transport. The difficulty is that very few significant German documents have survived. The conventional estimate for many years was 600,000, later lowered to 500,000 and now estimated at between 435,000 and 450,000. Whatever the figure, it was a truly colossal number of victims to be murdered, in such a tiny space (approximately one square kilometre) and in such a short period of time. All the victims were Jews, except for approximately 1,500 ethnic Poles who were sent to Bełżec for hiding or assisting Jews, or for other supposed anti-Nazi behaviour. For an in-depth historical study of Bełżec on this issue, as well as on the history of Bełżec more generally, see Arad 1987; O'Neil [2004] 2008. Incidentally I continue to encounter those who confuse Bełżec with Belsen, or Bergen-Belsen, a camp in northern Germany with a completely different history altogether.

After the camp was closed down in December 1942, the gas chamber and barracks were demolished. The Germans made extraordinary efforts to dig up the mass graves and burn the bodies, and the entire area was covered with earth and planted with trees. The enormity of the crime that had been perpetrated in Bełżec was to be concealed for ever. A sense of loneliness and nothingness continues to pervade this terrifying, silent place.

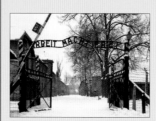

Photo 38

For the text of this announcement, by SS Captain Karl Fritzsch, the first Schutzhaftlagerführer (commander) of Auschwitz, who was then 37 years old, see Czech 1990: 13, 811, citing two slightly different versions. Fritzsch initially made this announcement on 14 June 1940, to the very first transport of prisoners to Auschwitz. The transport came from Tarnów and consisted of 728 Polish political prisoners; among them were a handful of Jews, including Maximilian Rozenbusz, the director of a local Jewish school. Of these 728, 137 in fact survived the war, none of them Jews (Gilbert 1986: 122, citing the Auschwitz museum archives). Auschwitz was initially used as a camp for Poles: those suspected of anti-Nazi activities (such as membership in the resistance), intellectuals, schoolteachers, and priests. It was some time later—in March 1942—that transports specifically of Jews began to

arrive. Auschwitz continued to function as a German concentration camp until was liberated by Soviet forces on 27 January 1945.

From the very start, Auschwitz served as a camp for slave labour, in addition to its role (considerably expanded in 1943) as a place of industrialized mass murder in gas chambers. This is where it differed from Bełżec, which had no labour camp attached but instead was set up principally for the gassing of prisoners immediately on their arrival. There were no survivors of the gas chambers. That is why so very few people survived Bełżec; the only way to survive was to escape, and that was nigh on impossible. In Auschwitz the situation was rather different. Out of a total of 1.3 million prisoners who entered the camp from June 1940 to January 1945 perhaps as many as 200,000 survived—notably including those prisoners who were transferred to other concentration camps, whether during the war or at the very end of the war (in which case they may have survived Auschwitz but may not have survived the war itself). (For these figures, and all Auschwitz figures given in these notes, see Piper 1991; as he explains at length, the subject is complex, and the historical records are incomplete. The figure of 1.1 million Auschwitz deaths is a conservative estimate; the actual figure may be as high as 1.5 million.)

To survive Auschwitz was thus theoretically possible, even if it was extremely difficult. It presupposed, first of all, not being sent to the gas chamber but rather being sent to the Auschwitz labour camp (or to a labour camp elsewhere). But the conditions of slave labour were exceptionally brutal. There was no recognition whatever of what we would today call human rights moreover, given that prisoners were

differentiated in the camp by nationality and other criteria, with different degrees of inhuman treatment applied to each group, there was scope for Jews to be routinely treated worst of all and to be done to death very rapidly. But the possibility that Auschwitz prisoners could become labourers at all meant that perhaps they could survive, or at least some for longer than others. Thus even by Commander Fritzsch's standards, the slogan *Arbeit Macht Frei* ('Work makes you free') over the entrance to the camp was cynical and deceitful, masking the true nature of the place.

What prisoners were ordered to do was in any case often not 'work' in the normal sense of the word: the aim was not productivity but rather to degrade and torment the prisoners, and by severely limiting food rations cause them to suffer an incessant, chronic hunger, to push them to the brink of total exhaustion. They were forced to perform tasks normally undertaken by machines, such as pulling heavily loaded wagons or carrying heavy railway sleepers back and forth, all at great speed. In such circumstances, prisoners were unable to last long: those who could no longer work were deemed superfluous, and would be taken away and killed; those who were initially able to keep up the brutal pace nevertheless eventually died of exhaustion or random beatings, unless they managed to be reallocated to a 'safer' unit charged with lighter work (and preferably working indoors), such as sorting the personal belongings of the arriving prisoners. Work in the concentration camp did not secure life, as it does in an ordinary peacetime environment; rather, it ruined life and indeed was designed to destroy it. It provided their guards, who were perfectly aware of the futility of the efforts of the prisoners, with endless

opportunities to subject them to humiliation, violence, terror, and torture. To some extent things changed at Auschwitz during the course of the war, when some prisoners were used productively, as slave labourers for the German wartime arms industry, for example, and prisoner labour was also used for the construction and expansion of the camp itself; but this was an exception rather than the rule. It is no coincidence that the slogan *Arbeit Macht Frei* was used at the entrance to quite a few Nazi concentration camps other than Auschwitz, and indeed can still be seen at the entries to Dachau, Gross-Rosen, Sachsenhausen, and the small fort at Theresienstadt, for example (for such photos, as well as details of prisoner labour in the concentration camps, see Reinartz and von Krockow 1995: 9, 25–7, 57, 177, 201, and see also Gutman 1994). It is true that at the beginning there were cases of Poles being sent to Auschwitz as a punitive measure and later released, but this was very far indeed from what usually happened. *Vernichtung durch Arbeit* ('annihilation through slave labour') would be a more accurate description, as indeed Fritzsch implied in his speech to the new arrivals.

Perhaps it should also be noted that the chilling message of *Arbeit Macht Frei* relates to a moral universe totally at odds with traditional Judaism. The central Jewish institution of the sabbath, during which any kind of work is completely forbidden, is what is understood in the Jewish tradition as the key to metaphysical freedom. Man is sustained by the spiritual, not the material alone. Work, or indeed any form of slavery to the material world, cannot bring freedom; it is precisely the sabbath, the divinely ordained abstention from work and the opportunity to find tranquillity,

serenity, peace, and repose, which brings freedom.

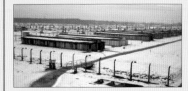

Photo 39

No one who was not present during those terrible times can say what Auschwitz was actually like. Even though so much of the physical fixtures has been left behind — watchtowers, barbed wire, prisoner barracks, and the ruins of the gas chambers — none of it can adequately convey the reality of the horrors enacted there daily.

There are many reasons why Auschwitz became so infamous, quite apart from the atrocities themselves. Auschwitz was the largest of all the German concentration camps. It was by far the single largest place of Jewish victimhood during the Holocaust: at least 960,000 Jews were murdered there. It was the most international, with citizens of virtually every country in German-occupied Europe being deported there, from the north of Norway to the south of France and the Greek islands. Jews constituted more than 90 per cent of the victims, but many other groups of people were also brought there and murdered: approximately 75,000 ethnic Poles, 21,000 Sinti and Roma (Gypsies), and 15,000 Soviet prisoners of war, as well as smaller groups of homosexuals, Jehovah's Witnesses, common criminals, and communists of a variety of nationalities — in turn causing Auschwitz to be inscribed into many different ethnic, national, political, and

religious histories. There were also large numbers of Auschwitz survivors who gave testimony or wrote memoirs of what happened there. Among them were people who became outstanding authors and reached wide audiences (Tadeusz Borowski, Charlotte Delbo, Viktor Frankl, Primo Levi, and Elie Wiesel, to name but a few). Finally, the fact that (in contrast to Bełżec) many of Auschwitz's buildings and installations survived has prompted ceremonies of all sorts to be held at the site (in recent years with substantial media coverage) and encouraged ordinary visitors to come in great numbers and see the place for themselves (on which see Section 5).

As is well known, Auschwitz has come to symbolize the Holocaust — and justifiably so, even if no more than about one-quarter of the six million Jews murdered during the Holocaust were murdered there. But in Auschwitz as nowhere else one can sense something of the pace and fury of the genocide, as well as its colossal size. The view of Auschwitz-Birkenau seen in this photo shows probably less than a quarter of the total extent of this camp.

A vast amount of scholarly literature has been published about Auschwitz. One important recent work, which brings together the results of research undertaken by specialists from the Auschwitz museum (which is where the study of Auschwitz has largely been centred since the war) as well as historians from Israel, the USA, and elsewhere, is Gutman and Berenbaum 1994. Published in association with the United States Holocaust Memorial Museum, it offers a detailed, comprehensive, and authoritative survey, including the history of the camp, the mechanism of destruction, the perpetrators, the inmates, the resistance, and wartime knowledge

about Auschwitz in the outside world. Reference to this work is given as appropriate in these notes.

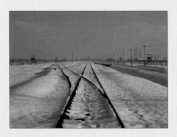

Photo 40

In 1942 the Germans decided to expand the Auschwitz camp and make it the main centre for the mass murder of the Jews of Europe. A new camp, considerably larger than the main camp (with its *Arbeit Macht Frei* entrance gate), was established in Birkenau, some two miles away. Two small existing buildings were initially adapted for use as gas chambers there, until eventually four large gas chambers were constructed, which began to be used in the spring of 1943. The railway spur seen in this photo was constructed some time later—in May 1944—principally to accommodate the extremely large number of Jewish deportees expected to arrive in Auschwitz from Hungary: 437,000, perhaps as many as 40 per cent of all Jews deported to Auschwitz. This extension of the railway line to a point immediately adjacent to two of the gas chambers in Birkenau and in close proximity to the other two was intended to speed up the process of mass murder: previously the prisoners destined for Birkenau had arrived about one mile away (roughly halfway between Birkenau and the original Auschwitz base camp), and it was there that the SS had decided who would be sent to the labour camp and who to the gas chambers. Thus the splitting of families took place not only in the setting seen in the photo but also at the so-called Alte Judenrampe ('former Jewish ramp') some distance away.

Most Jews who were deported to Auschwitz were carefully deceived by the Germans into thinking that they were being taken to a place where they would be 'resettled', i.e. where they could live and work in peace. Whatever their suspicions, the arriving prisoners had no idea of what really awaited them. For their part, the SS who ran the camp wanted to ensure that the operation of murdering their prisoners proceeded smoothly, rapidly, and without rioting. One technique which they used for that purpose was the mobilization of Jewish prisoners in special units (known as Sonderkommando), whose main job was to clean the gas chambers thoroughly after each batch of victims, burn the corpses in the crematoria, and finally dispose of their ashes. They had to work quickly so that the next batch of victims would see no traces of what had happened. But the Sonderkommando also briefly met their fellow Jews in their last moments while still alive, in supervising them as they were undressing immediately before they were forced into the gas chambers—the idea was to conceal what awaited them and to reassure them, in their own language, that all was well.

There were Jews in Auschwitz, in other words, who in that sense collaborated with the Germans so as to prolong their own lives, just as there were Jews in the ghettos who perhaps from the same motive carried out German orders to police the Jewish population and provide deportation lists. Such Jews thus had some of the characteristics of being simultaneously perpetrators and victims—a 'grey zone', as described by Primo Levi (1988: 22–51). These were tragic figures, who 'chose' such roles under great duress and would thereafter shoulder a considerable burden of guilt for their complicity. But it was part of the German technique: the moral corruption of the victims was a continuing element of the murder process throughout the Holocaust. Those who survived may have done so at the expense of others—starving prisoners may have stolen food from each other (Levi 1988: 56), to give a relatively simple example; and in the ghettos the Jewish leadership often agreed to deportations in the belief that others would thereby be saved. On the other hand, there are countless stories by survivors of Jews who refused any dealings with the Germans—Jewish councils which would not obey German orders at all, or Jews arriving in Auschwitz who were ordered to join the Sonderkommando but refused to do so and were therefore sent immediately to be gassed (Levi 1988: 41).

The whole subject of Jewish 'collaborators' is a complex one and remains sensitive and controversial. The classic work on the Jewish councils is by Isaiah Trunk ([1972] 1996). On the Sonderkommando see Greif 2005; he tracked down and interviewed several of the tiny handful of former Sonderkommando still living, and his commentary on the interviews emphasizes the horrific, unprecedented circumstances and therefore the need to suspend moral judgement about their behaviour, as Levi did before him (1988: 43). Indeed, Jewish public opinion, hitherto unequivocally critical of the Jewish councils and the Sonderkommando, has in recent years become more balanced and nuanced, and survivors with such backgrounds have begun to emerge from obscurity and appear in interviews in the media (Greif 2005: 79). Important in this context is the uprising of the Sonderkommando in Birkenau in 1944—the only case of armed resistance in the history of the camp, which succeeded in completely destroying one gas chamber and crematorium, although 451 Sonderkommando prisoners were killed in the process (for details see Greif 2005: 40–6).

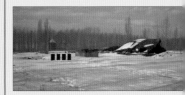

Photo 41

Each of the four buildings housing the gas chambers of Auschwitz-Birkenau also had its own crematorium where the corpses were burned—after first being exploited for economic purposes by having any gold teeth extracted and (in the case of women) their hair shaved off for reprocessing into felt for use in industry, for example for making ropes, mattresses, and socks for submarine crews. In contrast with the procedure at Bełżec, where women had their hair cut off just before entering the gas chamber, in Auschwitz the hair was cut from the heads of women who had already been gassed (see Strzelecki 1994: 259–61). If the crematoria were full to capacity, as often happened during the mass murder of the Jews of Hungary in the spring and early summer of 1944, the bodies were burned on pyres in the open air. The ashes were then unceremoniously scattered in nearby fields or dumped in ponds and rivers.

A special unit of prisoners met the arriving Jews at the railway line and

collected their belongings, while the Sonderkommando were on hand to assist the Jews in their final moments before entering the gas chamber, in keeping with the SS instruction to ensure that those moments were as tranquil as possible. There was nothing that they could do to save them anyway. Rudolf Höss, the commandant of the Auschwitz camp during most of its existence, relates in his autobiography (which he wrote in a Polish prison before being executed on the grounds of the camp in 1947) that in his inspections of those awaiting extermination he encountered a wide range of people: a mother who managed to joke with her children despite the terror in her eyes; a young woman in front of a gas chamber who very calmly helped the small children and elderly women undress; women who shrieked, tore their hair, and became totally hysterical; children who refused to enter the gas chamber; a man who hissed at him, 'Germany will pay a heavy penalty for the mass murder of the Jews'; and a Dutch Jew who gave him a list of Dutch families hiding Jews (cited in Trunk 1979: 56–7).

As the Red Army approached Auschwitz in the autumn and winter of 1944, the Germans stopped the gassings and tried instead to destroy the evidence of the mass murders in Birkenau. One gas chamber and crematorium had already been completely destroyed—as the result of an uprising of the Sonderkommando in October 1944. The Germans left the other three in ruins, in the desperate but unsuccessful attempt to conceal from the world the nature of the crimes committed there. The photo shows just one of these (Gas Chamber and Crematorium no. 2). The fact that these gas chambers now stand in ruins, and the reason why they are in ruins, have become part of the reality of this

appalling site of desolation and devastation, the largest cemetery ever known.

In the Jewish cemetery in Tarnów, where several thousand Jews were brought to be shot (see the note on photo 31), a memorial pillar has been erected with the inscription in Hebrew *hashemesh zareḥah velo bushah* ('the sun shone but was not ashamed'). The phrase echoes a line in 'The City of Slaughter', a famous poem by the Hebrew poet Hayim Nahman Bialik writing about a major anti-Jewish pogrom in 1903 in the city of Kishinev in Bessarabia (now Chișinău, capital of Moldova).

Photo 42

Thinking about the Holocaust in general, and in particular what happened in Auschwitz, involves confronting a number of immensely disturbing questions. For example, how was it possible that the mass murder of a defenceless minority was undertaken as the official state policy of a civilized European nation? How was it that local people, as well as major international agencies, stood by in silence as this minority was progressively humiliated and then taken away to be murdered? How could ordinary human beings commit such brutality? How could God have allowed this all to happen, even to more than a million children?

The ruins of the gas chambers do not in

themselves offer any answers; they merely shock us into asking questions. In any case, this gas chamber (which has been restored and partially reconstructed) survived only because the SS used it towards the end of the war as an air-raid shelter. Still, the surviving traces of the physical Auschwitz do speak to us of how the Holocaust has scarred our world. There is no closure to this story; the trauma it has inflicted remains unmastered. The Germans were demonic for having undermined the reputation of humanity, for having demonstrated that humanity's basic moral core to resist evil can falter and fail. The question for humanity, then, is whether the post-Holocaust world can be mended. For the Jews, the Holocaust represents the destruction of six million lives and of literally thousands of thriving communities across the continent of Europe, even if there were surviving remnants. Painstaking restoration has taken place, built up out of these remnants—but essentially Jewish life in occupied Europe was left in ruins.

It is a legacy of colossal challenges. The memorialization of the tragedy, and the education of the coming generations, form the subject of the next two sections of this book. As will be seen, there are a multitude of meanings and approaches. For many Jews the main lesson of Auschwitz is to demonstrate the need for a strong State of Israel and well-defended diaspora Jewish communities, protected from antisemitism. For today's Germans and Poles, the emphasis needs to be placed on a culture of dialogue and healing. But we are all affected by Auschwitz, in one way or another. 'Never again', the common, simple, two-word slogan, means different things to different people; but above all it means that

Auschwitz is not only about the past but a terrible warning for the future—that humanity must recognize its capacity to commit genocide and therefore needs to develop suitable responses based on a remembrance of what once took place there. The historical Auschwitz has a commanding voice; it may indeed keep us awake until the end of time.

4. How the Past is Being Remembered

Photo 43

Monuments using fragments of broken tombstones have been erected in many Jewish cemeteries in southern Poland, specifically in memory of the Holocaust. In some cases (in Brzozów or Milówka, for example) such fragments have merely been laid vertically into a bed of concrete. More commonly, they have been used as facing materials for a dedicated Holocaust monument—as for example in Bochnia, Myślenice, Oświęcim, and the Miodowa Street cemetery in Kraków. Presumably the sheer quantity of broken stones made it possible for a complete wall to be made, as seen in this photo.

The survivors did what they could with the materials that were available. In Brzozów the simple bed of concrete contains the smashed relics of about twenty stones—that is all that is left; there are no other stones in the

cemetery at all. Sometimes, where relatively intact stones were to be found, they were simply re-erected vertically in the cemetery on a new bed of concrete, in effect creating a lapidarium—a sort of museum of Jewish tombstones. The records had been destroyed, and so it was not possible to ascertain precisely where in the cemetery the graves that each stone commemorated were actually located. The regular, straight lines of such tombstone restorations typical of a lapidarium (for example, in Oświęcim) mean that of course the stones are not placed directly over the relevant graves and do not correspond to the people buried underneath.

What this cemetery work constitutes is thus simultaneously a monument to the Holocaust and a restatement of the site as a Jewish cemetery. It is both things at once. One could say that by lovingly piecing the fragments together in memory of their local communities the survivors were symbolically both binding up their wounds and reconsecrating the burial ground.

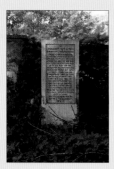

Photo 44

The tragedy of this one family, separated and murdered in different German camps, was replicated in hundreds of thousands of other Jewish families.

The precise dates of death are given on this stone for each family member because in the Jewish tradition it is important to recite prayers on the anniversary for the repose of the soul. Religious Jews take this duty very seriously, and indeed the Basak family (as the inscription mentions) is descended from distinguished rabbis. Jews thus made the effort, even during the war itself, to learn precisely what had happened to their relatives. Holocaust survivors also went to considerable lengths to try and find out the date of death of their relatives (especially important in the case of parents), so as to fulfil their religious duty. If it turned out, on the basis of later information, that a wrong date had been used, a rabbi would be consulted as to the correct ritual procedure (see for example Zimmels 1977: 154–5). After the Holocaust the rabbinate in Israel devised a generalized solution for those who had no idea about the date of death of their loved ones, although a different solution was resorted to in Hungary (Zimmels 1977: 158). A married woman whose husband had not returned also needed proof of his death if she wanted to remarry.

Erecting a special commemorative tombstone was not the only solution for memorializing the Holocaust dead in Poland. Very commonly, survivors added a brief inscription to an existing tombstone (where available), and in the Rema Synagogue in Kraków (which still functions as a synagogue to this day) there is the possibility of arranging a commemorative plaque with dates; the synagogue has many such inscriptions. One other phenomenon which should be mentioned is the practice of exhumation—of Jews who were shot by the Germans in villages or forests (for example, if they had been in hiding and were then subsequently

discovered) and buried in mass graves on the spot. There are a number of cases where survivors or the families of the victims returned after the war to exhume such corpses, give them a formal burial in a Jewish cemetery, and erect an appropriate tombstone. There are quite a few such tombstones in the Jewish cemeteries of Galicia, for example in Nowy Sącz and the Miodowa Street cemetery in Kraków, but also in smaller places such as Pilzno.

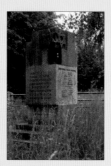

Photo 45

The lamentation wall in Kraków (photo 43) is on the inside of the cemetery wall and cannot be seen from the street. The street facade of the wall is plain brick, giving no hint whatever of what lies on the other side. Holocaust monuments in Poland have on the whole been private Jewish statements of loss, rather than public acknowledgements of what happened to the local Jewish citizenry.

There are some notable exceptions, however, particularly in Kraków (where there is a museum and an important new monument at the site of the former ghetto, in addition to such features as the remains of the ghetto wall, as seen in photo 34), as well as the sites of the former concentration camps as discussed below. In a number of towns where the Germans created a ghetto

(such as Kraków, Tarnów, or Rzeszów), a square has been renamed as Plac Bohaterów Getta (Heroes of the Ghetto Square), so in that sense it can be said that there is some local, publicly acknowledged memory of the catastrophe that befell the Jews during the German occupation. Another noteworthy case is that of Mielec. At the very beginning of the war, twenty Jews were forced into the synagogue there, which was then set on fire; the Jews were burnt alive and the synagogue burnt down. Today there is an obelisk in a small piece of parkland in the town centre marking the spot where the synagogue used to be, and there is a plaque attached to the obelisk describing what happened.

But these are exceptions: in general there has been no routine erection of public monuments as can be found, for example, in city after city in Germany and also (albeit to a much lesser extent) in Hungary and Slovakia. In recent years this has begun to change in Poland, as the memory of the Holocaust becomes an increasingly public concern rather than a private Jewish affair. So far quite a few local authorities have agreed to the installation of plaques in public places, although often as a result of foreign Jewish initiatives. (See also the note on photo 56.)

The daubing of neo-Nazi or other antisemitic graffiti on Holocaust monuments occurs in Poland, as indeed in many other countries. It is a particularly painful sight inside a Jewish cemetery in Poland, as for many Jews it brings to mind a long history of anti-Jewish disturbances—not to mention the Holocaust itself—in that country, as well as the antisemitic policies of the Polish government in the 1930s and post-Holocaust pogroms. It is common to find Jews today who

continue to stereotype Poles in this way, attributing to them much of the blame for the Holocaust. They say that the Poles' helped the Germans to kill Jews, and even that the Poles were worse than the Germans—either because they were cruel to the Jews purely for the pleasure of it, or because they were such committed antisemites that they taught the Germans how to practise anti-Jewish cruelty. The daubing of 'Nazi OK' on a Holocaust monument would seem to many Jews to confirm such feelings. However, anti-Jewish *violence* is in fact quite rare in present-day Poland; and anti-Jewish *sentiment* is probably no worse than in other European countries. (On this subject, see further the notes on photos 57, 58, and 63, and for a useful, wide-ranging collection of essays analysing anti-Polish stereotypes and recent trends in Polish–Jewish dialogue, see Cherry and Orla-Bukowska 2007.)

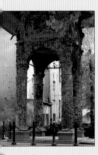

Photo 46

After the war the ruins of synagogues destroyed by the Germans survived for varying lengths of time, depending on their condition (whether they constituted a danger to passersby), whether there were any Jews who had returned to the locality, and whether the building could be reused in some way. Over the decades more and more were eventually pulled down, especially given the absence of

re-established Jewish communities from all but a handful of the large towns. Even listed buildings (i.e. those included in the pre-war Catalogue of Artistic Monuments), such as the eighteenth-century synagogue of Chrzanów, were demolished (Jagielski 1996: 91). In other words, what remains today is very far from what there was at the end of the war: it is not known how many synagogues and prayer-houses have disappeared. It is quite likely that Jews themselves agreed to the demolition of ruined synagogues after the war, or even that they actually sold the buildings (as frequently happened in Hungary). Disentangling who actually was responsible for the demolition is today no longer easy: the wartime devastation and the post-war demolition and clearance have become merged in the popular memory. The sites where these synagogues had stood were either built on or else just left as wasteland or grassed over as public open space. The survival of this *bimah* is thus all the more remarkable; there is no other such case in Polish Galicia. (For an appreciation of the important visual and architectural role of this kind of *bimah* in the Polish synagogue, see photo 18.)

A small Jewish community did re-establish itself in Tarnów after the war, but in the absence of any surviving synagogue buildings it held prayer services in a small apartment in the city centre. The community slowly dwindled, until it finally died out in the 1990s. The Torah scrolls were then sent to the Jewish community in Kraków, and the traditional synagogue fittings and furniture were taken to the local museum, where they have remained on display in tribute to the Jewish history of the city. Adam Bartosz, the director of this museum, has written extensively on the Jews of Tarnów, including a

detailed guidebook to the city's Jewish heritage sites (Bartosz 1992, 2007), and has taken a considerable personal interest in marking and preserving many of these sites, as well as organizing the concerts held at the *bimah*.

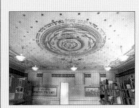

Photo 47

In the whole of Poland only about 250 pre-war synagogue buildings and prayer-houses have survived, of which more than sixty are to be found in Polish Galicia. Of these sixty, two are functioning synagogues (both in Kraków), one is a fully fledged Jewish museum (also in Kraków; see photo 50), and several other synagogues in Kraków have been restored to the Jewish community there. The fate of synagogue buildings in other places covers a wide range: many are still used as warehouses; others have been converted into use as libraries, art galleries, city archives, and schools. Some have been used for quite bizarre and inappropriate purposes—as cinemas, fire stations, shops, and restaurants, even in one case (Gorlice) as a bakery and in another case (Ahavat Re'im in Kraków) as an Orthodox church. The extraordinary case of Poznań in the north of Poland, where the synagogue was turned by the Germans into a swimming-pool (and where it is still used as a swimming-pool to this day), has no counterpart in Polish Galicia. For a basic listing and detailed survey see, respectively, Bergman and Jagielski 1990 and 1996,

although since those publications were prepared many of the uses have changed—and indeed continue to change. The authors, Eleonora Bergman and Jan Jagielski, of the Jewish Historical Institute in Warsaw, have for years been collecting material not only on surviving synagogue buildings throughout Poland but on all aspects of the 'traces of memory' covered in this book, including Jewish cemeteries and Holocaust memorials; they are certainly the leading authorities in Poland on the subject (for example, as co-authors of Gruber and Myers 1995). I am grateful to them for their generous help in enabling me to consult their extensive archive, a document from which provided the evidence for one of the comments about Niebylec below in this note.

The use of former synagogues for commercial or industrial purposes, for example as warehouses or garages, often entailed considerable damage to their internal structure, let alone the damage to their paintings; frequently the buildings were converted beyond recognition, with no sign whatever of their former use. For all these reasons, the village library/synagogue in Niebylec is really a treasure, especially given the total disappearance of the painted wooden synagogues that were a highly distinctive feature of traditional Polish Jewish life. For a detailed study of a magnificent painted wooden synagogue in eastern Galicia see Hubka 2003.

The painted ceiling rose seen here, complete with a representation of Leviathan biting its tail—a messianic image, used in quite a few synagogues in Galicia (for example in Łańcut and also in the synagogue in Strzyżów, which is today also a library)—is merely one element of a sophisticated iconographic programme using conventional motifs. Each wall had its

pictures. These include a painting of Jerusalem and its Wailing or Western Wall (seen here at the rear, on the western side of the synagogue), floral motifs over the arched windows, and a fully painted *aron hakodesh* surround containing theatrical *trompe l'œil* drawn-back curtains with a valance. The inscriptions indicate that the ceiling rose was painted in 1905/6 by the Jewish artist Eliezer Garfinkel from Sieniawa; his nephew, Aharon Yosef Garfinkel, continued the work in 1937. (Eliezer Garfinkel's brother is known to have painted similar murals in the Zasanie Synagogue in the city of Przemyśl.) It certainly says something about village Judaism in Poland that the tiny Jewish community of Niebylec, which in 1900 numbered only 343 people (exactly 50 per cent of the population, most of them farmers and petty traders), commissioned artists to decorate their place of worship. According to the librarian the paintings were restored in 1978. It is in fact clear that the paintings have been restored, since there are some minor errors in the Hebrew inscription over the Jerusalem panel, errors which would not have been made by the artist but rather by a restorer unfamiliar with Hebrew.

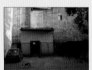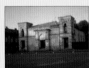

Photos 48 and 49

The Jewish community of Nowy Sącz, which goes back to the seventeenth century, was an important one. In the 1920s it numbered about nine thousand people, or approximately one-third of the total population of this city, and had a flourishing religious and cultural life, including a wide range of Zionist clubs and associations. Two

well-known Jewish historians came from here: Emanuel Ringelblum (1900–44), who set up the Oneg Shabbat archive in the Warsaw ghetto, and Raphael Mahler (1899–1977). In the 1840s the town (known in Yiddish as Tsanz) became home to the great hasidic leader R. Hayim Halberstam, still famous among hasidim the world over as the author of a work called *Divrei ḥayim*. Known also as the Tsanzer rebbe, R. Hayim had a profound impact on the whole region, making the city an important hasidic centre for the whole of Galicia, attracting large numbers of pilgrims from across the Austro-Hungarian empire and beyond, especially on the main Jewish festivals (on hasidic pilgrimage to his grave see the note on photo 23). R. Hayim founded a dynasty: his descendants established hasidic communities throughout western Galicia, including Sieniawa, Bobowa (Bobov), Chrzanów, Cieszanów, Grybów, Gorlice, and Tarnów. All this came to an abrupt end during the Holocaust. Many of the Jews of Nowy Sącz were shot in the Jewish cemetery, but most were deported to Bełżec in August 1942, and in July 1943 the Germans declared the city *Judenrein*—empty of Jews.

After the Holocaust, a small number of survivors returned to the town and re-established a community; but in consequence of the antisemitic campaign of the Polish communist government in 1968, when many thousands of Jews from all across Poland were forced to leave the country, the community collapsed. For an evaluation of the events of 1968 see Głuchowski and Polonsky 2009.

Almost all trace of the many pre-war synagogues and prayer-houses of Nowy Sącz has disappeared. Before the war, the broad open square in front of the large synagogue (now functioning as a car park) in fact contained another

substantial synagogue which has now vanished, as has R. Hayim Halberstam's own *beit midrash*. But it is important to draw attention to the fact that, through its name, the art gallery preserves the memory of the city's main synagogue—even if there is nothing remaining inside this eighteenth-century building to indicate that it was once a synagogue. (Although careful scrutiny of the front elevation would suggest this: the central door was the entry for men, and the two side doors the entries for women.) Elsewhere such memory has largely been erased: synagogues now used for other purposes are by no means routinely labelled in the way that has been done in Nowy Sącz. There are honourable exceptions—at the two main synagogues in Rzeszów, for example—and as early as the 1960s official plaques were being erected on some state-owned buildings such as libraries and art galleries indicating that they were once synagogues and identifying them as historical monuments. In recent years this is becoming increasingly common, although there are often difficulties if the building is now privately owned. But there is no nationwide policy of memorializing former synagogues now used as shops, restaurants, offices, and cinemas by affixing a plaque, or in any other way.

The Nowy Sącz synagogue/art gallery also has a plaque on the main facade in memory of the Jews of the city and surrounding villages who were murdered in the Holocaust. It was put up in 1994 by the association of former Jewish inhabitants of the city now living in Israel. Commemorative plaques of this sort in a public space are still relatively rare in Polish Galicia (although see, for example, the note on photo 1), but the associations of former inhabitants committed to such memory work (also commonly

involving publication of a memorial volume for their home town) has undoubtedly helped in ensuring appropriate, ongoing public remembrance.

The small lean-to shed serving as the present-day 'Synagogue of Nowy Sącz' is an original pre-war *beit midrash* consisting of just one small room. It was founded by Rivke Krisher in 1924 in memory of her late husband Natan Krisher, and after the war was in regular use until 1968. Jacob Miller, a Jew from Nowy Sącz who survived the Holocaust (the only member of his large family to do so), went back to his home town, but was forced to emigrate to Sweden in 1968. He returned to Poland in 1989 and took upon himself the work of restoring this building as well as looking after the Jewish cemetery, which contains R. Hayim Halberstam's grave. Rabbi Zalman Lehrer, a follower of the Tsanzer rebbe born in the city and now a prominent member of the Jewish community of Antwerp (Belgium), supported Jacob Miller in restoring the *beit midrash*. Now very elderly, Jacob Miller is—tragically—the only local person who worships here. (On pre-war Orthodox Jewish life in Nowy Sącz see Lehrer and Strassman 1997.)

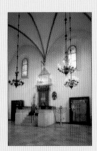

Photo 50

The Old Synagogue museum inherited relatively little from the pre-war collections of precious objects held in Kraków's synagogues and by private

llectors: these were systematically ooted by the Germans in December 939, according to the museum's irector (Duda 1999: 62). Duda's olleague, Elżbieta Długosz, who urated an exhibition on hasidism at he museum in 2005, points out in the xhibition catalogue that despite the biquitous presence of hasidim in pre- ar Poland, very little of their portable aterial culture survived except for ooks of their published writings, some ems of clothing, and pictures of asidim (drawings, paintings, and hotographs). She was able to find just handful of other items of hasidic rovenance from Galicia to put on splay; one of these, an authentic pre- ar seal of R. Yehoshua Halberstam of ochnia, had to be borrowed from the cal museum in Bochnia (Długosz 005). In fact, the richest collections of alician Judaica in pre-war Poland were robably not in Kraków anyway but ther in Lwów (today L'viv in Ukraine), t the Museum of Artistic Crafts. In ecent years this museum has mounted avelling exhibitions displaying many f its astonishing holdings, coming to raków in 1993 and Gdańsk in 2006. ee Skromak et al. 2006 for a lavishly ustrated catalogue covering an xceptionally wide range.)

he National Museum in Kraków had a odest collection of Judaica before the ar, and it survived thanks to having een packed away in boxes and stored the cellar. Today it is one of the rgest collections of Judaica in Poland, onsisting of about four hundred items. significant part was purchased by the inistry of Religious Affairs and Public ducation before the war; many items ere acquired with the help of Jewish ntique dealers who acted as termediaries to purchase objects om Galician synagogues. (For a brief ublished source on this Judaica ollection, see Lebet-Minakowska

2004.) On display are some fine pieces from Polish Galicia, including a handwashing laver from Nowy Wiśnicz, a wooden turret-shaped spice-box made in Kraków in 1861, a nineteenth- century wooden Hanukah menorah from Przeworsk, a twentieth-century Hanukah *dreidl* from Kraków, an eighteenth-century *yad* (Torah pointer) from Kraków, an early nineteenth- century circumcision knife from Jarosław, and a pair of eighteenth- century Torah finials from Chrzanów. The museum also has a small collection of papercuts that were traditionally displayed in the windows of Jewish houses during the festival of Shavuot.

There are small exhibitions of Judaica in many towns of Polish Galicia today, usually as a single showcase or two in the local museum (such as in Chrzanów, Nowy Sącz, or Tarnów). Unfortunately, relatively little of antiquarian interest is on display; much was destroyed during the war, and anything of value would seem to have been sold off to dealers. On the other hand, in these provincial settings the fragments that have been left behind (fragments of Torah scrolls or *mezuzah* parchments, photographs of unknown bearded Jews) have sometimes been meticulously preserved for what they are—traces of a vanished culture. In the tiny hamlet of Zyndranowa (south of Dukla, a couple of miles from the Slovak border), local people have made a small museum of such fragments, including a number of Jewish tombstones they found in the river. In Pilzno a local enthusiast of model- making has reconstructed an entire Polish village in miniature, including its Jewish elements: there is an excellent copy of the synagogue in Bobowa (complete with carved miniatures of hasidic worshippers) and a small Jewish cemetery with

Hebrew inscriptions on the miniature tombstones. In Rymanów, a doctor who was on particularly good terms with the local Jewish community had his own personal collection of Judaica in his private home which he was fond of showing to his visitors: sabbath candlesticks, Hanukah menorahs, even ornamental silver collars for the *tales* (prayer-shawl)—a speciality of Sasów in eastern Galicia. Visitors came away astonished at the encounter with him, as is revealed by the entries in his visitors' book, for example: 'I cannot express what a moving experience it was to meet you and your wonderful family here in Rymanów. How marvellous it is to meet people who respond so completely to the longing of the Jewish people for understanding . . .'.

Photo 51

The Auschwitz museum, which was officially created in 1947 by an act of the Polish parliament, occupies a small part of the forty square kilometres that during the war constituted the zone of the camp (*Interessengebiet*), though it includes the Auschwitz main camp and its primary subsidiary camp, Auschwitz-Birkenau (sometimes shortened in these notes to 'Birkenau'). Most of the barracks of the main camp have been converted into museum spaces for the benefit of visitors. The museum's historical exhibitions cover a wide range of themes—the history, functioning, and

administration of the camp, including the conditions of the slave labourers, resistance activities, and the plunder of Jewish property. A number of showcases display original artefacts that were left behind when Auschwitz was hurriedly evacuated in January 1945 in the face of advancing Soviet troops. These include vast piles of hair that was shorn off the heads of women's corpses before they were burnt in the crematoria. Other showcases exhibit suitcases, shoes, spectacles, and indeed a whole range of ordinary personal possessions that deportees had brought with them. The showcase seen here is one of these displays—the only one, in fact, which relates directly to the Jewish identity of the victims.

The testimonies related by Auschwitz survivors who were religious Jews refer repeatedly to the importance of their faith in helping them keep up their spirits in those appalling times. Certainly there were religious Jews who felt that for some reason they had been abandoned by God, who was no longer worthy of their prayers, and doubtless there were others who, if they were able to give any serious thought to the matter, vacillated in their attitude. But there were also many others who scorned their executioners and did what they could to pray, engage in the study of religious texts (which they now had access to only from memory), and otherwise maintain their religious and cultural dignity—'let them proceed with their business, and we shall proceed with ours', to cite a classic formulation of the idea, uttered by a young hasidic Jew in a cellar in Kraków while the Germans paced overhead (Schindler 1990: 187 n. 29). In some cases they even regarded themselves as having the unique opportunity to practise martyrdom for their faith.

It is not always clear from survivor testimonies whether such Jews rationally understood that according to Jewish law they would not have been expected to put their lives in unnecessary danger in order to fulfil a religious duty—for example, risking the murderous anger of a German guard by attempting to recite the daily prayers or observe the sabbath or other Jewish festival. Indeed, there are many examples in these testimonies of religious Jews heroically doing precisely that—living in their own world as best they could, regardless of the consequences.

The memoirs of R. Zvi Hirsch Meisels, a distinguished rabbi and Talmud scholar from the town of Vac in Hungary who was deported to Auschwitz in 1944 and went on to survive the war, indicate that he was one such person. Among the many heroic stories he describes is how he went to great effort to locate the *taleisim* that had been taken away from the deportees on their arrival at the camp. He was anxious to find his own *talis*, which he had inherited from his grandfather. He found it, brought it back to his barrack, and cut it down in such a way that he could wear it under his prisoner's uniform. Eventually the *kapo* (prisoner in charge) of his barrack realized he had something underneath his uniform and started to beat him. When R. Meisels said it was a religious garment that he had brought with him from home, the *kapo* shouted at him, and asked him where his God was. Meisels replied that, just as a surgeon performs incisions before an operation on a sick person, so God makes incisions on the Jewish people; the ignorant onlooker would not understand the purpose of either kind of incision. One cannot understand God's ways, or even try to understand them. If one tried, then God might say,

'If you don't understand, just come up to Heaven and I'll explain it to you.' He continued: 'Don't ask too many questions, or they may invite you upstairs to listen to the answers.' The *kapo* scowled and said to the rabbi, 'You are a clever Jew; you can leave in peace . . .'. And that is how R. Meisels wore his cut-down *talis* until just a few days before liberation. (See Rosenbaum 1976: 85–7.)

The consequences of the Holocaust as a formal theological challenge for Jewish religious thought have been written about extensively in the decades since the war; for one recent survey, see Katz, Biderman, and Greenberg 2007. At a more popular level, collections of stories about religious heroism, or 'spiritual resistance' as it is sometimes called, have become an important defining genre in the growing Orthodox Jewish 'inspirational' literature on the Holocaust, which essentially seeks to demonstrate that the six million Jews who died did not go mindlessly 'like sheep to the slaughter'. Probably the first and most widely read hasidic author who contributed to this field was Moshe Prager; his main work, *Nitsotsei gevurah* ('sparks of heroism'), was assembled on the basis of interviews in displaced persons' camps and published in Hebrew in 1952, though it was more than twenty years before an English version (Prager 1974) appeared. The Kaliver rebbe, a Hungarian hasidic leader who survived Auschwitz, encouraged his followers to put together an 'encyclopedia' on the subject, which also contains Holocaust biographies of rabbinical personalities, including many from Galicia (Kaliv World Center 2002). For a review of some of these materials see Webber 2000a.

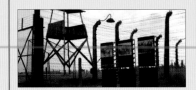

Photo 52

The conservation of the Auschwitz site undertaken in the first decades after the war was undoubtedly not done to present-day standards—for example, the restoration work on the gas chamber of the Auschwitz main camp, after it had been converted by the SS towards the end of the war into an air-raid shelter (see photo 42), was somewhat clumsy. More care was taken in later years, notably including the use of original materials in the restoration of the wooden watchtowers, and great care has been exercised recently in finding a suitable technique to restore the original concrete posts supporting the barbed wire fences.

The principal difficulty throughout is that the Birkenau camp was not built to last; on the contrary, the design and materials used for the wooden barracks were simply adopted wholesale from temporary structures used by the German army during the war for the stabling of horses. It is also not clear what the objectives ought to be: how far, for example, should the ruins of the gas chambers in Birkenau (see photo 41) be preserved as ruins? Should they be at least partially reconstructed? To find conservation solutions for this wide range of problems is far from straightforward, not to mention the huge costs involved. There is no entry charge for visitors to the museum. The Polish Ministry of Culture has paid for the museum's budget from the start; significant support began to come from other sources only in the 1990s, when a number of European governments,

including Germany, agreed to make contributions. For a useful overview of some of the complex conservation issues faced by the museum, written by the former chairman of the conservation committee of the International Auschwitz Council, see Rymaszewski 2003: 113–32.

Another, quite different, problem concerns the fact that in addition to its museological role to educate future generations about the Holocaust, Auschwitz is also a cemetery, probably the largest cemetery ever to exist. It is hard to combine both roles at the same site. The view that I have long advocated (as a member of the International Auschwitz Council) is that part of Birkenau—probably the fields at the edge of the camp where the ashes of hundreds of thousands of the cremated victims were simply scattered—ought to be reserved as a formally consecrated cemetery, something similar to a military cemetery but where victims' families and community organizations would be allowed to erect their own memorial tombstones, so that the individuals who were murdered in Auschwitz can at least be remembered by name, and with respect (for an elaboration of this view see Webber 2006: 60). One noteworthy gesture in this direction is the new permanent exhibition mounted in Birkenau in the building where prisoners selected by the SS for the labour camp were given a delousing shower and had a number tattooed on their arms. In this building, known in the camp jargon as the 'Sauna', prisoners were stripped of their identity and given a number instead. The new exhibition in the Sauna consists of hundreds of photographs of Jews, with whatever could be reconstructed of their names, personal details, and family histories. These photos, which had been brought to Auschwitz by the

eportees, were found after the war, nd—very appropriately—have now een mounted as a display in the same uilding which during the war had been evoted to depriving them of their entities. In that sense it is a true estoration.

he photographs displayed on these ll-weather stands were taken by the S during 1944 and were discovered fter the war by an Auschwitz survivor amed Lili Jacob, completely by chance nd in another camp altogether. They onstitute a unique and very powerful ocumentary record, although they ere taken by the SS for their own urposes and not at all for post-war storical memorialization, which is ow they are usually understood today. here are numerous surviving hotographs from Auschwitz other an these, most notably a small series f clandestine photographs taken by risoners themselves on a camera that ad been smuggled into the camp. For full account of the subject, see for xample Świebocka, Webber, and Vilsack 1993.

hoto 53

should be said (for the avoidance of onfusion) that Block 27 has no trinsic historical significance as aving functioned as a uniquely Jewish arrack during the war, nor was it just in is barrack that Jews were imprisoned. ather it is one of several barracks that e Auschwitz museum has reserved r exhibitions that allow the story of uschwitz to be told from different

national perspectives (Austrian, Dutch, French, Hungarian, Italian, etc.). Block 27 is the exhibition space devoted to Jewish victimhood in Auschwitz. Within the building, one room has been suitably equipped as a memorial shrine for the benefit of Jewish visitors wishing to pray and meditate, helping to confirm Block 27 as a legitimately Jewish memorial space. In 2003 the then president of Israel, Moshe Katzav, installed a further memorial outside the building, this time in the form of a birch tree; an accompanying plaque indicates that its purpose was to commemorate the sixtieth anniversary of the Warsaw Ghetto Uprising and to acknowledge Jewish resistance generally during the Holocaust. Indeed, behind the 1998 Israeli memorial stone is a plaque on the outside wall of Block 27, in memory of four female Jewish prisoners (Ella Gertner, Roza Robota, Regina Safirsztain, and Esther Wajcblum) who were publicly hanged in the Auschwitz women's camp on 6 January 1945, three weeks before the camp's liberation, for their resistance activities in Auschwitz—in particular, their contribution to the uprising of the Jewish Sonderkommando in October 1944 which succeeded in burning down one complete gas chamber and crematorium in Birkenau (see Czech 1990: 775 and Greif 2005: 46, 372 n. 53, with slightly different spellings of the women's names).

Auschwitz has very few plaques and memorials. The main monument, in Birkenau, consists of an abstract sculpture and accompanying plaques in twenty languages (notionally to represent the different nations whose citizens were murdered there, paralleling the national exhibitions); it was erected in the 1960s, following an international competition. There is also a Roma (Gypsy) monument, as well as a special monument commemorating

French citizens, also in Birkenau. These monuments were all agreed to during the period when Poland was a communist country, and would seem to have been largely the result of specific initiatives in the context of political considerations operative at the time. Jewish initiatives were then significantly hampered by the absence of diplomatic relations between Poland and Israel.

With the end of communism in 1989, the situation changed fundamentally and the museum has since adopted quite a different policy. An exhibition devoted entirely to Jews was installed inside the former Sauna building in Birkenau (see the note on photo 52); groups of symbolic tombstones with inscriptions in Polish, Yiddish, Hebrew, and English were erected as memorials near the ruins of the gas chambers (one such group of tombstones can be clearly seen in photo 41); historical photographs of Jews taken by the SS were installed on display boards (photo 52); and explanatory texts in Hebrew, alongside Polish and English, were provided not only on those display boards but also on about fifty other display boards carrying historical information that have been erected throughout Birkenau (others have been installed in the main Auschwitz camp as well). As a linguistic symbol representing the Jewish world, Hebrew is fully in evidence at the Auschwitz site.

Efforts to give due acknowledgement of the overwhelmingly Jewish identity of the Auschwitz victims have thus considerably speeded up in recent years, although more work remains to be done. The previous emphasis on 'national' exhibitions was unsatisfactory: there certainly were Hungarian, Dutch, and Italian citizens murdered in Auschwitz, but more than

90 per cent of them were Jews, brought to Auschwitz simply because they were Jews. By emphasizing national citizenship, the extent of Jewish victimhood had deliberately been made to disappear from view because Jews were reduced to one 'nationality' among many. Before 1989 Auschwitz was not, for Poles, a symbol of Jewish suffering. In a paper published in 1988 the Polish Canadian sociologist Iwona Irwin-Zarecka wrote that Auschwitz is rather 'a general symbol of "man's inhumanity to man" and a symbol of the Polish tragedy at the hands of the Nazis. It is a powerful reminder of the evil of racism, and not a singular reminder of the deadliness of antisemitism. In the most literal sense of memories evoked on site, it is an "Auschwitz without Jews"' (Irwin-Zarecka 1988: 147).

A more sensitive, comprehensive approach to the subject thus became part of the remit of the International Auschwitz Council, an advisory body to the Polish government that was established in 1990 under the energetic chairmanship of Professor Władysław Bartoszewski (a non-Jew, himself a Polish survivor of Auschwitz and a member of Żegota, the wartime Polish Council for Aid to Jews) and including several Jewish members; its job is to scrutinize the full range of issues, often quite difficult and controversial, that the Auschwitz museum needs to deal with. For instance, the Council agreed in 2006 that the Jewish exhibition in Block 27 was unsatisfactory and needed a complete revamp, and that the task of installing a new exhibition would be undertaken by Yad Vashem, Israel's principal Holocaust museum and memorial in Jerusalem. This new exhibition will at last institutionalize the considerable co-operation that has developed between the museum and Yad Vashem in recent years, and also

provide a permanent Israeli memorial in Auschwitz.

The very fact of an Israeli embassy in Warsaw is itself not to be taken for granted. Israel did not exist as a sovereign Jewish state until 1948, three years after the end of the war. During the Holocaust the Jews were totally defenceless, as a minority group lacking their own state to protect them or to run to. Since the re-establishment of diplomatic ties between Poland and Israel, a succession of Israeli ambassadors to Poland has spearheaded important new cultural developments, both in the area of Holocaust commemoration in Poland and also in the reinvigoration of Jewish life in the country (on which see Section 5). Among the embassy's many activities in this field on behalf of the world Jewish community is the awarding of medals to ethnic Poles who rescued Jews during the Holocaust. (See also photo 59.)

Photo 54

Although the Bełżec site had long been officially designated as a place of memory by the local authorities (to the extent that in the 1960s a modest monument was erected), it was substantially at the initiative of a Holocaust survivor, Miles Lerman, that this remarkable new monument came into existence. Mr Lerman, who was born in the neighbouring town of Tomaszów Lubelski and whose mother, sister, nephews, and other relatives were murdered in Bełżec, was passionate about the need for a fitting new memorial on the site. As chairman of the United States Holocaust Memorial Museum in Washington, DC, he negotiated an agreement with the Polish government in 1995 and later with the American Jewish Committee to bring the project to fruition; he also took on the responsibility for raising the necessary funds. This is a particularly important case, but it has happened not infrequently that Holocaust memorialization projects in Poland have been undertaken by dedicated individuals and institutions, working together with local and national Polish authorities. The architects who designed the project were a Polish team: Andrzej Solyga, Zdzisław Pidek, and Marcin Roszcyk.

The site itself is hard to understand, being both a sacred place (as a burial ground) and an accursed place (as the site of a murder camp). There had been no significant attempt to educate the public about what had happened there, even if the fact that the site had been preserved and had lain relatively undisturbed for decades meant that its sanctity as a burial ground was thereby not compromised. The mechanics of constructing a new monument and educational facility at the site, however, brought to the surface a series of controversies during the construction phase in 2003, widely reported in the Jewish press at the time. There were accusations and counter-accusations between rival Jewish organizations over the moral ownership of the site, the lack of openness and transparency over what was being done, and in particular over the acceptability in Jewish law of archaeological excavations being conducted at the site and the consequent disturbing of Jewish graves. Holocaust commemoration can, quite understandably, touch raw nerves. In fact the rabbinical authorities (co-ordinated by Michael Schudrich, the chief rabbi of Poland) found a good solution: the fact that the pathway into the hillside corresponded to the route taken by the victims meant by definition that no actual graves would be disturbed; and the use of large boulders, even if intended primarily for aesthetic reasons, also ensured total protection of the graves underneath the ground—visitors do not actually walk on this area. More information on the Bełżec memorial and museum can be found in the commemorative booklet issued at the dedication (American Jewish Committee 2004), on which much of the above note and caption have relied.

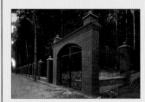

Photo 55

The scale of the task of restoring Jewish cemeteries is enormous: at least one thousand Jewish cemeteries are known to exist in Poland, quite apart from anything up to a further four hundred cemeteries which may have been deliberately bulldozed or built over during the war or in the aftermath of the war (Gruber and Myers 1995: 31–2). Some cemeteries have been so totally gutted that they are just open fields today—lacking both tombstones and a boundary wall or fence. Jewish law prescribes that a cemetery is an eternal resting-place that must be maintained as such, out of respect for the dead who are buried there, but the small community of several thousand Jews who live in Poland today does not have the resources to restore and maintain so very many cemeteries, especially as the overwhelming majority of the cemeteries are in remote provincial areas far from the main centres of present-day Jewish life in Warsaw, Kraków, Łódź, and Wrocław. Hence the involvement of foreign Jews. These include Holocaust survivors, Jews who emigrated from Poland before the war (especially those who formed *landsmanshaftn*, organization of émigrés from specific localities), and the followers of particular hasidic rebbes. Through their efforts to conserve the traces of the Jewish memory of their home towns by arranging group visits, publishing memorial books and newsletters, and establishing websites (most notably Gesher Galicia, or more generally JewishGen.org, an excellent resource for those researching family genealogies or information on particular locations), a veritable host of initiatives has arisen in recent years to address the problem of abandoned cemeteries.

The Jewish cemeteries in Polish Galicia that have benefited from this work include the large cemeteries in the city of Przemyśl (a particularly fine restoration, undertaken by Professor John J. Hartman of the University of Michigan through his Remembrance and Reconciliation Foundation) and in Chrzanów (rededicated in 2007 following a similarly elaborate restoration project). Noteworthy restorations have taken place in smaller market towns too. In Kęty, an astonishing restoration undertaken by Henry Kanner, a Holocaust survivor living in the United States, was completed in 1992, turning the cemetery into a beautiful memorial garden complete with topiary bushes and a monument in the form of a menorah. In Limanowa the Jewish

metery was restored by Leo Gatterer, Holocaust survivor from the nearby village of Dobra, now living in Germany, who also financed the re-fencing of the Jewish cemetery in Nowy Sącz. In Jaworzno a meticulous restoration was undertaken by Rose Sontag, a Holocaust survivor now living in New York; she even taught the local Polish piekun (caretaker) enough Hebrew to enable him to restore the painted lettering. The restoration of the cemetery in Trzebinia includes a very unusual entry gate made from part of the former *taharah shtib* (the building where the dead were washed prior to burial), an idea implemented at the initiative of Sigi Rabinowicz, now living in Israel. In the village of Brzostek, the birthplace of my own grandfather, Joseph Simon Webber, the Jewish cemetery was completely devastated; my own family has rebuilt the fence and erected a memorial to the pre-war Jewish community and those members of it who were deported and murdered during the Holocaust. The Jewish cemetery in the neighbouring small town of Pilzno, which had been watched over for fifty years by the Saczka family who lived in the small house next door, was restored in the mid-1990s by the family of R. Joseph Singer, a descendant of the rabbis of this small town, who had emigrated to New York before the war and established a synagogue on the Lower East Side.

There have been many, many other restorations, far too numerous to mention here. One agency which has been particularly active in sponsoring cemetery restorations and associated projects (such as clearing vegetation, renewing access roads, providing signage, and returning recently rediscovered Jewish tombstones to the local Jewish cemetery), or facilitating them through collaboration with local schools and municipal authorities, is the Warsaw-based Foundation for the Preservation of Jewish Heritage in Poland. In recent years the Foundation has been involved in a variety of local schemes promoting memorialization and educational work across Poland, such as a remarkable 'Chassidic Route' publishing project to give visibility to hasidic traditions and promote a heritage-focused tourist route, especially in Galicia. The cemetery work it has undertaken has involved initiatives in several localities in Polish Galicia, including Baligród, Brzozów, Jarosław, Leżajsk, Narol, Sanok, and Ustrzyki Dolne. One Polish Jewish businessman who restored a number of cemeteries in Polish Galicia, including Strzyżów and Sanok, was the late Sigmund Nissenbaum, an Auschwitz survivor living in Germany, who built up a large business in the 1990s selling kosher vodka to Poles, from which he was able to finance his cemetery projects.

Less well known are the local Polish volunteers who have contributed their time and energy to cleaning abandoned Jewish cemeteries — cutting the weeds, pruning the trees, removing garbage, and encouraging the local children to come and light candles on All Souls' Day — as their contribution to the reclaiming of the Jewish past. In the late 1980s Jan Ziobroń, a retired schoolteacher in the small town of Radomyśl Wielki, went much further than routine maintenance and created a fine memorial garden in the local Jewish cemetery. Since 2004 certificates have been handed to these activists in an annual ceremony to honour and thank them for their work, an initiative of Michael H. Traison, an American Jewish philanthropist, implemented in conjunction with the Israeli embassy and Polish Jewish heritage organizations.

Polish Galicia is usually well represented in these annual awards: in 2008, for example, certificates were given to Piotr Błażejewski, the mayor of Bukowsko; Agnieszka Cahn of Myślenice; and Mieczysław Zdyrski of Tarnobrzeg; it was announced at that ceremony that so far 120 Poles, from all over Poland, had now been honoured in this way.

The existence of these ceremonies confirms the huge importance attached to this work. The full-scale restoration of Jewish cemeteries is usually marked by elaborate rededication ceremonies, constituted as major local civic events. These are often held with the participation of the city president or mayor, together with dignitaries from neighbouring towns and villages, the local Polish Catholic clergy, local schoolchildren and their teachers, and local scholars. Michael Schudrich, the chief rabbi of Poland, is usually present, and often so is the Israeli ambassador. The Jewish groups who have contributed to the restoration project arrive with their families and friends. Speeches are given, usually followed by a walking tour of the historical Jewish sites in the locality, a reception in the city hall, and sometimes a concert. The local school or library may put on a historical exhibition, and the organizers of the event may also arrange the publication of a souvenir memorial booklet. The whole event involves a range of emotions — a sense of closure for some, estrangement and alienation for others, and the bittersweet emotions of former Polish and Jewish classmates meeting each other for the first time in decades.

And yet, despite all the magnificent work which has been done, there are still hundreds of abandoned Jewish cemeteries in Poland which are still to be restored and cared for.

Photo 56

The absence of proper Jewish educational opportunities for girls meant that Jewish girls, and even Orthodox Jewish girls, were often better educated in secular subjects than they were in Judaism. This provided the Orthodox rabbis of the day with an important argument for supporting the founding of Beis Ya'akov, as this school system was known in Poland at that time. A network of schools was rapidly established in interwar Poland, with as many as 30,000 pupils by 1934–5 (Marcus 1983: 154); Duda reports that in the 1930s there were 450 girls being educated to become teachers in Kraków, including some from the USA (Duda 1999: 40), though Martin, quoting a contemporary Polish source, puts the figure much lower, at 120 (Martin 2004: 180).

Among other commemorative street plaques to be found in Kazimierz, the former Jewish district of Kraków, two are particularly worthy of mention. Both are for writers and poets. One is at 5 Berka Joselewicza Street,

in honour of Mordechai Gebirtig (1877–1942), a carpenter by profession and a socialist in outlook but famous as a poet and composer of a wide range of Yiddish folk-songs, including some for children. The themes of his songs in his later years inevitably turned to the Jewish predicament: one of the best known is 'Dos shtetl brent' ('Our shtetl is on fire'), which was written in 1936 after a pogrom in the town of Przytyk (near Radom in central Poland). It was sung in the Kraków ghetto and became the marching song of the Jewish fighting organization there (see photo 35). A poem he wrote in 1940, when the Germans announced the expulsion of Jews from Kraków, has also remained well known. It starts: 'Farewell, my Cracow / Farewell. / Horse and wagon are waiting in front of my house. / The wild enemy drives me out / Like one drives a dog / Without mercy away from you' (The quotation is from Schneider 2000: 153.) Like all the other Jews, Gebirtig was ordered to leave his home, and expelled to the Kraków ghetto. There, on 4 June 1942, during a major round-up of Jews for deportation to Bełżec, he was shot and killed. After the war his songs were collected and published, and today they are widely performed as part of the Jewish heritage of the city. A fine bas-relief in memory of him, showing his head and shoulders against a background of the Kraków cityscape, was installed in 1992 by the Kraków Jewish Culture Festival over the main door to the house where he lived (on this important festival see pp. 130–1).

The other plaque, also a fine bas-relief, is in memory of the Kraków Jewish poet, writer, and film-maker Natan Gross (1919–2005). A Holocaust survivor, he went to live in Israel in 1950. In 1990 he published his memoirs, which in 2001 appeared in English as *Who Are You, Mr Grymek?* It includes a particularly nostalgic poem about Kraków and the absence of Jews there. Here is an excerpt: 'Autumn chestnuts spill from Cracow trees — / But no one hangs them on a Sukkoth booth. / Unchanged, Wawel stands. But near the Dragon's Den / There are no Jewish children. / [. . .] Where is our Vistula, where is our Cracow? / Where is that country that we called Poland? / [. . .] All these years, all these years, we still have this: / We meet, reminisce, meet and reminisce. / We are strung together like those Cracow chestnuts / On a thread of memories longer than our sorrow: / Our idyllic Cracovian Jewish childhood, / Our days of rage and triumph, youth, frivolity, / Our days of love and joy, our downfall and our care. / Who knows better than the cobblestones of Cracow / What pained us early, what pains us still: / The Jewish fate given us to fulfil. / Autumn rains soak the chestnuts of Cracow, / Autumn on the Planty, winter in our hearts. / Evening falls. Hurry home. They are locking the gates' (pp. 329–30). The bas-relief in memory of Natan Gross is at 12 Sarego Street, the house of his birth.

The three Kraków Jews whose memorial plaques are mentioned in this note were all, in their own way, unconventional. But in reviewing the long Jewish history of this great city, Henryk Hałkowski draws particular attention to the outstanding contributions of Sarah Schnierer and Mordechai Gebirtig, whom he considers as important for the memory of twentieth-century Jewish Kraków as the great rabbinical luminaries of the sixteenth and seventeenth centuries were for their times (Hałkowski 2007).

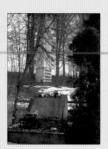

Photo 57

The two monuments are different from each other in a number of ways, quite apart from their respective size. The Polish state monument, erected during the time when Poland had a communist government, reflects a communist interpretation of Polish national history which stressed the unparalleled martyrdom of the Polish people at the hands of the fascists; Jewish victimhood was generally not acknowledged during that period as a specific, self-contained issue in its own right. If mentioned at all, it would be perfunctory—certainly the term 'Holocaust' was simply not used. Jewish interpretations of this history, on the other hand, while divided into socialist, religious, and Zionist approaches, tended to focus on instances of pre-war Polish antisemitism and to connect these with the central fact that the Holocaust largely took place in Poland—why else, so the argument runs, did the Germans deport Jews from faraway Holland, France, and elsewhere in order to murder them in Poland? The failure of post-war communist Poland to commemorate the Jewish disaster appropriately was thus easily explained in terms of an endemic Polish antisemitism. Furthermore, Polish Jewish authors, even those who manifestly considered themselves at home in Poland and in Polish culture, also found the indifference of Poles towards their persecuted Jewish neighbours unacceptable. For example, Mordechai Gebirtig (the songwriter mentioned in the note on photo 56) wrote a poem in 1940 entitled 'Es tut vey' ('It hurts'), addressing 'those Polish sons and daughters who bring shame on their country' by sneering at the suffering o the Jews under their common enemy, the Germans (Scharf 1996: 244). Even Poland as an occupied country, lacking its own government and suffering systematic repression, clearly had no independent resources to help the Jews, nevertheless there was little if any sense at that time of shared suffering, for example through shared involvement in resistance activities. Certainly there were honourable exceptions, such as the underground Polish organization (known as Żegota) that was set up in 1942 in Warsaw (wit a branch in Kraków from 1943) specifically to help Jews who had escaped from ghettos to find accommodation, to protect them from blackmail, to supply false documents, and to reclaim them by bribes or cunning from the hands of the Gestap (for details about Żegota see Gutman and Krakowski 1986: 252–99; Kunert 2002); and many thousands of Poles risked their lives to hide Jews from the Germans (see photo 59). These are important cases to include in the picture: as Władysław Bartoszewski, who was a member of Żegota, put it recently, 'in the Old Testament there were ten just people needed to save Sodom [Gen. 18: 23–32]; there were thousands of just people in Poland' (cited in Kunert 2002: 36). So even if these were marginal cases in statistica terms, it is nevertheless not possible t sum up the totality of this complex period in simple black-and-white terms; and in any case the idea that antisemitic prejudice can by itself

ccount for genocide is simplistic and ar-fetched.

till, the dual monuments seen here—n Zbylitowska Góra, just a few miles utside Tarnów—do speak for hemselves as clear evidence of elective, alternative ways of nderstanding the past. The key ymbol in the large state monument is hat of Polish martyrdom—the word ew' does not appear anywhere on it. he inscription on the back of the nonument refers somewhat blandly to citizens' who were the 'victims of litlerite terror'—the standard formula sed in the communist language of the tate to inscribe into Polish historical nemory Poland's losses in the war. In ll, six million Polish citizens died in the var, ethnic Poles and Polish Jews in qual number: roughly three million of ach group. German policy aimed at the estruction of the Polish nation as well s of its Jews, and here in Zbylitowska óra ethnic Poles were murdered in the ame place as Jews. Curiously enough, here are six mass graves here—three ewish graves and three Polish graves, ach with its own monument.

he small Jewish memorial stone over ne of these mass graves ommemorates the mass murder of ight hundred Jewish children. It was rected in 1948 and has inscriptions in hree languages (Hebrew, Yiddish, and olish), each with a different level of etail but all in a style that is engaged nd enraged. The children were rought from Tarnów on 11 June 1942 to his clearing in the forest and, as is tated in the inscription in Yiddish, they vere brutally murdered by having their kulls smashed, presumably against he trees. (See also photo 31.)

uch appalling tragedies cannot be ompared, even if they happened at the ame place, but the fact is that neither nscription explicitly refers to the

tragedies of the other. They are different histories with different narratives. For a thorough review of these different histories and of Polish–Jewish relations before and during the Holocaust, as well as the image of the murdered Jew in the post-war Polish national memory, see an engaging, very readable, book by Michael Steinlauf (1997). He says that the long-accepted figure of three million Polish losses in the war may well be much too high (he prefers a figure of two million); and he makes the point that even if Poland was exceptional in that in no other country did the mass murder of Jews take place amid the slaughter of the co-territorial population, nevertheless there is no real comparison—whereas Poland lost 10 per cent of its ethnically Polish population, what the Polish Jews lost of their pre-war population was 90 per cent (Steinlauf 1997: 28, 152 n. 13); see also Gutman and Krakowski 1986, or for a more recent work, containing a particularly fine collection of papers, Zimmerman 2003.

Photo 58

In the villages and small towns, local memories of the Jews before the war are many and varied. It is common to find positive stereotypes, such as the quality of their family life, the piety and honesty of hasidic Jews, and the beauty of Jewish girls. During the forty years of communist rule, when luxury goods, and even basic necessities, were hard to find, some Poles also remembered nostalgically the diversity of

manufactured products in which Jews traded in the main market squares, and their willingness to extend credit. But trade was itself evaluated negatively in the countryside, being regarded by Poles who worked on the land as a form of idleness, as well as being open to the strong suspicion that it was characterized by dishonesty. Since trade was the context in which Jews and Poles were most frequently in contact in such places, the negative socio-economic stereotype about Jews in general was well established, and the characteristics of Jews associated with it are still part of the popular memory. Furthermore, the Christian tradition had long had an aversion to its 'elder brother', charged with the guilt of deicide, in punishment for which Jews had for centuries been treated as social outcasts. As strangers with a strange, mysterious culture endowed with supernatural qualities, they were thought to have something demonic about them, which is why they would so often be blamed for misfortunes and crises affecting the local community, even including natural disasters, plagues, and wars.

Modern forms of Polish political antisemitism rested largely on foundations supplied by these stereotypes, and indeed new negative stereotypes were disseminated, including a focus on the profound involvement of Jews in the socialist and communist parties, together with their support of the Soviet Union and the communist secret police, seen as a betrayal of Polish national interests. And yet, at the local level, there certainly are positive memories of normal friendships between Poles and Jews, for example between children and neighbours. In practice, many Poles combine strands of both attitudes in their minds; memories cannot thus be simply categorized as

positive or negative. For example, the Polish scholar Alina Cała, who undertook pioneering research on this subject in southern Poland in the 1980s, found local Poles with antisemitic views who nevertheless had considerable respect for saintly rabbis and even admitted that they went to visit graves such as that of R. Elimelekh of Lizhensk (see photo 23), and left notes with their requests (Cała 1995: 142–5). Jewish religion and culture may be ridiculed, but they may also be admired. So it would probably be more accurate to say, as a broad generalization, that in so far as Poles think about Jews at all, the attitude to them is inconsistent and ambivalent; a similar conclusion was reached by the anthropologist Rosa Lehmann in a study she made of the small Galician town of Jaśliska (near Rymanów), and indeed she entitled her book Symbiosis and Ambivalence (Lehmann 2001).

One example of this emerged during the fieldwork I conducted out in the villages. An elderly woman I was interviewing on her memories of Jewish food told me she remembered enjoying eating matza in a Jewish friend's home during the Passover festival. When I asked her whether she had ever heard that in order to make matza Jews required the blood of Christian children, she said yes, she had heard many people say this, including the priest. I then asked her if she believed the priest. As a practising Catholic, she had no choice except to say that of course she believed her priest. She had in effect certainly internalized the old medieval Christian blood libel against the Jews—the false, outrageous accusation which has given rise to numerous pogroms in eastern Europe throughout the centuries, even in post-war Poland (in Kielce in 1946)—and indeed, as Cała points out, it is still common, even today, for parents to

scare their naughty children by telling them 'Watch out, or the Jew will grab you and turn you into matza' (1995: 56). But at the same time the woman I was speaking with did not take any of this seriously and evidently had had good relations with her Jewish neighbours.

The evidence, in other words, is not always easy to interpret. Certainly there are villages which have a monument in the main square that meticulously lists each Polish individual who was killed in the war, but without mentioning any Jewish names at all, even if all the Jews of that village had been taken away and murdered. And yet one cannot say that the whole village is therefore antisemitic. In those same villages it is possible to find the positive stereotypes that have been mentioned. Some villagers feel they did all they could to help their Jewish neighbours during the war; others, who may have profited from abandoned Jewish property or who held strongly nationalist, anti-Jewish opinions, might feel that 'Hitler did the dirty work for us'. But the majority are those in-between, shocked at what happened to the Jews during the German occupation but fearful that after the Jews had been finished off it would have been their turn next.

There is undoubtedly substantial loss of detailed memory as the Jews of pre-war Poland recede from popular consciousness. It is true that Polish press and television have in recent years devoted considerable attention to the subject of pre-war Jewish life and the Holocaust, with the result that Poles have come to learn much more about this than was commonly known before 1989. Nevertheless, the ordinary domestic transmission of stories about Jews, by elderly people to the younger generations, is very patchy; all that

young people in the villages have now are misremembered fragments of folk tales and stereotypes, though this is beginning to change as a result of what they are learning about Jews in school. It should also be mentioned that after the war there was substantial movement of populations in southern Poland, especially involving Poles being repatriated from territories that were within Poland's pre-war borders but were lost to Ukraine, with the result that large segments of local Polish society in the region are thus incomers, lacking roots and knowledge of local pre-war Jewish life in the places where they now live.

Incidentally, the village of Stary Dzików is not completely without physical traces of pre-war Jewish life: the former synagogue still exists, abandoned and in ruins. What little is known about the pre-war Jewish community of Stary Dzików is listed under 'Dzików Stary' in Dąbrowska, Wein, and Weiss 1980 and in Spector 2001.

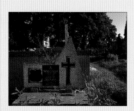

Photo 59

Many thousands of Jews the world over are alive today because of decisions taken by non-Jews to give food and shelter to Jews trying to hide from the German killers during the Holocaust, even though they were risking their own lives in doing so. Jews were hidden in attics and cellars, in cowsheds, under floorboards, and in underground pits; Jewish children were absorbed into convents; and there were others who, posing as non-Jewish relatives or friends, were accepted into private

homes in the villages or in apartments on the so-called 'Aryan side' of towns in which Jews had been imprisoned in a ghetto.

Giving assistance to Jews was highly dangerous: a whole family could be shot for taking in a Jew, and terrified neighbours who came to know that a Jew on the run was in their midst could put pressure on the family to get the Jew to leave or, worse still, betray them all to the Germans. Nevertheless, more than six thousand Poles have been formally identified as rescuers of Jews, following scrupulous examination of each individual case by Yad Vashem, Israel's Holocaust Remembrance Authority. Those who rescued Jews without ulterior motive—i.e. they did it neither for love nor for money—are identified as 'Righteous Among the Nations' and presented by Yad Vashem with a medal and a certificate of honour at a special ceremony, to record the gratitude of the Jewish people. The certificate carries the statement from the Talmud (from *Mishnah Sanhedrin* 4: 5) that saving a single life saves a whole world. A total of about 22,000 people have been thus honoured since the programme was launched in 1963; Poles comprise the largest group. Award ceremonies continue to be held: Jews are still to this day coming forward with names of rescuers who they feel should be honoured (sometimes because they have only just now been able to track them down); more than sixty years since the end of the war, the work of memory is still an ongoing reality.

Who were these rescuers, and what were their motives? Their determination to practise goodness in the face of evil was surely in all cases heroic, but it is otherwise hard to generalize about them. They included people from all walks of life, both educated professionals and illiterate

peasants; they were Christians of different denominations; agnostics as well as religious people; the rich and the poor. They were often quite ordinary people and have usually resisted being thought of as heroes. Perhaps what they have in common is that they were courageous non-conformists: people who didn't wish to allow the criminal law operating in wartime to dictate their conduct and didn't care what the neighbours thought. They were simply morally upright people who wanted to protect fellow human beings who were on the run—not only their pre-war friends but often total strangers. It was not easy to hide Jewish people, even Jewish children: pretending they were distant relatives or friends of the family could be hard to pull off. For example, if they were native speakers of Yiddish, they may not have spoken Polish well enough to pass as ethnic Poles, let alone know how to participate correctly in a church service. Memoirs commonly refer to the fear that was on the faces of Jews who were trying to live on the Aryan side of town. (The literature on this subject is extensive; the classic work is Tec 1986.)

Rescuers paid a high price for their actions. After the war, their neighbours often regarded them with hostility, seeing them as a living reproach that they too could have acted differently. Perhaps partly because of this, it is rare to find a reference on a Christian tombstone in Poland that the deceased rescued Jews. This is yet another reason why the case of Maria Dzik in Tuchów is of such importance, although it is not the only case where such heroism is publicly carved in stone for posterity: the tombstone of Tadeusz Pankiewicz in Kraków, the remarkable Polish pharmacist who assisted Jews in the Kraków ghetto, similarly carries an inscription which refers to this.

ach case of rescue is inspiring and worth retelling, and there are several published collections of the stories (for English-language texts about Polish rescuers see for example Bender and Krakowski 2004). It must be said, however, that the Jews who were rescued did not routinely come back to thank their rescuers, though of course there were exceptions. The Galicia Jewish Museum has mounted an exhibition about the Polish Righteous, the first institution in Poland to do so. It is based on portrait photographs taken by Chris Schwarz of twenty-one rescuers, still living in and around Kraków in 2006, all now very elderly. For these photos and their respective stories, together with useful introductory essays, see Craddy, Kuncewicz, et al. 2006; one of the projects of the new Museum of the History of Polish Jews, planned to open in Warsaw in 2011, is to provide an online comprehensive clearing house of information about Polish rescuers.

Photo 60

The 'Schindler tourism' stimulated by Spielberg's film has led to plaques and other commemorative materials being added to the site of the enamelware Emalia factory, including the erection in 2004 of a sign above the gates, stating (in Polish) 'The Factory of Oskar Schindler – Emalia'. Local Kraków travel agencies offer special *Schindler's List* tours of the city, and there are even local guidebooks which, in addition to sections covering the former Jewish quarter of Kazimierz, include a chapter

providing detailed coverage of Spielberg's Kraków. (See for example 'Route 4: Retracing *Schindler's List*', in Legutko-Ołownia 2004: 112–21, and also photo 26.) From these sources it has become more widely known that Spielberg's cinematic presentation of Kraków during the Holocaust in fact involved a considerable amount of artistic licence. For example, he filmed the Kraków ghetto not in its actual historical location in Podgórze on the other side of the River Vistula (too many post-war buildings there made it less photogenic) but rather in Kazimierz itself (largely unchanged since the war), even though the reality was precisely the opposite: it was from Kazimierz that the Jews were rounded up in 1941 and expelled to the newly created ghetto in Podgórze (see photo 34). Numerous scenes in the film that supposedly took place there were in fact filmed in Kazimierz, making it necessary for present-day guides to clarify this for visitors wishing to see the actual buildings shown in the film. Virtually nothing is left of the original buildings of the concentration camp of Płaszów (in Podgórze), which also featured heavily in the film; a complete reconstruction of thirty-four barracks and eleven watchtowers was specially carried out in a former quarry nearby, complete with a road made of fake Jewish tombstones. For some film critics and historians, as well as Holocaust survivors, there is thus some discomfort with the way in which many Holocaust films (not just *Schindler's List*) claim authenticity but in fact partly fictionalize the subject in order to put across their artistic and moral messages.

But despite such failings Spielberg evidently wanted to convey the historical reality of the story, concluding his film with a scene with the actual survivors whom Schindler

had rescued. They had certainly wanted the story to be told, and after the war told Schindler that they would do what they could to offer their gratitude to him publicly. Oskar Schindler was in fact among the very first to be honoured by Yad Vashem as one of the Righteous Among the Nations (see previous note): he was given the honour in 1963. Schindler died in 1974 and so did not live to see Spielberg's film, nor even the book written in 1980 by the Australian author Thomas Keneally who first wrote up the story—at the encouragement of Leopold Pfefferberg-Page, one of the Kraków Jews rescued by Schindler. (For a statement by Pfefferberg-Page as well as by many others who were rescued, see Skotnicki 2008.) Needless to say, the house where Leopold Pfefferberg lived in Kraków before the war is itself on the Schindler tourism route (Legutko-Ołownia 2004: 118).

The memory of the Holocaust, in other words, continues to be under construction, sometimes in quite unexpected ways. The film based on the extraordinary success of Oskar Schindler in rescuing a thousand Jews has certainly given a very wide global audience some access to the events of the Holocaust—but as a story with a powerful happy ending it is very far from typical of what happened.

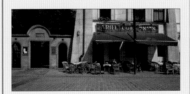

Photo 61

The reconstruction of Kazimierz as a setting for Jewish heritage tourism can be seen as part of the wider European phenomenon of heritage tourism

more generally and in that sense is justifiable and intelligible. From a Polish perspective, it also represents the conscious, public attempt to reinscribe and relegitimize the Jewish history of the country and the Jewish contribution to Polish culture—and to do so especially in Kraków, the capital of Poland in medieval times, a city whose heritage includes numerous important Polish architectural monuments from that period, including the royal castle and the burial places of the Polish kings. One of the major beneficiaries of national Polish heritage funding was the old Jewish cemetery next to the Rema Synagogue in Kazimierz (see photo 21): it was in very poor condition after the German occupation, but on artistic and historical grounds the city has painstakingly restored a great number of its magnificent Renaissance and baroque tombstones dating back to the sixteenth and seventeenth centuries.

Many Jewish visitors, however, especially those from outside Europe, may find a restored Kazimierz problematic: what they see before their eyes cannot be entirely real. In their minds, Poland after the Holocaust is a country which at least in Jewish terms is in ruins (as described in Section 1), whether because of the horror and destruction associated with the death camps or because of the abandoned synagogues and cemeteries. In either case, Kazimierz today is still seen as a ghost town, best regarded as a place of the imagination—Yiddishland, as it has sometimes been called (see for example Silvain and Minczeles 1999). In this view, the erection of Hebrew-language signs at newly created fashionable cafés such as Ariel in the centre of old Kazimierz is not a restoration of the past but simply commercial exploitation. Nor is the

ambience such signs are intended to create at all authentic; on the contrary, Kazimierz for such Jews still symbolizes absence.

The truth is more complicated. There is still a small Jewish community in Kraków, conventionally said to number about 150 people, and across the road from the Ariel café is the Rema Synagogue (photo 21), which is still in regular use as a synagogue on sabbaths and festivals. On ordinary weekdays, however, it functions as a museum, and a fee is charged to enter the building. Next door to the Ariel café is the arched entry to the seventeenth-century Popper Synagogue, used since the war as a youth club and an exhibition space—almost a museum, but not quite. The Old Synagogue museum (photo 50) is at one end of the street, while at the other end is a magnificent seventeenth-century Jewish mansion, on the ground floor of which is a Jewish-style café and a bookshop specializing in books on Jewish subjects and Jewish souvenirs; signs outside the building advertise day-trips to Auschwitz.

All these realities coexist alongside each other in a single street. Different people move through Kazimierz with different mental landscapes of the place, depending on whether they are local people, Polish or foreign tourists, synagogue worshippers, Holocaust survivors, foreign Jews making a pilgrimage to the Jewish holy places (and death camps) in Poland, or Polish Jews returning to their place of origin, in search of their roots or otherwise attempting to reconnect with their past (or perhaps with how they imagine it to have been). All of them may be customers at the Ariel café, even if they are mentally in quite different worlds and have little to say to each other. The regeneration of a gentrified, vibrant,

and touristified Kazimierz may be difficult for some to deal with, but it has unquestionably created important new realities in post-Holocaust Kraków, including a hotel (the Eden), run by an American Jew, which offers kosher food and has a functioning *mikveh* (Jewish ritual bath) on the premises. For a thorough description and analysis of the urban regeneration of Kazimierz see Murzyn 2006; see also Section 5 below. Henryk Hałkowski has published an unusual, somewhat sceptical presentation of some of the Jewish legends about Kazimierz accepted as authentic by many Orthodox Jewish visitors and part of the patter offered by tourist guides (see Hałkowski 1998).

 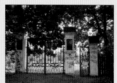

Photos 62 and 63

As is well known, antisemitic prejudice exists in countries without Jews; nowadays it is also spread by the media and the internet to people who may well have never met a Jew in their lives. Although Polish antisemitism is conventionally explained by historians in terms of theological, economic, political, and other hostilities between populations who for centuries had lived alongside each other and knew each other well, antisemitic graffiti in remote Polish towns where no Jews have lived since the Holocaust are perhaps not surprising in the modern context.

It is commonly asserted by Jews who have their origins in Poland, as well as by foreign Jewish visitors to Poland, that there is an enduring, if not

endemic, Polish antisemitism. In believing this they have three main twentieth-century reference points. The first of these is the notion that pre-war Poland was an extremely antisemitic country, and that, by the 1930s, both the Polish regime and Polish society were waging a bitter and increasingly successful war against the Jewish population, consisting of pogroms, degradation, and the infliction of growing misery. The Poles were in effect pushing the Jews to the 'edge of destruction'—in fact the title of an influential book by Celia Heller ([1977] 1980)—and then (to cite the second reference point) the Germans, with Polish help, destroyed them. The third reference point is the series of specific incidents instigated by Poles that took place *after* the war, most notably the infamous pogrom in the city of Kielce in July 1946, in which forty-two Jews were killed and forty more were injured.

Regarding the first point, the existence of antisemitism in pre-war Poland is an incontrovertible fact—for example, in a series of anti-Jewish violent disturbances, in anti-Jewish economic boycotts, or in the publicly stated views of leading Polish politicians that Jews were an alien group in Poland, neither capable nor deserving of being integrated into the Polish nation. But—in contrast to neighbouring Germany at the time—antisemitism in pre-war Poland was far from being pivotal, systematic, or genocidal, and (as far as the second point is concerned) despite the appalling case of the massacre of Jews by Poles in the town of Jedwabne in north-east Poland in 1941, the Poles neither initiated nor implemented the mass murder of Jews during the Holocaust, nor is there any documentary evidence to support the view that the Germans chose Poland to

build death camps because of the intensity of Polish antisemitism. On the other hand, the subject is complicated and open to a variety of differing interpretations, elaborated in the scholarly literature (for references see the note to photo 27); on the complexity of Polish–Jewish relations during the Holocaust, see for example Gutman and Krakowski 1986, and see also the note to photo 57.

On the post-war incidents, the facts are that between September 1944 and September 1946 at least 327 Jews were killed by Poles in 115 localities across the country, including a nasty episode in Kraków in August 1945 when a mob attacked a synagogue, beating up the worshippers and local residents, burning Torah scrolls, and killing one elderly woman. During this period a total of at least forty-six Jews were killed in the province of Kraków and twenty-three in the province of Rzeszów, including eleven Jews who were trying to cross the border into Slovakia but were murdered in Krościenko, and eighteen Jews murdered in Nowy Targ in two separate incidents in April and May 1945 (as recorded on their tombstone in the Miodowa Street cemetery in Kraków). (For a thorough review of the figures and the relevant evidence, see Engel 1998.) Unfortunately there was no systematic collection of data on anti-Jewish violence at the time. Scholars have put forward estimates of a total of 1,000 Jews, even 1,500, who were murdered by Poles during this time (Engel 1998: 60 n. 34), but without producing detailed evidence; Engel's figures, as he admits himself, are provisional and probably conservative.

The reasons for this post-Holocaust anti-Jewish violence in Poland, which came to a virtually complete stop after

e Kielce pogrom, are complex to evaluate. It was a combination of actors, including (but not limited to) longstanding Polish antisemitism and the tendency of right-wing Polish political parties to portray Jews as the enemies of Poland: Jews were prominent in the highly unpopular new communist regime, which indeed faced substantial opposition. During the same two-year period immediately after the war as many as 6,000 Polish government officials and their supporters were murdered by opposition nationalist partisans (Engel 1998: 64). The violence against Jews thus took place in a context of considerable upheaval, and the motives for the killings were far from uniform: sometimes Jews (as well as those who hid them during the war) were specifically singled out, sometimes it was only the Jewish communists, and sometimes the attackers were simply bandits looking for money who picked on Jews as likely targets (1998: 73–5).

Certainly the anti-Jewish atmosphere in those post-war years brought on the feeling that there was no future for the Jews in Poland. Jewish survivors commonly reported that Poles exhibited little sympathy for those who returned to their home towns to search for their loved ones, reclaim their homes from the people who had occupied them after their Jewish owners had been deported by the Germans, and rebuild their lives. On the contrary, there was enough violence or fear of violence (especially against those who wished to reclaim their homes) to cause survivors to reach the conclusion that they should leave the country—and indeed there was a mass emigration of the survivors, mainly to Palestine (as it then was) or the United States. Doubtless another factor

contributing to the emigration, at least in the smaller places, was the trauma of returning to one's home town and finding destroyed synagogues and cemeteries and only a tiny remnant of fellow survivors instead of the thriving community there had been before the war.

The case of Kraków gives a useful illustrative example of the background and the relevant figures. According to a survey conducted in 1946, there were 6,637 Holocaust survivors in the city at that time, of whom the great majority (4,330) had survived the war in the Soviet Union. The rest were made up as follows: 618 were survivors of the German death camps and labour camps in Poland; 430 had been in hiding in forests; 371 had survived death camps and labour camps in Germany; 332 had been in hiding in bunkers; 326 had been hidden by Poles; and 230 had been members of underground or partisan units. But the city was swollen with survivor refugees from many different places who came to Kraków only for a short period as it was a transit point for those wishing to emigrate, whether legally or illegally. Of the approximately 6,000 Jews officially registered in Kraków in the spring of 1947, only 2,200 were native to the place, in the sense of having been born in the city or having lived there before the war. By 1950 the total number of Jews in Kraków had diminished to about 4,000, of whom many were still waiting for official authorization to emigrate (I am indebted to Edyta Gawron of the Department of Jewish Studies at the Jagiellonian University, Kraków, for these figures and for her permission to quote them from an unpublished paper of hers (Gawron 2005); they are based on documents in the archive of the Jewish Historical Institute, Warsaw).

In such a context, present-day antisemitic graffiti in a town as remote as Ulanów merely represent a phenomenon which many Jews would understand as obvious, even as typical. The phrase 'welcome to the ghetto', written in English presumably in order to address present-day American Jews coming back on a visit to the town of their origin, suggests that the old hostility to the returning Jews in the 1940s has still, even today, not completely died out. But things are not always exactly as they seem: the cemetery was restored in the 1980s at the initiative and expense of the local authority. It could be that this was an unpopular use of public money in a town which is very far from wealthy—hence attracting the anti-establishment graffiti. There *was* a ghetto in Ulanów for a brief period during the war; in the minds of today's Polish youth in that place, reared on what they have been told about those times by their parents and grandparents, perhaps the Jewish cemetery represents that ghetto. The living Jews of the town who were rounded up and sealed inside that ghetto now come to be represented in the popular imagination by the fenced-off cemetery containing the remains of the Jewish dead. Whatever the motivation or reasoning, these graffiti in Ulanów are particularly disturbing. However, they are far from unique. Antisemitic graffiti elsewhere sometimes include the Star of David hanging from a gallows, but simply defacing a Holocaust monument, as in photo 45, carries the same message.

Sometimes it is the context which is provocative. In the town of Jawiszowice, where there was an Auschwitz sub-camp during the war, one former barrack of the camp has been preserved as a historical

monument in what is now a public park in the town centre. A few years ago I saw an interesting graffiti 'conversation' on one wall of this barrack. Someone had daubed 'Polska dla Polaków' ('Poland [is] for the Poles'), a common nationalist slogan; someone else had then come along and added 'i Żydów' ('and for Jews'). Then a third person had come along and crossed out the reference to the Jews. Meanwhile a fourth person (or perhaps one of the previous three) put a Christian cross into the 'o' of 'Polska' and the 'o' of 'Polaków', after which yet another person had turned the cross on the word 'Polaków' (Poles) into a gallows. The case of this barrack in Jawiszowice (as well as many other cases which could be cited) points to the fact that antisemitism is not at all the only preoccupation of those who daub graffiti in Poland today, whose efforts more usually focus on popular football teams or else consist merely of abstract line drawings: graffiti are also often used as a public arena for dialogue on the important issues.

Hence the anti-Nazi response, stimulated by a new generation of young local Jews who identify with their heritage and encouraged by Poles who are in cultural sympathy with them. Those Poles who cling to the old antisemitism nowadays compete with those who want to reject anti-Jewish prejudice, which many see as a relic from the old nationalist or communist Poland. More educated elements of the younger generation want to move on, and together with today's small Polish Jewish community have in recent years begun to develop an authentic Polish interest in Jewish culture. To cite the view of Michael Schudrich, the chief rabbi of Poland: 'To view Poles today as being mostly antisemitic is false and unfair. Poland and her people have

changed, and it is mostly for the better. We [Jews] need to change, too' (Schudrich 2007: 140). The Jewish student group in Kraków known as Czulent (named after a traditional sabbath food, which in English is usually spelled 'chulent'), was founded in 2004. It has its own premises with a library, based in the newly constructed Jewish Community Centre building in Kazimierz, and it sponsors various educational activities including a 'literary salon' (meetings with writers) and a 'Galicia project' aiming at preserving the memory of Jewish life in southern Poland. Czulent is certainly part of what is coming to be spoken about as the revival of Jewish culture in Kraków (on which see the note on photo 66).

Photo 64

Art competitions on Jewish themes by Polish schoolchildren have become well established, and for example the National Museum in Kraków had an excellent temporary exhibition in 2004 of about fifteen such paintings made by children from the town of Bobowa, alongside its permanent exhibit of Judaica (see the note on photo 50). The painting seen here is by Katarzyna Cholewa, then a pupil of the Stanisław Konarski High School in Oświęcim. It can be understood in different ways. While it cannot be a picture of present-day realities in Oświęcim (the main synagogue was completely burnt down

by the Germans in November 1939), it could be a representation of a fantasy about the future, although it is also possible that it is an attempt to visualize pre-war Polish–Jewish relations, i.e. to show the main church and the main synagogue in the town as they looked before the war (they were indeed physically close to each other, more or less on the same street, at the top of a hill). The painting is part of a collection put together by Mirosław Ganobis, who in the early 1990s founded a Poland–Israel Friendship Society in Oświęcim. One of his early projects was to collect such paintings on Jewish themes from elementary and high schools in the town. Mr Ganobis told me that the young artist knew about Jews only from books and what she had learned about them in school; the girl in the painting is supposed to be Polish, and the basic intent of the image is to represent the theme of coexistence. He kept his collection at home until the opportunity arose to exhibit it in the restored synagogue. Art, as he put it, can build bridges between communities, by nourishing dialogue and mutual respect.

The restored synagogue in Oświęcim (a town which had a substantial Jewish community before the war) is a different building from the one that might be depicted in this painting. Founded by a group called the Chevra Lomdei Mishnayot (which roughly translates as 'association of those who study the Talmud'), it is a small, single-storey *beit midrash* in the town centre which survived the war and in the late 1990s was fully restored as a functioning synagogue. The existence of this sole surviving Jewish house of prayer in the town of Oświęcim, complete with Hebrew inscriptions (on which see photo 6), in such close proximity to the Auschwitz death camp, was felt to be of such symbolic

significance that when American Jewish philanthropist Fred Schwartz heard about it he was moved to undertake a remarkable, visionary project. He organized a group of like-minded people, acquired both the synagogue and the house next door, converted the two buildings into one, and created what is now the Auschwitz Jewish Centre. There is no Jewish community in the town today; the purpose of this initiative is to provide Jewish visitors to Auschwitz with a place where they can come and be on their own as Jews and, if they wish, conduct prayer services. The idea of the centre is (as it was put at the rededication ceremony) to reassert the dreams of those who perished so nearby; to seek some kind of reconciliation with the horrors of the past and find uplifting hope for the future; and to provide a window onto the history of the Jews of Galicia. Hence, in addition to the meticulous restoration of how such a small *beit midrash* would have looked before the war, the centre showcases the pre-war Jewish life of the town: it includes a small museum of Oświęcim Jewish memorabilia (some donated by Mirosław Ganobis), a library and study room where visitors can undertake Jewish genealogical research and view videos of survivor testimonies, and a large meeting room, which is where the exhibition of paintings was held. The centre, whose director is Tomasz Kuncewicz, a Pole who graduated from Brandeis University (USA) in Jewish studies, also holds lectures and seminars for local people interested in Jewish religion and culture, and in that way encourages Polish–Jewish dialogue. Since 2005 the centre has been an affiliate of the Museum of Jewish Heritage in New York.

At the ceremony of rededication, which took place in 2000, the speeches that were made robustly emphasized the

imagination, courage, and extraordinary symbolic power of reconsecrating a synagogue for Jewish prayer and study in the city of Auschwitz. Prince El Hassan bin Talal of Jordan (brother of the late King Hussein, and representing an Arab country that has made a peace treaty with Israel) spoke of Auschwitz as the negation of religion, as the declaration of war on humanity—and thus the importance of hope, the will to survive and the return to faith as represented by the restored building. Michael Lewan, president of the United States Commission for the Preservation of America's Heritage Abroad, said that it was good that next to a camp of death should now be a camp of life: 'Americans need to relive the joy of our ancestral past. ... We honour our past and build a future. Today, Oświęcim has performed an act of love and an act of peace. As Pope John Paul II has said, these Jewish places are part of our common past.' Tadeusz Rakoczy, the local bishop, spoke of the resurrection of the synagogue, and he quoted the vision of Ezekiel concerning the resurrection of the dead: 'Thank God that I have lived so long to witness a day when in the city of Oświęcim I can sing Hallelujah together with Jewish people.' Fred Schwartz concluded with the words: 'To my right is a synagogue, to my left a Catholic church, and in front of me is a Muslim prince. If the Bible were being written today, this event would be in it.'

The event was obviously exceptional, and the sentiments expressed were forceful. But the passion and vision underlying many of the activities aiming at the restoration of a Jewish presence in post-Holocaust Poland—the theme of Section 5—are often generated by a highly dedicated sense of purpose.

People Making Memory Today

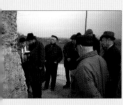

Photo 66

Since 1945 the Kraków Jewish community has been led continuously by the Jakubowicz family—first by Maciej Jakubowicz, who died in 1979, then by Czesław Jakubowicz, who died in 1997, and latterly by Tadeusz Jakubowicz. All of them, who survived the war by being hidden by a Polish family in a village near Dobczyce, have been well-known and respected figures both locally and internationally, as lay leaders of one of the last active Jewish communities in Poland and acting as its official representatives with government as well as with Israeli and international diaspora Jewish organizations and Jewish visitors to the city. Nowadays there is scarcely a civic event in Kraków which Tadeusz Jakubowicz is not invited to attend, if not also to give a speech on behalf of the Jewish community.

Rabbi Sacha Pecaric, a native of Croatia, served as the community rabbi in Kraków from 1997 to 2005. His post was funded by the Ronald S. Lauder Foundation, an American Jewish charity whose mission since the fall of communism in 1989 has been to encourage the revival of Jewish life in eastern Europe. Active in Poland, Hungary, and elsewhere, the foundation has supported Jewish schools, youth camps, and rabbinical posts. With the help of the Lauder Foundation, Rabbi Pecaric established a religious Jewish book series named Pardes Lauder, which beginning in 2001 published in Kraków a bilingual Polish–Hebrew prayer book, a bilingual Haggadah (domestic liturgy for Passover), and translations into contemporary Polish of biblical books. Among these works (some of which were translated in co-operation with Ewa Gordon) is a five-volume translation of the Torah into modern Polish—the first such translation to be made by a Jew since the Second World War. Rabbi Pecaric's contribution has thus been of great significance: previous translations of the Torah into Polish were either too archaic in their use of language or were too closely reliant on Christian sources and ideas rather than having contemporary Jewish relevance.

The Jewish community in Kraków continues to be well served with Orthodox rabbis, and in 2009 there were three of them: Rabbi Chaim Boruch (Edgar) Gluck, whose title is 'Chief Rabbi of Galicia', Rabbi Eliezer Gurary, director of the Kraków branch of the Chabad Lubavitch Jewish outreach organization, and Rabbi Boaz Pash, the community rabbi; a Kraków branch of the Reform (Progressive) Jewish movement is also in the process of formation. The community benefits from kosher food facilities and a new community centre. All this is part of what is hailed as a revival of Jewish life in Poland. Rabbi Michael Schudrich, a native of the USA who since 2004 has been the chief rabbi of Poland (and who was funded by the Lauder Foundation when he first came to Poland in 1992 as the rabbi of Warsaw) has been particularly energetic in promoting this revival, including a wide range of Jewish cultural and religious activities such as adult education classes, youth clubs, and summer camps. Many of the Jewish children who were hidden by Poles during the Holocaust never came to be told of their origins, and during communist times the concealment of Jewish identity continued, either by force of habit or for fear of antisemitism. Even if individuals knew or suspected that they had Jewish origins, it was often the case that their parents and grandparents, assimilated into Polish culture, said little or nothing about it to their offspring.

After the fall of communism that taboo was lifted, and the discovery of Jewish identity has gathered speed, often in unusual circumstances (such as deathbed confessions). Suddenly the Jewish community of Kraków (as elsewhere in the large cities in Poland) finds itself with a penumbra of people, mainly young people (such as those associated with the Czulent student group), who have begun to develop a serious interest in Jewish religion and culture but otherwise feel they have little in common with the elderly Holocaust survivors who had identified as Jews since the end of the war and thus had dominated Jewish community life. Dealing with this situation is one of Rabbi Schudrich's main challenges, supported by the other rabbis in his community. They have taken a strong personal interest in three groups of people: young Jews interested in reconnecting with their Jewish roots; Polish Catholics who have discovered that they are in fact Jewish (inasmuch as they descend from Jews through the female line, which in Jewish law is the defining criterion) and wish to find ways of mobilizing it; and non-Jews who wish to convert to Judaism, especially those who have Jewish origins on their father's or grandfather's side, which otherwise would not qualify them as Jews under Jewish law. In addition, there are Poles with no Jewish roots who feel an obligation to preserve Jewish memory in Poland. (On the rediscovery of Jewish identity in Poland see Gebert 1994, or, for a more recent statement, Krajewski 2005; a brief mission statement by Rabbi Schudrich can be found in Schudrich 2007.)

One of Rabbi Schudrich's mentors in this process has been Rabbi Chaskel Besser, a hasidic rabbi born in Poland in 1923 who served the Lauder Foundation as director of its activities in Poland. Rabbi Besser's broad open-mindedness and deep personal concern with the special problems of a repressed, submerged Jewish life in eastern Europe have undoubtedly influenced the steady process of Jewish revival that has been taking place in Poland since 1989. It was a senior appointment made by the Lauder Foundation: Rabbi Besser was the vice-president of Agudas Yisroel, a political party founded in 1912 that represents the interests of strictly Orthodox Judaism, and in that capacity used his diplomatic skills with Polish and other east European governments to argue the case for the preservation of Holocaust sites and Jewish cemeteries.

Standing behind this small group of Jews at the Holocaust memorial in Płaszów is thus a well-educated, committed set of Jewish religious leaders who seek to safeguard Jewish life in Poland for the future.

Photo 67

The museum attracts huge numbers of visitors from across the world: from about 500,000 annually in the mid-1990s, their number has been steadily

rising, reaching well over 1 million in 2007 and again in 2008. Over 400,000 of the visitors in 2008 were Polish. Jewish visitors to Auschwitz sometimes express surprise to see large numbers of Polish visitors there, along with non-Jewish visitors from many other countries, but it needs to be remembered that Auschwitz is not only a symbol of the Holocaust but also a key national symbol of Polish suffering during the German occupation of the Second World War. About 75,000 Poles were murdered there, along with at least a further 36,000 non-Jewish victims, including 21,000 Sinti and Roma (Gypsies). Quite apart, therefore, from the wider commemorative and educational purpose of the Auschwitz museum in addressing young people of all countries and backgrounds—the overwhelming majority of visitors (over 700,000 annually) are of school or university age—very large numbers of non-Jews, especially Roman Catholics, come to visit Auschwitz. Whatever the motive for the visit, the information plaques erected throughout the site, as well as the explanations given by the museum's official guides, clearly emphasize the overwhelmingly Jewish identity (at more than 90 per cent) of those who were murdered at Auschwitz—in contrast to the situation during communist times, when this central fact was consciously obscured. Its reinstatement is simply in the interests of historical truth. The museum cannot, of course, find out how many visitors are Jewish, but it is likely not to be a high percentage; approximately 44,000 of the annual visitors (less than 5 per cent) are Israelis. (The breakdown of the figures given here is for 2008; for further details on visitor numbers to the Auschwitz museum see the museum's annual reports, which are posted on the museum's website.)

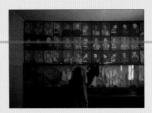

Photo 68

The Nazi policy of racial genocide specifically included the mass murder of children. Hence when Jews were deported to Auschwitz the children were taken too, which explains why there were such large numbers of children murdered there. For example, the first deportation of Jews to Auschwitz, which came from Poprad in Slovakia in March 1942, consisted of 999 women and girls, of whom 116 were under the age of 17. It is known from the transport lists that the deportation of 69,119 Jews from France during the period from March 1942 to August 1944 included as many as 9,820 children under the age of 17, of whom 7,368 were under 14. It is not possible to give a precise total figure for all children murdered in Auschwitz, since the relevant details are not available for the deportations from Hungary and Poland, the two largest national groups of Jews brought to Auschwitz, at approximately 437,000 and 300,000 respectively, although it is mentioned in many testimonies that the Hungarian Jews arrived in Auschwitz with large numbers of children. There were also about 6,000 Roma (Gypsy) children who were brought to Auschwitz. Most of the children who came to Auschwitz were sent immediately to the gas chambers: children had little chance of surviving the selection on the arrival ramp, and children born to Jewish women in the camp (i.e. if the women were pregnant on arrival) were usually murdered immediately. If young people

were taken into the labour camp, their living conditions and the work they were expected to undertake did not differ much from the arrangements assigned to adults, and they were subjected to the same brutality, tortures, and executions if they broke camp rules. They were often subjected to medical experiments by SS doctors, and they died in great numbers due to malnutrition and disease. Probably about 435 children were amongst those liberated when Soviet forces arrived in January 1945. For further details on the subject of children in Auschwitz see Kubica 1994, from which the above figures have been taken; on children's prams see Strzelecki 1994: 256, where he quotes the testimony of an Auschwitz survivor recalling that so many prams were brought by the prisoners to Auschwitz that on one occasion, when they were being sent back by the SS for reuse in Germany, it took more than an hour for a column of such prams, five abreast, to pass.

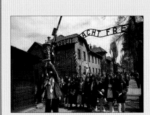

Photo 69

Visiting Poland specifically and exclusively in order to see the death camps has in recent years become an established Jewish habit, and indeed there are regular one-day trips to Auschwitz from London often arranged by synagogues and Jewish community organizations. The phenomenon of 'dark tourism', as it is sometimes called, is nothing new (for example, visits to the battlefields of the First

World War in France and Belgium are well established), but the rise of 'Holocaust tourism' to Poland, which started slowly and uncertainly after 1989, has gathered speed in recent years. Although some religious rituals, such as prayers for the dead, are commonly included in such visits, it would seem that such tourism can also be part of a new secular religion of Jewish identity based on Holocaust remembrance, to be understood in the context of the erection of important new Holocaust museums (especially in the United States) and the annual cycle of Holocaust commemorations among Jewish communities everywhere. The March of the Living is certainly the most elaborate of its kind, but the genre is now an important element of present-day Jewish life. For further reading see Kugelmass 1994, Sheramy 2007, and Webber 2000b.

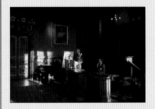

Photo 71

The main idea behind the founding of the new institute of Jewish studies at the Jagiellonian University in the 1980s was simply the awareness that the history of the Jews in Poland was not only a valid subject in its own right but also an integral part of Polish history. The initiative was led from the very top—by the late Professor Józef Gierowski, then the rector of the university. His vision was that such an institute, whose mission would specifically include the training of academic specialists in the field (along

ith a training in Yiddish and Hebrew), ould contribute to educating Poles out antisemitic prejudice and indeed to oser relations generally between Jews nd Poles. For a description of the unding of this Research Centre (as it as then known), which in turn gave se to the establishment of other such stitutes of Jewish studies elsewhere Poland, see Pilarczyk 1992.

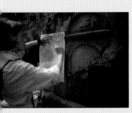

hoto 72

n the artistic sophistication of Jewish mbstones in Poland, see photos 24 nd 43 and the note on photo 21. though the scholarly study of Jewish mbstones has a long history, the bject was first brought to popular ublic attention in post-war Poland rough the work of Monika Krajewska Warsaw, who travelled throughout oland in the 1970s to make artistic notographs of surviving Jewish meteries—at a time when they were most completely ignored in the urist guidebooks. (See Krajewska 83, 1993.) The subject is now firmly in e public arena (and in the guidebooks s well), and Monika Krajewska runs orkshops each year at the Jewish ulture Festival, thereby encouraging hers to take an interest. Many of the olish enthusiasts will have taken niversity courses in Jewish studies ee the note on photo 71) and thus ow how to appreciate the Hebrew scriptions.

ontemporary local Polish scholars ho have written detailed studies of wish tombstones in Galicia include

Leszek Hońdo (1999a, 1999b, 2000, 2001) and Marcin Wodziński (1998, 2005). Among local Kraków artists whose works have been exhibited during the Jewish Culture Festival are Ewa Gordon, who specializes in Hebrew calligraphy, and Marta Gołąb, who has made a remarkable contribution to the revival of the old Jewish art of papercutting.

Photo 73

Janusz Makuch has described himself self-deprecatingly and metaphorically as a *shabbes goy*, a term which refers to a non-Jew who might come into a Jewish home to light the fire or perform other labours forbidden to Jews on the sabbath. What he means is that, just as Jews might rely on a non-Jew to perform tasks that they themselves cannot do on the sabbath, so too, now that the Jews who used to perform popular Jewish culture were murdered in the Holocaust, the task of performing that culture can only be done if non-Jews perform in their place.

The phenomenon has been richly documented by Ruth Ellen Gruber. Her work touches on several themes of direct relevance to the material covered in this book. She draws attention to the increasing public recognition of the distinctive Jewish contribution to European culture, as manifested for example in local government support for the restoration of former Jewish quarters and festivals of Jewish culture. Performances of Jewish music and screenings of Jewish films attract large

audiences in many countries across Europe, often in places with a total absence of a local Jewish population. Both public and private agencies end up taking on cultural activities that would normally have been undertaken by Jews. Jewish culture may thus come to be represented from an outsider perspective—something particularly evident in the case of non-Jewish klezmer bands performing what is advertised as east European Jewish music, although a good part of it may be almost unrecognizable as such to Jews themselves. What it amounts to is not really the regaining of a lost Jewish culture that vanished in the Holocaust but rather what Ruth Gruber has imaginatively called 'virtual Jewishness' or a 'virtual Jewish world', peopled by 'virtual Jews'. The phenomenon has now become fashionable in many places across Europe, and it is underpinned by Jewish heritage tourism and the manufacture, merchandising, display, and sale of 'Jewish cultural products' to sustain it—books, music, art, souvenirs, even newly made miniature wooden figurines of Jews. (See Gruber 2002, and on the Kraków Jewish Festival and the comments of Janusz Makuch cited here see especially pp. 45–51; see also photo 61. The wooden figurines, widely on sale in Kraków, have been the subject of a special study by the anthropologist Erica Lehrer (Lehrer 2003).)

The scale of these 'virtually Jewish' operations may be quite substantial: for instance there is in Kazimierz a Centre for Jewish Culture, operated and staffed by non-Jews, which opened in 1993 under the directorship of Joachim Russek. In its first three years it managed to programme more than 625 events, including lectures, concerts, exhibitions, and seminars.

The extent of book publishing in Poland on Jewish topics is similarly astonishing: in 1995–6 alone, more than 500 serious titles on Jewish history, literature, and culture appeared, and it is said that more Yiddish books were translated in Poland than in the United States or Israel (Gruber 2002: 11–13). There is nowadays unquestionably a large public in Poland interested in learning about Judaism and Jewish culture. Among the things one is beginning to see are Polish-language books dedicated to the Jewish memory of specific localities, and—perhaps even more to the point —the inclusion (perhaps for the first time since the war) of a chapter or two on local Jewish history in popular illustrated albums on the general history of a particular town or district. A good example of the latter is a recently published album on Bobowa (Majcher 2008) that includes not only a section on the Jewish history of the town and a chapter on the local synagogue but also a detailed essay on the hasidic dynasty of Bobov that came from there (Bartosz 2008) —a notable attempt, in other words, to integrate Jewish history within local Polish history.

Meanwhile in Kraków there are at least two main publishers of books of Jewish interest, each with its own bookshop in Kazimierz: Wydawnictwo Hagada, run by Lucyna and Zdzisław Leś, and the neighbouring Austeria, run by Małgosia and Wojtek Ornat. The Ornats, who also own the Klezmerhois hotel and restaurant in a building in Szeroka Street that belongs to the Jewish community and which formerly contained a *mikveh* (Jewish ritual bath), were among the pioneers of the positive attitude to Jewish culture in Kraków; they also organize concerts, exhibitions, and lectures on Jewish topics. The books they have published

on Jewish themes by contemporary Polish Jewish writers such as Konstanty Gebert and Stanisław Krajewski have done a great deal to bring Jewish culture to a young generation of Poles, both Jewish and non-Jewish.

A number of foreign Jewish agencies, mainly American, have been instrumental in facilitating this revival of Jewish culture in Kraków, most notably the 'Jewish Heritage Initiative' programme of the Taube Foundation for Jewish Life and Culture. Among other agencies that support Jewish activities in Poland are the American Jewish Joint Distribution Committee (whose philanthropic work in supporting Jewish life in Poland has been a major lifeline extending back well before the Holocaust), the Rothschild Foundation Europe, the American Jewish Committee, World Jewish Relief, and the YIVO Institute for Jewish Research. There are also a number of small private foundations which have been active in promoting Jewish revival (sometimes in connection with cemetery restoration projects), such as the Michael H. Traison Fund for Poland.

It is worth noting how Szeroka Street, the wide main street of Kazimierz, is the common setting for the making of Jewish memory in Kraków. The VIP visits (photo 70), the Jewish-style cafés popular with tourists, journalists, and literati (photo 61), the large ceremonies for participants in the March of the Living, and the open-air final concert of the Festival of Jewish Culture, all take place here, gaining their sense of authenticity from the old surviving buildings, including the sixteenth-century Rema Synagogue at one end of the street and the Old Synagogue at the other. The stage for the concert performers seen here is directly in front of the Rema Synagogue, but in recent years it has usually been positioned in front of the Old Synagogue instead.

The stage is not the only element of the annual Jewish Culture Festival that has moved since it was first launched in 1988: the festival itself has shifted its ground and considerably broadened the range of its activities. Today's understanding of 'Jewish culture' includes an ever-expanding range of books, films, and paintings, as well as musical, theatrical, and other performance arts. Such inclusiveness about 'culture' in general is unquestionably a sign of the times: what has been happening in Poland in recent years as regards Jewish culture is in that sense in harmony with developments elsewhere, also in the context of many other minority groups seeking expression of their cultural identity.

In this book I have tried to represent different, multi-layered approaches to the realities of present-day Poland. Here, by way of conclusion, let me leave the reader with one final set of rival perspectives. For some Jews the content of this 'virtual' Jewish culture raises difficult questions: how 'Jewish' is it, in fact? Has Jewishness here been appropriated in the context of another agenda? Or is it, on the contrary, a path which Jews should embrace for their own good? Some would say that much of what has been happening in Kazimierz is an illusion, or of no major consequence: Jews cannot in any case put down permanent roots outside the Holy Land. Jewish dreams for the future are oriented towards an eventual return to the ancient homeland, and the preoccupations of their neighbours in the diaspora are a distraction and no concern of theirs. Jewish history for them has consisted of a series of journeys from place to place, and Poland is no exception, even if Jews lived there for centuries. Jewish life collapsed in Poland during the Holocaust, and there can be no going back now. It is time to say goodbye; the culture cannot be re-created without Jews.

And yet, on the other hand, it can certainly be argued that respect for the past, and respect for those who respect that past in the only way they know how, is worthy of serious Jewish attention. The Jewish Culture Festival of Kraków—the largest of its kind in Europe—creates an environment in which it is once again acceptable, fashionable even, to be Jewish in Poland, where the memory of Jewish culture and the memory of Jews is cherished and esteemed. It takes place with a full knowledge of the tragedy of the destruction, and it attempts wholeheartedly to restore a Jewish presence in a true fullness and inclusiveness. This is surely a worthy project. After all, recalling the good times, weeping for the catastrophe, and hoping for a brighter future are normal human emotions; these emotions gain added intensity when experienced in a city such as Kraków with its complex Jewish past. There is, then, something very powerful about these traces of memory in present-day Poland which appeals to the imagination.

Bibliography

A Note on the Standard Reference Works

There is a substantial literature on all aspects of Polish Jewish history in general and on Galicia in particular. The subject was a flourishing one in pre-Holocaust Poland, and among the many distinguished historians who contributed to it were several who came from Galicia themselves and indeed wrote about Galicia, most notably Majer Bałaban (born in Lwów in 1877) and his contemporaries Ignacy Schiper (born in Tarnów in 1884) and Mojżesz Schorr (born in Przemyśl in 1874), followed in the next generation by Philip Friedman (born in Lwów in 1901) and his contemporaries Raphael Mahler (born in 1899 in Nowy Sącz) and Salo Baron (born in Tarnów in 1895). For a useful survey of their scholarly contributions to the subject see Biderman 1976, a book which focuses principally on Bałaban, who was the only person to hold a university post in Jewish history in interwar Poland, and lists about 50 of his publications (mostly in Polish), among them a two-volume history of the Jews of Kraków. The post-war literature has grown considerably, particularly in the last twenty-five years; it includes not only specialized monographs but also two important scholarly annuals—the Hebrew-language series *Gal-ed: letoledot yehudei polin vetarbutam*, published by the University of Tel Aviv's Institute for the History of Polish Jewry and Israel–Poland Relations, and the English-language series *Polin: Studies in Polish Jewry*, edited by Antony Polonsky and published on behalf of the Institute for Polish–Jewish Studies, Oxford, and the American Association for Polish–Jewish Studies. More than twenty volumes have now been published in each of these series. Of particular interest here is volume 12 of *Polin*, which focuses specifically on Galicia (Bartal and Polonsky 1999a), although articles on Galicia have appeared in individual volumes of both series from time to time.

For readers of this book interested in following up issues mentioned in the captions and notes there is a wide range of English-language reference materials available that provide useful information. First of all, there are a number of encyclopedias, including *The Jewish Encyclopedia* (New York, 1901–6) and the *Encyclopaedia Judaica* (Jerusalem, 1972; 2nd edn. 2007), which include many articles of relevance, including entries on 'Poland' and 'Galicia', as well as on the larger towns and famous personalities. The two-volume *YIVO Encyclopedia of Eastern Europe* (Hundert 2008) covers the subject more directly, with excellent contemporary essays on many more places, historical and cultural processes, and important personalities. The most authoritative and comprehensive source on Jewish communities in Poland is the monumental seven-volume Hebrew-language *Pinkas hakehilot: polin* ('Community Records: Poland'), published by Yad Vashem (Israel's official Holocaust remembrance authority) as part of a larger *Pinkas hakehilot* series (of twenty-two volumes) that includes not only Poland but all of Europe as well as Libya and Tunisia. Detailed Jewish histories of all the places mentioned in this book can be found in volumes 2 and 3 of *Pinkas hakehilot: polin* (the volumes are numbered 1–7 within the specific sub-series relating to Poland). Volume 2 (Dąbrowska, Wein, and Weiss 1980) covers eastern Galicia, and volume 3 (Wein and Weiss 1984) covers western Galicia and Silesia. I have relied on these two volumes for historical information and for all population figures that are cited, including the relevant figures (based usually on the Polish national census of 1921) used to distinguish 'towns' from 'villages'. A very condensed English-language version of *Pinkas hakehilot*, with entries on 6,500 Jewish communities taken from the twenty-two published volumes of the full *Pinkas hakehilot* series as well as a further nine then unpublished volumes, is the three-volume *Encyclopedia of Jewish Life before and during the Holocaust* (Spector 2001). A remarkable six-volume Hebrew-language encyclopedia covering all the rabbinical personalities of Galicia, from earliest times down to the Holocaust and including rabbis of even the smallest places, has been compiled by Rabbi Meir Wunder (1978–2005). The Holocaust period is covered, in varying levels of detail, in all the above encyclopedias; an excellent and authoritative Holocaust encyclopedia is the four-volume *Encyclopedia of the Holocaust* (Gutman 1990), although it is not strong on the smaller places in Galicia referred to in this book. An important, detailed bibliographical work on the history of Galicia (both east and west, both Jewish and non-Jewish) is that of Paul Robert Magocsi (1983); it concentrates largely on Ukrainians, who were the majority population, but includes useful material on the Jews. For a general history of Poland the standard work is Davies 1981, or for a concise history see Lukowski and Zawadzki 2001.

A number of important resources exist for the benefit of those with Jewish roots in Galicia who are interested in undertaking historical and genealogical research, whether about their

families or the localities they lived in prior to the Holocaust. There are two key books: one by Miriam Weiner, covering the whole of Poland (Weiner 1997) and, for Galicia, the invaluable book by Suzan Wynne (1998; 2nd edn. 2006). The very wide scope indicated by Wynne for areas of such research is fairly daunting, including the very random range of extant archives that survived the war and are now in Israel or still in Poland; *Yizkor* books (post-war Jewish memorial books on specific places, which generally include pre-war photos, hand-drawn maps of the town showing the main Jewish sites, personal memories, and lists of local Holocaust victims); reports on the present-day condition of some synagogues and cemeteries; the names of local history enthusiasts, and other useful information about possible sources, such as passenger lists of pre-war shipping lines. There is a special section devoted to sources for the history of Jewish Kraków, and a complete listing of towns and villages throughout Galicia where Jews were known to be living in 1877. Those who are unsure of present-day Polish spellings of place names are advised to consult the indispensable reference gazetteer compiled by Gary Mokotoff and Sallyann Amdur Sack (1991), which provides alternative place names for a given town or village in different languages and spellings, including Yiddish. A great deal is now available on the web, principally Gesher Galicia, a non-profit special interest group, with its own quarterly newsletter (*The Galitzianer*), which since 1993 has been publishing feature articles on specific places and reports on current research on Galicia, and a website hosted by JewishGen (www.jewishgen.org/galicia/). JewishGen is an organization with a very substantial programme promoting Jewish genealogical research, discussion groups, and numerous web pages devoted to individual Jewish communities, including materials from the relevant *Yizkor*

books, data on tombstones in specific Jewish cemeteries, and lists of names of Holocaust victims. Since 2002 JewishGen has been affiliated with the Museum of Jewish Heritage in New York.

There is also nowadays an increasing number of Polish tourist guidebooks to Jewish Poland. Probably the pioneering, comprehensive work was that of Przemysław Burchard, covering the whole of Poland (Burchard 1990); in the early years of my research I found it invaluable. More recent, and much more widely available, is the heavily illustrated English-language guidebook by Adam Dylewski, also covering the whole of Poland (Dylewski 2002), and there is an important English-language Polish website at www.diapozytyw.pl/en, hosted by the Adam Mickiewicz Institute, Warsaw, which on its 'Traces of the Past' pages gives historical information and photographs of numerous places of Jewish interest throughout Poland, including most if not all of Dylewski's book. In recent years many locally published guidebooks and tourist handbooks focusing on Jewish heritage have appeared (some in English, some in Polish, some in bilingual editions), not only for the larger cities such as Kraków (e.g. Rejduch-Samkowa and Samek 1995) but also for a lot of much smaller places, including one very good short gazetteer covering approximately fifty towns and villages in southern Poland with pre-war hasidic communities, heavily illustrated with pre-war photos (Potocki 2008). See also www.polin. org.pl, a portal hosted by the Warsaw-based Foundation for the Preservation of Jewish Heritage in Poland, with photos, films, and other materials on about four hundred places in Poland, and www.kirkuty.xip.pl, which has illustrated pages (mainly in Polish, but some in English) specifically on the subject of Jewish cemeteries in Poland, on which there is coverage of about five hundred. On Holocaust sites and

Holocaust memorials, I also found invaluable th specialist, extremely detailed, guidebook to Second World War monuments and memorials ir Poland, even in the smallest places, published b the Rada Ochrony Pomników Walki i Męczeństwa in 1988, as well as an earlier, English-language edition (Council for the Preservation of Monuments to Resistance and Martyrdom 1968 these listings are principally concerned with the memorialization of Polish national losses during the war, but the relatively few Jewish monument as well as references to Jewish victimhood on other plaques and monuments, are also include As for guidebooks published outside Poland, the key work, based on thorough research, is that of Ruth Ellen Gruber (2007). For a detailed historica atlas (essential if one is interested in tracing the numerous border changes) see Magocsi 1993, which has copious historical notes accompanying each map.

It should be noted that most of the above literature, with the outstanding exception of Wunder 1978–2005, does not specialize in matters of interest to religious Jews. The pioneering Jewish religious guidebook to Poland is undoubtedly the two-volume Hebrew-language work of Avraham Mordechai Alter (Alte 1987); for more recent material see Kasnett 1997 Popular English-language religious histories have also begun to appear in recent years, for example on the hasidim of Tsanz (Nowy Sącz) (Lehrer and Strassman 1997) or on the hasidic dynasty of Bobov (Bobowa) (Gliksman 1997); and Jewish religious outreach organizations such as Aish Hatorah (www.aish.com) have begun to post on their websites 'crash courses' in Polish Jewish history as well as videos about the visits they arrange to Poland.

Consistent with the approach of this book, the above listings are far from comprehensive but

re intended merely to give an indication of the range of the available literature and to offer some suggestions for those who wish to do some further reading. Full details of all the titles mentioned both in the above note and in the notes to the photographs can be found in the list of references that follows immediately below.

References

LTER, AVRAHAM MORDECHAI. 1987. *Bedarkhei polin ha'avelot: sipurah shel polin heḥarevah*, 2 vols. Jerusalem: Makhon Zekher Naftali, Merkaz Leheker Hahasidut Umahshevet Yisra'el.

MERICAN JEWISH COMMITTEE. 2004. *Belzec Memorial Museum*. New York: American Jewish Committee.

NKORI, ZVI. 2003. *Chestnuts of Yesteryear: A Jewish Odyssey*. Jerusalem: Gefen.

RAD, YITZHAK. 1987. *Belzec, Sobibor, Treblinka: The Operation Reinhard Death Camps*. Bloomington: Indiana University Press.

SSAF, DAVID. 2008. 'Hasidism: Historical Overview' (trans. David Louvish), in Gershon David Hundert (ed.), *The YIVO Encyclopedia of Jews in Eastern Europe*, i. 659–70. New Haven: Yale University Press.

AEDEKER, KARL. 1905. *Austria-Hungary, including Dalmatia and Bosnia: Handbook for Travellers*, 10th edn. Leipzig: Karl Baedeker.

AŁABAN, MAJER. 1935. *Przewodnik po żydowskich zabytkach Krakowa*. Kraków: Stowarzyszenie Solidarność B'nei B'rith w Krakowie.

AR-ITZHAK, HAYA. 2001. *Jewish Poland: Legends of Origin. Ethnopoetics and Legendary Chronicles*. Detroit: Wayne State University Press.

ARTAL, ISRAEL, and ANTONY POLONSKY (eds.). 1999a. *Polin: Studies in Polish Jewry*, 12: *Focusing on Galicia: Jews, Poles, and Ukrainians 1772–1918*. London: The Littman Library of Jewish Civilization.

—— 1999b. 'Introduction: The Jews of Galicia under the Habsburgs', in Bartal and Polonsky (eds.), *Polin: Studies in Polish Jewry*, 12: *Focusing on Galicia*, 3–24.

BARTOSZ, ADAM. 1992. *Tarnowskie judaica*. Warsaw: PTTK Kraj.

—— 2007. *Żydowskim szlakiem po Tarnowie / In the Footsteps of the Jews of Tarnów*, trilingual Polish–English–Hebrew edn. (trans. Annamaria Orla-Bukowska and Hanoch Fenichel). Tarnów: Muzeum Okręgowe w Tarnowie.

—— 2008. 'From the House of Chaim', in Karol Majcher, *Bobowa: Historia, ludzie, zabytki*, 178–85. Warsaw: Przedsiębiorstwo Wydawnicze Rzeczpospolita.

BAUMINGER, ARYEH. 1959. 'Toledot hayehudim bekroke bishnot 5064–5475 (1304–1815)', in Aryeh Bauminger, Meir Busak, and Natan Michael Gelber (eds.), *Sefer kroke: ir va'em beyisra'el*, 9–38. Jerusalem: Mosad Harav Kook.

BEIDER, ALEXANDER. 2008. 'Names and Naming', in Gershon David Hundert (ed.), *The YIVO Encyclopedia of Jews in Eastern Europe*, ii. 1248–51. New Haven: Yale University Press.

BENDER, SARA, and SHMUEL KRAKOWSKI (eds.). 2004. *The Encyclopedia of the Righteous among the Nations: Rescuers of Jews during the Holocaust. Poland*, 2 vols. Jerusalem: Yad Vashem.

BEN-SASSON, HAIM HILLEL. 1972. 'Poland', *Encyclopaedia Judaica*, vol. xiii, cols. 709–32. Jerusalem: Keter.

BERGMAN, ELEONORA, and JAN JAGIELSKI. 1990. 'The Function of Synagogues in the PPR, 1988', in Antony Polonsky (ed.), *Polin: Studies in Polish Jewry*, 5: 40–9. Oxford: Basil Blackwell; repr. Oxford: The Littman Library of Jewish Civilization, 2008.

—— 1996. *Zachowane synagogi i domy modlitwy w Polsce: Katalog*. Warsaw: Żydowski Instytut Historyczny.

BIDERMAN, ISRAEL M. 1976. *Mayer Balaban, Historian of Polish Jewry: His Influence on the Younger Generation of Jewish Historians*. New York: Dr I. M. Biderman Book Committee.

BROWNING, CHRISTOPHER R. 1992. *Ordinary Men: Reserve Police Battalion 101 and the Final Solution in Poland*. New York: HarperCollins.

BUBER, MARTIN. 1948. *Tales of the Hasidim: The Later Masters*. New York: Schocken Books.

BURCHARD, PRZEMYSŁAW. 1990. *Pamiątki i zabytki kultury żydowskiej w Polsce*. Warsaw: Reprint.

BUSAK, MEIR. 1959. 'Yehudei kroke bemaḥatsit hasheniyah shel hame'ah ha-19', in Aryeh Bauminger, Meir Busak, and Natan Michael Gelber (eds.), *Sefer kroke: ir va'em beyisra'el*, 89–125. Jerusalem: Mosad Harav Kook.

BUSZKO, JÓZEF. 1999. 'The Consequences of Galician Autonomy after 1867' (trans. Jolanta Goldstein), in Israel Bartal and Antony Polonsky (eds.), *Polin: Studies in Polish Jewry*, 12: *Galicia: Jews, Poles, and Ukrainians, 1772–1918*, 86–99. London: The Littman Library of Jewish Civilization.

CAŁA, ALINA. 1995. *The Image of the Jew in Polish Folk Culture*. Jerusalem: Magnes Press.

CHERRY, ROBERT, and ANNAMARIA ORLA-BUKOWSKA (eds.). 2007. *Rethinking Poles and Jews: Troubled Past, Brighter Future*. Lanham, Md.: Rowman & Littlefield.

Council for the Preservation of Monuments to Resistance and Martyrdom. 1968. *Scenes of Fighting and Martyrdom: Guide. War Years in Poland 1939–1945*. Warsaw: Sport i Turystyka.

CRADDY, KATHERINE, TOMASZ KUNCEWICZ, et al. 2006. *Polish Heroes: Those Who Rescued Jews*. Kraków: Galicia Jewish Museum.

CZECH, DANUTA. 1990. *Auschwitz Chronicle: 1939–1945*. London: I. B. Tauris.

DĄBROWSKA, DANUTA, AVRAHAM WEIN, and AHARON WEISS (eds.). 1980. *Pinkas hakehilot: entsiklopediyah shel hayishuvim hayehudiyim lemin hivasedam ve'ad le'aḥar sho'at milḥemet ha'olam hasheniyah. Polin*, 2: *Galitsiyah hamizraḥit.* Jerusalem: Yad Vashem.

DAVIES, NORMAN. 1981. *God's Playground: A History of Poland*, 2 vols. Oxford: Clarendon Press.

DŁUGOSZ, ELŻBIETA. 2005. 'Hasidic Customs and their Traces in Museum Collections', in Elżbieta Długosz (ed.), *Czas chasydów / Time of the Hasidim*, exhibition catalogue, bilingual Polish–English edn. (trans. Małgorzata Walczak and Kris Nowicki), 77–107. Muzeum Historyczne Miasta Krakowa (The Historical Museum of the City of Kraków) / Katedra Judaistyki Uniwersytetu Jagiellońskiego (Department of Jewish Studies, Jagiellonian University).

DOBROSZYCKI, LUCJAN, and BARBARA KIRSHENBLATT-GIMBLETT. 1977. *Image Before My Eyes: A Photographic History of Jewish Life in Poland, 1864–1939.* New York: Schocken Books.

DORFMAN, RIVKA, and BEN-ZION DORFMAN. 2000. *Synagogues Without Jews, and the Communities that Built and Used Them.* Philadelphia: Jewish Publication Society.

DUBNOW, S. M. 1916–20. *History of the Jews in Russia and Poland from the Earliest Times until the Present Day* (trans. I. Friedlaender), 3 vols. Philadelphia: Jewish Publication Society of America.

DUDA, EUGENIUSZ. 1999. *The Jews of Cracow* (trans. Ewa Basiura). Kraków: Hagada and Argona-Jarden Jewish Bookshop.

DYLEWSKI, ADAM. 2002. *Where the Tailor was a Poet . . .: Polish Jews and their Culture. An Illustrated Guide* (trans. Wojciech Graniczewski and Ramon Schindler). Bielsko-Biała: Pascal.

DYNNER, GLENN. 2006. *Men of Silk: The Hasidic Conquest of Polish Jewish Society.* New York: Oxford University Press.

ELIACH, YAFFA. 1982. *Hasidic Tales of the Holocaust.* New York: Oxford University Press.

ENGEL, DAVID. 1998. 'Patterns of Anti-Jewish Violence in Poland, 1944–1946', *Yad Vashem Studies*, 26: 43–85.

GANZFRIED, SOLOMON. 1961. *Kitzur shulḥan arukh: Code of Jewish Law. A Compilation of Jewish Laws and Customs*, rev. edn. (trans. Hyman E. Goldin), 4 vols. New York: Hebrew Publishing Company.

GĄSOWSKI, TOMASZ. 1992. 'Jewish Communities in Autonomous Galicia: Their Size and Distribution', in Andrzej K. Paluch (ed.), *The Jews in Poland*, i. 205–21. Kraków: Jagiellonian University Research Centre on Jewish History and Culture in Poland.

GAWRON, EDYTA. 2005. 'The Role of Social and Religious Jewish Organizations in Cracow during the Period of the Polish People's Republic (1945–1989)', unpublished paper given at the conference '700 Years of Jewish Presence in Kraków', Polish Academy of Arts and Sciences, Kraków, 26–28 September 2005.

GEBERT, KONSTANTY. 1994. 'Jewish Identities in Poland: New, Old, and Imaginary', in Jonathan Webber (ed.), *Jewish Identities in the New Europe*, 161–7. London: The Littman Library of Jewish Civilization.

GESHURI, M. SH. 1959. 'Haḥazanim vehaḥazanut bekroke', in Aryeh Bauminger, Meir Busak, and Natan Michael Gelber (eds.), *Sefer kroke: ir va'em beyisra'el*, 344–51. Jerusalem: Mosad Harav Kook.

GILBERT, MARTIN. 1986. *The Holocaust: The Jewish Tragedy.* London: Collins.

GLIKSMAN, DEVORAH. 1997. *Nor the Moon by Night: The Survival of the Chassidic Dynasty of Bobov.* New York: Feldheim.

GŁUCHOWSKI, LESZEK W., and ANTONY POLONSKY (eds.). 2009. *Polin: Studies in Polish Jewry*, 21: *1968: Forty Years After.* Oxford: The Littman Library of Jewish Civilization.

GOLDMAN, BEN-TSIYON, and AHARON BEN-TSIYON BEIGEL (eds.). 1991. *Ner hama'aravi venerotav shehidlik.* New York: no publisher given.

GOSTYŃSKI, ZALMAN. 1973. *Des pierres racontent . . . /Shteiner derzeilen . . .*, bilingual French–Yiddish edn.; photos by Adam Bujak and Zalman Gostyński. Paris: Union des Juifs Originaires de l'Europe de l'Est (Ferband fun di mizrach-airope'ishe yidn in frankreich).

GREIF, GIDEON. 2005. *We Wept Without Tears: Testimonies of the Jewish Sonderkommando from Auschwitz.* New Haven: Yale University Press.

GROSS, NATAN. 2001. *Who Are You, Mr Grymek?* (trans. William R. Brand), London: Vallentine Mitchell.

GRUBER, RUTH ELLEN. 2002. *Virtually Jewish: Reinventing Jewish Culture in Europe.* Berkeley: University of California Press.

—— 2007. *Jewish Heritage Travel: A Guide to Eastern Europe.* Washington, DC: National Geographic.

GRUBER, SAMUEL, and PHYLLIS MYERS, with ELEONORA BERGMAN and JAN JAGIELSKI. 1995. *Survey of Historic Jewish Monuments in Poland: A Report to the United States Commission for the Preservation of America's Heritage Abroad*, 2nd edn. [n.p.]: Jewish Heritage Council, World Monuments Fund.

GUTMAN, ISRAEL (ed.). 1990. *Encyclopedia of the Holocaust*, 4 vols. New York: Macmillan.

—— 1994. 'Auschwitz: An Overview', in Israel Gutman and Michael Berenbaum (eds.), *Anatomy of the Auschwitz Death Camp*, 5–33. Bloomington: Indiana University Press.

—— and MICHAEL BERENBAUM (eds.). 1994. *Anatomy of the Auschwitz Death Camp.* Bloomington: Indiana University Press.

—— and SHMUEL KRAKOWSKI. 1986. *Unequal Victims: Poles and Jews during World War Two* (trans. Ted Gorelick and Witold Jedlicki). New York: Holocaust Library.

—— EZRA MENDELSOHN, JEHUDA REINHARZ, and CHONE SHMERUK (eds.). 1989. *The Jews of Poland between Two World Wars*. Hanover, NH: University Press of New England.

AŁKOWSKI, HENRYK. 1998. *The Legends from the Jewish Town in Kazimierz near Cracow*. Kraków: Mercury.

—— 2007. 'Świat przed katastrofą?' / 'A World before a Catastrophe?', in Jacek Purchla and Aleksander Skotnicki (eds.), *Świat przed katastrofą: Żydzi krakowscy w dwudziestoleciu międzywojennym / A World before a Catastrophe: Kraków's Jews between the Wars*, bilingual Polish–English edn., 21–32. Kraków: Międzynarodowe Centrum Kultury (International Cultural Centre).

AMERMESH, MIRA. 2004. *The River of Angry Dogs: A Memoir*. London: Pluto Press.

ELLER, CELIA S. [1977] 1980. *On the Edge of Destruction: Jews of Poland between the Two World Wars*. New York: Schocken Books.

OFFMAN, EVA. 1998. *Shtetl: The Life and Death of a Small Town and the World of Polish Jews*. London: Secker & Warburg.

OŃDO, LESZEK. 1999a. *Stary Żydowski cmentarz w Krakowie: Historia cmentarza, analiza hebrajskich inskrypcji*. Kraków: Wydawnictwo Uniwersytetu Jagiellońskiego.

—— 1999b. 'The Old Jewish Cemetery in Cracow', in Sławomir Kapralski (ed.), *The Jews in Poland*, ii. 235–49. Kraków: Judaica Foundation.

—— 2000. *Inskrypcje starego Żydowskiego cmentarza w Krakowie*, pt. 1. Polska Akademia Umiejętności: Prace Międzywydziałowej Komisji Historii i Kultury Żydów, no. 3. Kraków: Nakładem Polskiej Akademii Umiejętności.

—— 2001. *Żydowski cmentarz w Tarnowie*, Studia Judaica Cracoviensia. Kraków: Wydawnictwo Uniwersytetu Jagiellońskiego.

UBKA, THOMAS C. 2003. *Resplendent Synagogue: Architecture and Worship in an Eighteenth-Century Polish Community*. Hanover, NH: Brandeis University Press.

HUNDERT, GERSHON DAVID. 2000. 'Jewish Life in Eastern Europe', in David Goberman, *Carved Memories: Heritage in Stone from the Russian Jewish Pale*, 27–43. New York: Rizzoli.

—— (ed.). 2008. *The YIVO Encyclopedia of Jews in Eastern Europe*, 2 vols. New Haven: Yale University Press.

IRWIN-ZARECKA, IWONA. 1988. 'Poland after the Holocaust', in John K. Roth and Elisabeth Maxwell (eds.), *Remembering for the Future: Jews and Christians during and after the Holocaust*, i. 143–55. Oxford: Pergamon Press.

JAGIELSKI, JAN. 1996. 'Monuments of Jewish History in the Works of the Jewish Historical Institute', in Eleonora Bergman (ed.), *Jewish Historical Institute: The First Fifty Years, 1947–1997* (trans. Robert L. Kirkland III), 89–95. Warsaw: Żydowski Instytut Historyczny, Instytut Naukowo-Badawczy.

JAGODZIŃSKA, AGNIESZKA, forthcoming. 'Kaddish for Angels: Revisioning Funerary Tradition in Nineteenth-Century Jewish Warsaw', in Simon Bronner (ed.), *Revisioning Ritual: Jewish Traditions in Transition*, Jewish Cultural Studies 3. Oxford: The Littman Library of Jewish Civilization.

Kaliv World Center. 2002. *Shema Yisrael: Testimonies of Devotion, Courage and Self-Sacrifice, 1939–1945* (trans. Yaakov Lavon). Southfield, Mich.: Targum Press.

KASNETT, YITZCHAK. 1997. *The World That Was: Poland. A Study of the Life and Torah Consciousness of Jews in the Shtetlach, Towns and Cities of Poland*. Cleveland Heights, Ohio: Hebrew Academy of Cleveland.

KASSOW, SAMUEL. 2008. 'Shtetl', in Gershon David Hundert (ed.), *The YIVO Encyclopedia of Jews in Eastern Europe*, ii. 1732–9. New Haven: Yale University Press.

KATZ, STEVEN T., SHLOMO BIDERMAN, and GERSHON GREENBERG (eds.). 2007. *Wrestling with God: Jewish Theological Responses during and after the Holocaust*. Oxford: Oxford University Press.

KIELBICKA, ANIELA. 1986. 'The Liquidation of the Jewish Associations in Cracow during the Nazi Occupation', *Yad Vashem Studies*, 17: 295–317.

KRAJEWSKA, MONIKA. 1983. *Time of Stones*. Warsaw: Interpress.

—— 1993. *A Tribe of Stones: Jewish Cemeteries in Poland*. Warsaw: Polish Scientific Publishers.

KRAJEWSKI, STANISŁAW. 2005. *Poland and the Jews: Reflections of a Polish Polish Jew*. Kraków: Austeria.

KRINSKY, CAROL HERSELLE. 1985. *Synagogues of Europe: Architecture, History, Meaning*, Cambridge, Mass.: Architectural History Foundation.

KSIĘGA ADRESOWA MIASTA KRAKOWA. 1932. *Księga adresowa miasta Krakowa i województwa krakowskiego 1932*. Kraków: MAR (Małopolska Agencja Reklamy).

KUBICA, HELENA. 1994. 'Children', in Israel Gutman and Michael Berenbaum (eds.), *Anatomy of the Auschwitz Death Camp*, 412–27. Bloomington: Indiana University Press.

KUGELMASS, JACK. 1994. 'Why We Go To Poland: Holocaust Tourism as Secular Ritual', in James E. Young (ed.), *The Art of Memory: Holocaust Memorials in History*, 175–83. Munich: Prestel.

KUNERT, ANDRZEJ KRZYSZTOF (ed.). 2002. *'Żegota': The Council for Aid to Jews, 1942–1945. Selected Documents*. Warsaw: Rada Ochrony Pamięci Walk i Męczeństwa.

LEBET-MINAKOWSKA, ANNA. 2004. 'Judaica Collections at the National Museum in Kraków' (trans. William Brand), in *Catalogue of the 14th Jewish Culture Festival in Kraków*. 63–4. Kraków: Plus.

LEGUTKO-OŁOWNIA, AGNIESZKA. 2004. *Kraków's Kazimierz: Town of Partings and Returns*. Kraków: Bezdroża.

LEHMANN, ROSA. 2001. *Symbiosis and Ambivalence: Poles and Jews in a Small Galician Town*. New York: Berghahn Books.

LEHRER, ERICA. 2003. 'Repopulating Jewish Poland—in Wood', in Michael C. Steinlauf and Antony Polonsky (eds.), *Polin: Studies in Polish Jewry*, 16: *Jewish Popular Culture in Poland and its Afterlife*, 335–55. Oxford: The Littman Library of Jewish Civilization.

LEHRER, SHLOMO ZALMAN, and LEIZER STRASSMAN. 1997. *The Vanished City of Tsanz*. Southfield, Mich.: Targum Press.

LEVI, PRIMO. [1986] 1988. *The Drowned and the Saved* (trans. Raymond Rosenthal). London: Penguin.

LEW, MYER S. 1944. *The Jews of Poland: Their Political, Economic, Social and Communal Life in the Sixteenth Century as Reflected in the Works of Rabbi Moses Isserles*. London: Edward Goldston.

LIGOCKA, ROMA. 2002. *The Girl in the Red Coat: A Memoir* (trans. Margot Bettauer Bembo). New York: St Martin's Press.

LOUKOMSKI, GEORGE K. 1947. *Jewish Art in European Synagogues: From the Middle Ages to the Eighteenth Century*. London: Hutchinson.

LUKOWSKI, JERZY, and HUBERT ZAWADZKI. 2001. *A Concise History of Poland*. Cambridge: Cambridge University Press.

MAGOCSI, PAUL ROBERT. 1983. *Galicia: A Historical Survey and Bibliographic Guide*. Toronto: University of Toronto Press.

—— 1993. *Historical Atlas of East Central Europe* (cartographic design by Geoffrey J. Matthews). Seattle: University of Washington Press.

MAHLER, RAPHAEL. 1985. *Hasidism and the Jewish Enlightenment: Their Confrontation in Galicia and Poland in the First Half of the Nineteenth Century* (trans. Eugene Orenstein). Philadelphia: Jewish Publication Society of America.

MAJCHER, KAROL. 2008. *Bobowa: Historia, ludzie, zabytki*. Warsaw: Przedsiębiorstwo Wydawnicze Rzeczpospolita.

MANEKIN, RACHEL. 1999. 'Politics, Religion, and National Identity: The Galician Jewish Vote in the 1873 Parliamentary Elections', in Israel Bartal and Antony Polonsky (eds.), *Polin: Studies in Polish Jewry*, 12: *Galicia: Jews, Poles, and Ukrainians, 1772–1918*, 100–19. London: The Littman Library of Jewish Civilization.

—— 2008. 'Galicia' (trans. Deborah Weissman), in Gershon David Hundert (ed.), *The YIVO Encyclopedia of Jews in Eastern Europe*, i. 560–7. New Haven: Yale University Press.

MARCUS, JOSEPH. 1983. *Social and Political History of the Jews in Poland, 1919–1939*. Berlin: Mouton.

MARTIN, SEAN. 2004. *Jewish Life in Cracow, 1918–1939*. London: Vallentine Mitchell.

MENDELSOHN, EZRA. 1981. *Zionism in Poland: The Formative Years, 1915–1926*. New Haven: Yale University Press.

—— 1986. 'Interwar Poland: Good for the Jews or Bad for the Jews?', in Chimen Abramsky, Maciej Jachimczyk, and Antony Polonsky (eds.), *The Jews in Poland*, 130–9. Oxford: Basil Blackwell.

MOKOTOFF, GARY, and SALLYANN AMDUR SACK. 1991. *Where Once We Walked: A Guide to the Jewish Communities Destroyed in the Holocaust*. Teaneck, NJ: Avotaynu.

MURZYN, MONIKA A. 2006. *Środkowoeuropejskie doświadczenie rewitalizacji / The Central European Experience of Urban Regeneration*, bilingual Polish–English edn. Kraków: Międzynarodowe Centrum Kultury (International Cultural Centre).

O'NEIL, ROBIN. [2004] 2008. *Bełżec: Stepping Stone to Genocide*. New York: Museum of Jewish Heritage and JewishGen. The 2004 edition is available online at www.jewishgen.org/Yizkor/belzec1/Belzec1.html, last accessed January 2009.

ORLA-BUKOWSKA, ANNAMARIA. 1994. 'Shtetl Communities: Another Image', in Antony Polonsky, Ezra Mendelsohn, and Jerzy Tomaszewski (eds.), *Polin: Studies in Polish Jewry*, 8: *Jews in Independent Poland, 1918–1939*, 89–113. London: The Littman Library of Jewish Civilization.

—— 2004. 'Maintaining Borders, Crossing Borders Social Relationships in the Shtetl', in Antony Polonsky (ed.), *Polin: Studies in Polish Jewry*, 17: *The Shtetl: Myth and Reality*, 171–95. Oxford: The Littman Library of Jewish Civilization.

ORŁOWICZ, MIECZYSŁAW. 1914. *Ilustrowany przewodnik po Galicyi*. Lwów: Akademicki klub turystyczny we Lwowie.

PALOWSKI, FRANCISZEK. [1994] 1996. *Retracing 'Schindler's List': Guidebook*. Kraków: Argona Jarden Art.

PALUCH, ANDRZEJ K. 1992. 'Konzentrationslager Auschwitz: The View from Outside', in Andrzej K. Paluch (ed.), *The Jews in Poland*, i. 327–39. Kraków: Jagiellonian University Research Centre on Jewish History and Culture in Poland.

PANKIEWICZ, TADEUSZ. [1947] 1987. *The Cracow Ghetto Pharmacy* (trans. Henry Tilles). New York: Holocaust Library.

PASH, BOAZ. 2008. *The Remuh Synagogue and the Old Cemetery Guide* (trans. Tehilah van Luit). Kraków: Wydawnictwo Hagada.

PETERSEN, HEIDEMARIE. 2002. '"*Daz man nit zol in der shtat gin* . . ."': Jewish Communal Organisation in Sixteenth-Century Polish Towns', in András Kovács and Eszter Andor (eds.), *Jewish Studies at the Central European University*, ii. 153–62. Budapest: Central European University Jewish Studies Project.

PIECHOTKA, MARIA, and KAZIMIERZ PIECHOTKA. 1959. *Wooden Synagogues* (trans. Stephen S. Kayser). Warsaw: Arkady.

—— 1999. *Bramy Nieba: Bóżnice murowane na ziemiach dawnej Rzeczypospolitej*. Warsaw: Krupski.

—— 2004. *Heaven's Gates: Wooden Synagogues in the Territories of the Former Polish–Lithuanian*

Commonwealth (trans. Krzysztof Cieszkowski). Warsaw: Krupski.

ILARCZYK, KRZYSZTOF. 1992. 'The Jagiellonian University Research Center on Jewish History and Culture in Poland', in Andrzej K. Paluch (ed.), *The Jews in Poland*, i. 483–8. Kraków: Jagiellonian University Research Centre on Jewish History and Culture in Poland.

inkas hakehilot: Polin, vol. 2. *See* Dąbrowska, Wein, and Weiss 1980.

inkas hakehilot: Polin, vol. 3. *See* Wein and Weiss 1984.

IPER, FRANCISZEK. 1991. 'Estimating the Number of Deportees to and Victims of the Auschwitz-Birkenau Camp', *Yad Vashem Studies*, 21: 49–103.

OLONSKY, ANTONY (ed.). 2004. *Polin: Studies in Polish Jewry*, 17: *The Shtetl: Myth and Reality*. Oxford: The Littman Library of Jewish Civilization.

—— EZRA MENDELSOHN, and JERZY TOMASZEWSKI (eds.). 1994. *Polin: Studies in Polish Jewry*, 8: *Jews in Independent Poland, 1918–1939*. London: The Littman Library of Jewish Civilization.

OTOCKI, ANDRZEJ. 2008. *Śladami chasydzkich cadyków w Podkarpackiem*. Rzeszów: Carpathia.

"RAGER, MOSHE. 1974. *Sparks of Glory: Inspiring Episodes of Jewish Spiritual Resistance by Israel's Leading Chronicler of Holocaust Courage*. Brooklyn, NY: Mesorah Publications.

ada Ochrony Pomników Walki i Męczeństwa. 1988. *Przewodnik po upamiętnionych miejscach walk i męczeństwa lata wojny 1939–1945*, 4th edn. Warsaw: Sport i Turystyka.

"EDER, RUDOLF. [1946] 2000. 'Bełżec' (trans. M. M. Rubel), in Antony Polonsky (ed.), *Polin: Studies in Polish Jewry*, 13: *Focusing on the Holocaust and its Aftermath*, 268–89. London: The Littman Library of Jewish Civilization.

EINARTZ, DIRK, and CHRISTIAN GRAF VON KROCKOW. 1995. *Deathly Still: Pictures of Former German Concentration Camps* (trans. Ishbel Flett). Göttingen: Steidl.

REJDUCH-SAMKOWA, IZABELLA, and JAN SAMEK (eds.). 1995. *Katalog zabytków sztuki w Polsce*, iv: *Miasto Kraków*, pt. 6: 'Kazimierz i Stradom, Judaica: Bóżnice, budowle publiczne i cmentarze'. Warsaw: Instytut Sztuki Polskiej Akademii Nauk.

ROSENBAUM, IRVING J. 1976. *The Holocaust and Halakhah*. Hoboken, NJ: Ktav.

ROSMAN, M. J. 1986. 'Jewish Perceptions of Insecurity and Powerlessness in 16th- to 18th-Century Poland', in Antony Polonsky (ed.), *Polin: Studies in Polish Jewry*, 1: 19–27. Oxford: Basil Blackwell; repr. Oxford: The Littman Library of Jewish Civilization, 2004.

—— 2002. 'Innovative Tradition: Jewish Culture in the Polish–Lithuanian Commonwealth', in David Biale (ed.), *Cultures of the Jews: A New History*, 519–70. New York: Schocken Books.

—— 2007. *How Jewish Is Jewish History?* Oxford: The Littman Library of Jewish Civilization.

RYMASZEWSKI, BOHDAN. 2003. *Generations Should Remember*. Oświęcim: Auschwitz-Birkenau State Museum.

SABOR, AGNIESZKA, BARBARA ZBROJA, and KATARZYNA ZIMMERER. 2007. Annotated exhibition catalogue, in Jacek Purchla and Aleksander Skotnicki (eds.), *Świat przed katastrofą: Żydzi krakowscy w dwudziestoleciu międzywojennym /A World before a Catastrophe: Kraków's Jews between the Wars*, bilingual Polish–English edn., 79–155. Kraków: Międzynarodowe Centrum Kultury (International Cultural Centre).

SCHARF, RAFAEL F. 1996. *Co mnie i tobie Polsko . . .: Eseje bez uprzedzeń /Poland, What Have I To Do With Thee . . .: Essays Without Prejudice*, bilingual Polish–English edn. Kraków: Fundacja Judaica.

SCHINDLER, PESACH. 1990. *Hasidic Responses to the Holocaust in the Light of Hasidic Thought*. Hoboken, NJ: Ktav.

SCHNEIDER, GERTRUDE (ed.). 2000. *Mordechai Gebirtig: His Poetic and Musical Legacy*. Westport, Conn.: Praeger.

SCHUDRICH, MICHAEL. 2007. 'Polish–Jewish Relations in Poland: Where Have We Come From and Where Are We Headed?', in Robert Cherry and Annamaria Orla-Bukowska (eds.), *Rethinking Poles and Jews: Troubled Past, Brighter Future*, 137–40. Lanham, Md.: Rowman & Littlefield.

SCHWARZ, CHRIS. 2005. *Photographing Traces of Memory: A Contemporary View of the Jewish Past in Polish Galicia*, with introductory texts by Jonathan Webber. Kraków: Galicia Jewish Museum.

SHERAMY, RONA. 2007. 'From Auschwitz to Jerusalem: Re-enacting Jewish History on the March of the Living', in Mieczysław B. Biskupski and Antony Polonsky (eds.), *Polin: Studies in Polish Jewry*, 19: *Polish–Jewish Relations in North America*, 307–25. Oxford: The Littman Library of Jewish Civilization.

SILVAIN, GÉRARD, and HENRI MINCZELES. 1999. *Yiddishland*. Paris: Éditions Hazan.

SKOTNICKI, ALEKSANDER B. 2008. *Oskar Schindler: In the Eyes of Cracovian Jews Rescued by Him* (trans. Karolina Baran). Kraków: AA.

SKROMAK, ELŻBIETA, et al. (eds.). 2006. *Kultura Żydów galicyjskich: Ze zbiorów Muzeum Etnografii i Rzemiosła Artystycznego we Lwowie*. Stalowa Wola: Muzeum Regionalne w Stalowej Woli, Muzeum Historyczne Miasta Gdańska, and Muzeum Etnografii i Rzemiosła Artystycznego we Lwowie.

SMITH, STEPHEN S. 2000. *Forgotten Places: The Holocaust and the Remnants of Destruction. A Photographic Essay*. Newark: Quill Press, for the Beth Shalom Holocaust Memorial Centre.

SPECTOR, SHMUEL (ed.). 2001. *The Encyclopedia of Jewish Life before and during the Holocaust*, 3 vols. New York: New York University Press; Jerusalem: Yad Vashem.

STANISLAWSKI, MICHAEL. 2008. 'Kahal', in Gershon David Hundert (ed.), *The YIVO Encyclopedia of Jews in Eastern Europe*, i. 845–8. New Haven: Yale University Press.

STEINLAUF, MICHAEL C. 1997. *Bondage to the Dead: Poland and the Memory of the Holocaust*. Syracuse, NY: Syracuse University Press.

STEINSALTZ, ADIN. 1989. *The Talmud: The Steinsaltz Edition. A Reference Guide*. New York: Random House.

STRZELECKI, ANDRZEJ. 1994. 'The Plunder of Victims and their Corpses', in Israel Gutman and Michael Berenbaum (eds.), *Anatomy of the Auschwitz Death Camp*, 246–66. Bloomington: Indiana University Press.

ŚWIEBOCKA, TERESA, JONATHAN WEBBER, and CONNIE WILSACK (eds.). 1993. *Auschwitz: A History in Photographs*. Bloomington: Indiana University Press; Warsaw: Książka i Wiedza, for the Auschwitz-Birkenau State Museum, Oświęcim.

TEC, NECHAMA. 1986. *When Light Pierced the Darkness: Christian Rescue of Jews in Nazi-Occupied Poland*. New York: Oxford University Press.

TRUNK, ISAIAH. [1972] 1996. *Judenrat: The Jewish Councils in Eastern Europe under Nazi Occupation*. Lincoln: University of Nebraska Press.

—— 1979. *Jewish Responses to Nazi Persecution: Collective and Individual Behavior in Extremis*. New York: Stein & Day.

VISHNIAC, ROMAN. [1947] 1983. *A Vanished World*. New York: Farrar, Straus & Giroux.

WEBBER, JONATHAN. 1992. *The Future of Auschwitz: Some Personal Reflections*. Frank Green Lectures 1. Oxford: Oxford Centre for Postgraduate Hebrew Studies.

—— 2000a. 'Jewish Identities in the Holocaust: Martyrdom as a Representative Category', in Antony Polonsky (ed.), *Polin: Studies in Polish Jewry*, 13: *Focusing on the Holocaust and its Aftermath*, 128–46. London: The Littman Library of Jewish Civilization.

—— 2000b. 'Lest We Forget! The Holocaust in Jewish Historical Consciousness and Modern Jewish Identities', in Glenda Abramson (ed.), *Modern Jewish Mythologies*, 107–35. Cincinnati: Hebrew Union College Press.

—— 2006. 'Memory, Religion, and Conflict at Auschwitz: A Manifesto', in Oren Baruch Stier and J. Shawn Landres (eds.), *Religion, Violence, Memory, and Place*, 51–70. Bloomington: Indiana University Press.

WEIN, AVRAHAM, and AHARON WEISS (eds.). 1984. *Pinkas hakehilot: entsiklopediyah shel hayishuvim hayehudiyim lemin hivasedam ve'ad le'aḥar sho'at milḥemet ha'olam hasheniyah. Polin*, vol. 3: *Galitsiyah hama'aravit veshleziyah*. Jerusalem: Yad Vashem.

WEINER, MIRIAM. 1997. *Jewish Roots in Poland: Pages from the Past and Archival Inventories*. Secaucus, NJ: The Miriam Weiner Routes to Roots Foundation and YIVO Institute for Jewish Research.

WIESEL, ELIE. [1958] 1981. *Night* (trans. Stella Rodway). London: Penguin.

WISCHNITZER, RACHEL. 1964. *The Architecture of the European Synagogue*, Philadelphia: Jewish Publication Society of America.

WODZIŃSKI, MARCIN. 1998. *Groby cadyków w Polsce: O chasydzkiej literaturze nagrobnej i jej kontekstach*. Wrocław: Towarzystwo Przyjaciół Polonistyki Wrocławskiej.

—— 2005. *Haskalah and Hasidism in the Kingdom of Poland: A History of Conflict*. Oxford: The Littman Library of Jewish Civilization.

WUNDER, MEIR. 1978–2005. *Me'orei galitsiyah: entsiklopediyah leḥakhmei galitsiyah*, 6 vols. Jerusalem: Makhon Lehantsahat Yahadut Galitsiyah.

WYNNE, SUZAN F. 1998. *Finding Your Jewish Roots in Galicia: A Resource Guide*. Teaneck, NJ: Avotaynu; 2nd edn. (privately published, 2006): *The Galitzianers: The Jews of Galicia, 1772–1918*.

ZBROJA, BARBARA. 2007. 'Forgotten Heritage: The Architecture of Jewish Kraków', in Jacek Purchla and Aleksander Skotnicki (eds.), *Świat przed katastrofą: Żydzi krakowscy w dwudziestoleciu międzywojennym / A World before a Catastrophe: Kraków's Jews between the Wars*, bilingual Polish–English edn., 43–52. Kraków: Międzynarodowe Centrum Kultury (International Cultural Centre).

ZIMMELS, H. J. 1977. *The Echo of the Nazi Holocaust in Rabbinic Literature*. Hoboken, NJ: Ktav.

ZIMMERMAN, JOSHUA D. (ed.). 2003. *Contested Memories: Poles and Jews during the Holocaust and its Aftermath*, New Brunswick, NJ: Rutgers University Press.